THE PORTRAIT
IN PHOTOGRAPHY

Critical Views

THE PORTRAIT
IN PHOTOGRAPHY

Edited by
Graham Clarke

REAKTION BOOKS

Published by Reaktion Books Ltd
1–5 Midford Place, Tottenham Court Road
London W1P 9HH, UK

First Published 1992

Distributed in USA and Canada
by the University of Washington Press,
PO Box 50096, Seattle,
Washington 98145–5096, USA

Designed by Humphrey Stone

Photoset by Wilmaset Ltd, Birkenhead, Wirral
Printed and bound in Great Britain by
Redwood Press Ltd, Melksham, Wiltshire

British Library Cataloguing in Publication Data
The portrait in photography.
I. Clarke, Graham, 1948–
779.2
ISBN 0–948462–29–9
ISBN 0–948462–30–2 pbk

Contents

Photographic Acknowledgements

The editor and publishers wish to express their thanks to the following for permission to reproduce illustrations: Aperture Foundation, Inc., and the Paul Strand Archive (© 1952) p. 14; Bibliothèque Nationale, Paris pp. 12, 14, 16, 17; Birmingham Local Studies Library pp. 199, 202; John Carswell p. 167; Dulwich Picture Gallery p. 36; Fox Talbot Museum, Lacock, Chippenham, Wilts. p. 35; Fraenkel Gallery, San Francisco, and The Estate of Garry Winogrand p. 37; Richard Hoppé p. 134; Matthew Isenburg pp. 179, 182, 183 (top and bottom); Man Ray Trust, Paris pp. 101, 104, 105, 108; Mansell Collection, London pp. 19, 135, 141, 149, 151, 154; Ministère de la Justice, Service de l'Identification Judicaire, Brussels p. 161; Kodak Collection, National Museum of Photography, Film & Television p. 200; Royal Photographic Society, Bath pp. 57, 58, 61, 65, 67, 68, 69, 117; Service photographique de la Réunion des musées nationaux, Paris pp. 34, 42.

Notes on the Editor and Contributors

GRAHAM CLARKE is a Senior Lecturer in English and American Literature at the University of Kent, where he also teaches American Studies and a course on the photograph. His publications include *The American City – Literary and Cultural Perspectives* (ed., 1988), *The New American Writing* (ed., 1990), and *Walt Whitman: The Poem as Private History* (1991), as well as critical editions of T. S. Eliot, Edgar Allan Poe, and Henry James. His writing on photography includes essays on the daguerreotype, Don McCullin, Alfred Stieglitz, and post-war American photographers. He is currently completing a book on Alfred Stieglitz and New York City.

ROGER CARDINAL has written widely on French Surrealism and German Expressionism, and is the author of an essay on the modern poetic imagination, 'Figures of Reality' (1981), and of *The Landscape Vision of Paul Nash* (Reaktion Books, 1989). An international authority on Art Brut, on which he wrote the first book, *Outsider Art* (1972), he is currently preparing for Reaktion Books a wide-ranging survey of marginal creativity, *The Primitive*. He is Professor of Literary and Visual Studies at the University of Kent.

STEPHEN BANN is Professor of Modern Cultural Studies and Chairman of the Board of Studies in History and Theory of Art at the University of Kent. His books include *Concrete Poetry – An International Anthology* (ed., 1967), *Experimental Painting* (1970), *The Tradition of Constructivism* (ed., 1974), *The Clothing of Clio* (1984), *The True Vine* (1989), and *The Inventions of History* (1990). He recently co-edited, with William Allen, *Interpreting Contemporary Art* (Reaktion Books, 1991).

PAM ROBERTS is currently Curator of the Royal Photographic Society, Bath. She has published essays on a wide range of photographic subjects, including 'Our Photographic Legacy' (1989), 'Madame Yevonde: Colour, Fantasy and Myth' (1990), and the introduction to *Whisper of the Muse: The World of Julia Margaret Cameron* (exhibition catalogue, 1990). She has curated numerous photographic exhibitions, including the work of Cecil Beaton, Frederick Evans, Roger Fenton, Julia Margaret Cameron, Madame Yevonde, and (most recently) the retrospective exhibition of Don McCullin.

DAWN ADES is Professor of Art History at the University of Essex. She has published widely on art history and criticism, including *Dada and Surrealism Renewed* (1978), *Photomontage* (1976), *Dali* (1982), *Francis Bacon* (1985), and the Hayward Gallery exhibition catalogue *Art in Latin America: the Modern Era, 1820–1980* (1989).

ERIC HOMBERGER is Reader in American Literature at the University of East Anglia, Norwich, and is the author of *The Art of the Real: Poetry in England and America since 1939* (1977), *American Writers and Radical Politics, 1900–1939: Equivocal Commitments* (1986), *John LeCarré* (1986), *John Reed* (biography, 1990); he has also edited *Ezra Pound: The Critical Heritage* (1972), *The Troubled Face of Biography* (1988) and *John Reed and the Russian Revolution* (1992).

MICK GIDLEY, Director of AmCAS at the University of Exeter, has been awarded fellowships by the ACLS, the British Academy and the Netherlands Institute for Advanced Study. His publications include essays in American cultural history, three illustrated books on Native Americans, *A Catalogue of American Paintings in British Public Collections* (1974), a BAAS pamphlet, *American Photography* (1983), and, as co-editor, *Views of American Landscapes* (1989).

DAVID ELLIS is Senior Lecturer in English and American Literature at the University of Kent. His publications include *Wordsworth, Freud, and the Spots of Time: Interpretation in the Prelude* (1985), and (with Howard Mills) *D. H. Lawrence's Non-fiction* (1988). He has written widely on the nature of biography and is currently completing the third volume of the new Cambridge biography of D. H. Lawrence.

ALAN TRACHTENBERG is the Neil Gray Jr. Professor of English and American Studies at Yale University. He was a Fulbright lecturer in Leningrad and a fellow of the Center for Advanced Study in the Behavioural Sciences in Stanford, California, and of the Woodrow Wilson Center in Washington D.C. Alan Trachtenberg is the author of *Brooklyn Bridge: Fact and Symbol* (1965), *The Incorporation of America: Society and Culture in the Gilded Age* (1982), and *Reading American Photographs: Images as History, Mathew Brady to Walker Evans* (1989).

PHILIP STOKES is Senior Lecturer in the Department of Visual Arts, Nottingham Polytechnic. His publications include 'Trails of Topographic Notions' in *Views of American Landscapes* (1989), 'Photography as Cultural Nexus: Edward Cahen, his photographs, family and friends', in *Photoresearcher* (vol. 1, no. 1, 1990), the catalogue for the exhibition held at Editions Graphiques Gallery, Clifford Street, London (1990) entitled *Exhibition of Photographs by Ruralists and Friends*, and a selection of essays in *Contemporary Masterworks*, ed. Colin Naylor (1992).

Introduction

GRAHAM CLARKE

The portrait photograph exists within a series of seemingly endless paradoxes. Indeed, as the formal representation of a face or body it is, by its very nature, enigmatic. And part of this enigma is embedded in the nature of identity as itself ambiguous, for the portrait advertises an individual who endlessly eludes the single, static and fixed frame of a public portrait. In this sense, the very terms of the portrait photograph's status are problematic. The earliest portrait photographs, most notably the daguerreotype, insisted on their realism; they were literally mirror-images of those photographed. In making an image of an individual, these early photographs took their place within the wider tradition of the portrait painting. Yet, ironically, the portrait photograph achieved its dissemination at the very moment when painting, like literature, began to question the basis of mimetic representation. The great twentieth-century portraitists: Picasso, Bacon, Giacometti, and Sutherland, for example, have all attempted to image the individual in direct contrast to the 'real' world, as seemingly represented by the photograph.

As an analogue of the original subject, the portrait photograph surreptitiously declares itself as the *trace* of the person (or personality) before the eye. In an official context, the photograph validates identity: be it on a passport, driving licence, or form. It has the status of a signature and declares itself as an authentic presence of the individual. Once again, however, the authenticity is problematic. The photograph displaces, rather than represents, the individual. It codifies the person in relation to other frames of reference and other hierarchies of significance. Thus, more than any other kind of photographic image, the portrait achieves meaning through the context in which it is seen.

Look, for example, at the brilliant 1850s image, *Unidentified Girl with Gilbert Stuart's Portrait of George Washington* by the Boston-based portraitists, Southworth and Hawes. The more one looks at this image, the more ambivalent it becomes. It recalls, of course, the extent to which

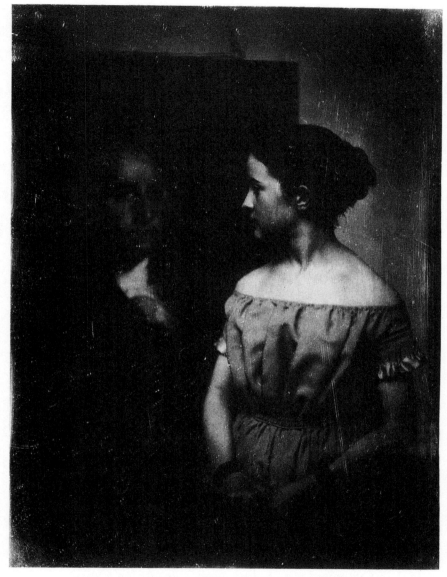

Southworth and Hawes, *Unidentified Girl with Gilbert Stuart's Portrait of George Washington*, daguerreotype, 1850s.

photographic portraiture was, from its inception, encoded within paint-erly traditions and, in turn, within painterly styles of representation. Here the figure of Washington, as a significant historical figure, echoes a Reynoldsian grand style in contrast to the incipient realism of the girl's figure, which is closer to the prosaic literalism of the Dutch school. Indeed the difference between the two figures is based on paradox. Of whom is this a portrait? The girl is 'unidentified' and, thus, has no individuality, no presence, no *status*. Her position as the subject seems displaced by the way she looks not at us, but at the portrait of Washington. Washington's image has extraordinary presence, even fascination. And yet its veracity as an image of an historical character is undermined by its contrast with the photograph as an analogue, not an impression, of the 'real'. The trace of Washington in a painting, however, promises access to an individual myth; it evokes an aura of celebrity as against the actual (sic) figure of the girl. The girl has significance only in relation to Washington. But the terms of representation are equally ambivalent. The painting is life-size, while the photograph encapsulates and reduces that size even as it insists on its veracity as a reflection of the real. We rarely view a life-size portrait photograph, nor do we usually view a figure in its entirety. Invariably we see a part of the body (head, head and shoulders, half-length, and so on). Just as the photograph flattens physical bulk, so it also frames and crops–once again suggesting presence through absence. It consistently offers the promise of the individual through a system of representation which at once hides and distorts the subject before the lens. Thus the portrait's meaning exists within wider codes of meaning: of space, of posture, of dress, of marks, of social distinction. In short, the portrait's meaning exists within a world of significance which has, in turn, already framed and fixed the individual. The photograph thus reflects the terms by which the culture itself confers status and meaning on the subject, while the subject as image hovers problematically between exterior and interior identities.

This partially explains the compulsive ambivalence of a portrait photograph. As Susan Sontag has suggested, 'facing the camera signifies solemnity, frankness, the disclosure of the subject's *essence*.' Nadar stressed a sense of the individual when he spoke about attempting to achieve a 'moral grasp of the subject – that instant understanding which puts you in touch with the model, helps you to sum him up, guides you to his habits, his ideas and his character, and enables you to produce . . . an *intimate portrait*' (my italics). 'Essence', 'intimate' – both terms which, like 'trace' and 'original', suggest the portrait photograph as an analogue

of the individual: a composite image of a personality in space and time. Once again, however, this promise is deceptive.

At virtually every level, and within every context, the portrait photograph is fraught with ambiguity. For all its literal realism it denotes, above all, the problematics of identity, and exists within a series of cultural codes which simultaneously hide as they reveal what I have termed its enigmatic and paradoxical meaning. All the essays that follow share this sense of enigma and paradox, which is at the centre of the portrait photograph. They do not, as it were, offer a 'history' of the portrait photograph, nor do they seek a comprehensive survey of its development and range. Some concentrate upon single portrait photographers, some upon kinds of portraiture, and some on the differences in portrait practice between different periods and national traditions. Taken together, however, they share a commitment to probe the portrait's enigmatic status as a means of individual identity. Their range of subject matter and difference in critical approach in turn underscores the degree to which the portrait photograph remains problematic, evasive and, ultimately, unknowable. One recalls Roland Barthes' *Camera Lucida* in which, of course, the most significant photographic image he discusses, probes and evokes, is a portrait of his (dead) mother in her youth. The presence and significance of this portrait reverberates through the entire text, and yet it is absent as an image. We never 'see' Barthes' mother. Barthes thus mines the paradox and enigma of the portrait photograph, suggesting once again its endless displacement from simple assumptions and certainties as to what a portrait photograph is, or who (or what) it signifies.

The essays which follow invite the reader to view the portrait photograph in as wide a context as possible – the subject is, after all, ubiquitous. Everyone not only looks endlessly at portrait photographs, but has had their portrait 'taken'. We see our image in frames, albums, on walls, desks, on documents, in boxes and (perhaps) in newspapers. Our own photographic images give an immediate, and personal, context to academic enquiry. If these essays begin to articulate the space between subject and image, between ourselves and our images, then they will have succeeded in ways beyond their immediate concerns as critical essays. I am reminded of Walker Evans's *Studio 54*: a composite portrait of hundreds of portrait images akin to the photographs produced by portrait machines and booths found in Woolworths. The faces in this photograph stare out from their anonymity; but they equally insist on their presence as individuals. Ultimately, they hover between the two

extremes and denote lost selves and hidden lives. Each, in its way, is an enigma. Whenever the camera in the Woolworth's booth flashes it duplicates that enigma, and it makes us part of the paradox. The most common event is, thus, made at once endlessly unique and, in the end, unknowable. That is perhaps why, when the strip of four images drops into its delivery tray outside the booth, people collect their portraits and say: 'That is not me'. But then, if it is not 'me', who else could it be?

I

Nadar and the Photographic Portrait in Nineteenth-Century France

ROGER CARDINAL

A thorough analysis of the emergence of the photographic portrait in France in the early nineteenth century would need to address a complex web of factors. The practice of reproducing an individual's likeness within a studio setting takes on meaning within the wider currency of contemporary images, in which the traditions of oil-portraiture and the inventions of journalistic caricature are clearly of weight. In the post-Napoleonic years, all visual media were affected by the acceleration in the reproductive capacities of the letterpress, lithography and photography. These spawned a plethora of publications – illustrated newspapers and journals, serialised novels, photogravure albums, postcards, *cartes-de-visite*, and so forth.

The photographic portrait was encouraged by the place within the contemporary ideology of the charismatic individual or celebrity. This last had evolved out of a certain post-revolutionary conception of the singular being, nexus of thrilling propensities and dynamic impulses, which, fertilised by the ideas of Rousseau, heroically incarnated in Bonaparte and aesthetically nurtured by the *petits romantiques* of the 1830s, was finally institutionalised within a journalism addicted to 'cultural gossip' and the ties between art and biography. All these factors affected contemporary assumptions about social identity, to the extent that character qualities were deemed to be encoded within the representations of people's physical appearance.

A short essay cannot do justice to all these topics, and in an effort to draw a few telling threads from a dense and tangled narrative, I shall concentrate here on one emblematic (though hardly typical) figure, Félix Nadar,[1] commonly acknowledged to be the foremost French portrait photographer of the century. Given that his reputation rests upon his exhaustive documentation of the faces of his contemporaries in the cultural, especially literary, sphere, I hope to give some notion of Nadar's achievement by focusing upon the portraits he made of certain major

writers. But first I want to weigh up the significance of the creative experience Nadar acquired *before* he took up photography.

A large percentage of early photographers turned to the camera only after unsuccessful exertions in traditional media. Several of Nadar's photographer contemporaries – painters like Louis-Auguste Bisson, Gustave Le Gray or Charles Nègre, caricaturists like Etienne Carjat, sculptors like Adam Salomon – were transitional figures, moving between distinct visual disciplines and adapting techniques as they did so. I suggest that the most important qualification which Nadar brought to his work as a portrait photographer was his experience as a jobbing draughtsman for the Paris satirical press.

In the years preceding the consecration of the photographic portrait proper, the painted or engraved portrait had given way to the caricatural sketch as the most popular medium for representing celebrities. Improvised in pencil, ink or wash, and reproduced via lithography or newsprint, the journalistic caricature had rapidly gained popularity in post-Imperial France, sustaining the careers of such famous practitioners as Daumier, Monnier and Grandville. The criteria and ambitions of the genre were somewhat ambivalent. On the one hand, the exaggeration of facial features served (as they still serve) the purposes of the satirist, and especially the political satirist. Yet alongside the principle of distortion for comic effect ran a more sober concern to elicit the essence of a person's character: the contemporary conception of the *portrait-charge* (roughly speaking, a portrait-sketch possessing an extra dose of verve and emphasis) supposes an intriguing coincidence of exaggeration and veracity. In a culture which set such store by the individual's 'image', a budding celebrity might positively thrive on the attentions of a sharp-penned caricaturist, just as later on in the century he might find an imposing photo-portrait to be *de rigueur*. Given this sort of cultural expectation, I want to suggest that the quotient of seriousness which adhered to the practice of the *portrait-charge* formed the supportive context wherein, as technology advanced, the photographic portrait would discover its rationale and its characteristic idiom.

So closely linked were the different arts in the early decades of the nineteenth century that I feel no qualms in setting out the criteria for the effective *portrait-charge* by way of the parallel instance of literary characterisation. I propose a brief digression to consider the case of a fiction-writer whom Nadar greatly admired, and who offers a most persuasive model for the nineteenth-century portraitist: Honoré de Balzac.

In the course of the two decades leading up to mid-century, Balzac's *Comédie humaine* had established a veritable gallery of individuals and social types, and his precepts, announced in more than one magisterial preface, were common knowledge. Balzac grandiloquently announced himself as being a scientist in literary guise, the 'secretary to society', a scrupulous observer and taxonomist of contemporary life and manners. In his fictions, the entry of each new character is unfailingly marked by a pen-portrait. The fact that the artists employed to illustrate the novels often complained that the writer had pre-empted their work is an index of Balzac's contemporary reputation as a meticulous cataloguer of appearances.

It must, however, be emphasised that Balzac used no real-life individuals in his fictions, though there are a few instances of characters partially derived from real people. He himself aspired to 'inventer le vrai' – to conjure up an illusion of truth – and it has been plausibly argued that his much-vaunted 'realism' was in truth a rhetorical effect, in the sense that textual references to a person's face, the colour of their hair or clothing, their posture or gestures, the lighting on their features, and indeed the patterns of the wallpaper in the house in which they live, constitute nothing more nor less than components of a literary code.[2] Furthermore, whereas a policeman, say, may write down a careful description in order to identify a specific criminal, Balzac's fictional portraits often tend to convey not so much a sense of idiosyncrasy as one of typicality. Thus, in visualising Old Grandet, the reader is likely to see not so much a person as a generalisation: 'the Miser'. So perhaps Balzac's portraits are less a matter of realistic documentation, and more a species of caricature with allegorical overtones.

Thus it is that a tension arises between Balzac's avowed methodology and his actual practice: claiming to act like a scientist, he instead developed procedures of verbal evocation which are more accurately seen as those of a caricaturist. Indeed, for every obeisance he makes to the dignified example of the palaeontologist Cuvier, or that of the zoologist Buffon, there seems to be another to the considerably less reputable authority of Johann Kaspar Lavater, author of the *Physiognomische Fragmente*, a name invariably paired with that of Franz Joseph Gall, the founder of phrenology (the 'science' of interpreting cranial bumps), who died in Paris in 1828. What Balzac derived from such sources was a suspect yet beguiling doctrine concerning human morphology, whereby facial features were taken to signal latent traits of character. This doctrine seemingly legitimised exaggeration in the form of outlandish

simile. Balzac commonly likens his characters to animals, as when the landlady Madame Vauquer has her nose compared to a parrot's beak, or the adventurer De Marsay is credited with the predatory gaze of a tiger.[3]

If such allusions seem calculated to amuse, there remains the probability that they were also seriously expected to inform. That we might nowadays deprecate the illusions of literary realism does not diminish the potency of the contemporary myth of Balzac as the creator of authenticity. I surmise that his model of the life-like portrait genuinely reflects the expectations of the age in regard to the *portrait-charge*, considered as a product of either writing *or* drawing. And if this is so, and taking into account Nadar's reverence for the novelist, we might quite properly invoke the Balzacian precedent in guessing at the way Félix Nadar conceived his *métier* when he first took up caricatural drawing in about 1846.

An entirely untutored draughtsman, Nadar seems to have drifted into this pursuit as a natural extension of his early journalistic efforts as translator, sketch-writer and reviewer, as well as editor of the arts weekly *Le Livre d'or*, to which friends like Gautier and Nerval and older writers like Balzac and Vigny had contributed. By the late 1840s, Nadar's drawings were appearing in semi-humorous magazines like *Charivari* and *La Silhouette*, and he developed a talent for the literary profile, in which a pictorial *portrait-charge* accompanies an often droll biographical notice. In 1848 he was to pioneer, in *La Revue comique à l'usage des gens sérieux*, the first sustained political cartoon-strip, 'Môssieu Réac' — the adventures of a vulgar opportunist in the mould of Daumier's Robert Macaire or Monnier's Joseph Prudhomme. By mid-century, Nadar was supervising a small team of collaborating draughtsmen; and having been commissioned to produce a series of textual/visual profiles for *Le Journal pour rire* in 1852, he hit on the idea of squeezing all the cultural celebrities of the age into one single lithograph. After much hard work and a strenuous subscription campaign, the *Panthéon Nadar* was issued in March 1854, as what one associate, Philippe Bisson, termed 'a delicious museum of grotesques'. It comprised 249 caricatures of celebrities from the realms of poetry, fiction, history, publicity and journalism, each numbered and standing in a long queue. (Nadar's original plan had been to produce four sheets, bringing in painters, sculptors, composers, actors, and performers, and achieving one thousand portraits in all; the first sheet proved so exhausting that the project went no further, although it is true that, in a revised edition of the *Panthéon* in 1858, he was able to extend the roll-call to 270.)

Our interest in this document springs from the fact that, in order to work up sufficient likenesses to fill up all 249 spaces, Nadar had not only plundered the stock of sketches he and his collaborators had amassed over the preceding decade, but had had recourse to photographic portraits expressly made for this purpose.[4]

Nadar himself indicates that he turned to photography more or less casually, simply taking over some equipment that a friend no longer wanted. That he did not see this as a momentous break with his past may be judged from the fact that it took some nine months after the issue of the *Panthéon* lithograph before he opened his first professional studio on the top floor of No. 113, rue Saint Lazare; and that, even then, his drawings continued to appear for at least another decade. The inference that Nadar saw photography not as a decisive rejection of drawing, but as its natural extension, is supported by a chapter in his memoirs in which a detailed survey of early exponents of the camera is followed without hiatus by an account of Nadar's own career – in which he devotes far more space to his practice as a *caricaturist* than to his career as a photographer.[5]

At one point Nadar gives to understand that he resorted to the camera only because he was finding it hard to catch the likeness of difficult subjects like Baudelaire, or because his sitters were prone to fatigue. In my view, such explanations are unconvincing. It should be said that Nadar the autobiographer is writing about the events of a half-century before, and I do not want to speculate as to why an old man might have skated over what we might want to see as a dramatic transition. My point is simply that it is likely that, if Nadar had any aptitude at all for reflection, he must, at some stage in his career as a portraitist, have been struck by certain radical differences between the two media in question.

The sheer scale of the *Panthéon Nadar* suggests an ambition to eclipse all rivals in the field of the *portrait-charge*; setting this alongside Balzac's avowed ambition to tabulate an entire society, we might well suppose that these hyperbolic schemes reflect a typical mid-century fixation on the encyclopaedic and the monumental. What is striking in Nadar's reminiscences is the typically Balzacian way in which he links the material and the spiritual in defining his ambition as a caricaturist:

. . . to transfigure into *comicalities* those hundreds of different faces, all the while preserving in each the unmistakeable physical likeness of its features, the individual imprint, – and the character, that is, the spiritual and intellectual likeness.

Nadar goes on to cite the specific example of celebrity No. 22, the novelist Alexandre Dumas the elder, declaring that here he had sought to emphasise:

all those hints of an exotic racial origin, and to bring out the simian echoes of a profile which immediately seems to ratify Darwin's theory, accentuating above all the predominant note in the person's *character*, that is, his extreme and infinite kindliness: – to squash that nose, all too fine in the original model, to enlarge those delicately incised nostrils, to tilt further the generous smile on those eyelids, to exaggerate . . . that fleshy lip . . . , – while not forgetting to give extra body and fluffiness to what Jules Janin dubbed his 'topknot'.[6]

Now, it was common knowledge that Dumas's grandmother had been a negress from San Domingo; his fleshy lips, flat nose and non-European shock of hair were inevitable targets for the caricaturist, whether this was the journalist Janin or the writer/draughtsman Nadar. The above pen-portrait corresponds point for point with the bulging face and ridiculous shock of hair of the *Panthéon* caricature: again reminiscent of Balzac in its analogical verve, the text evinces Nadar's unmistakeable taste for distortion, and his eye for salient (some might say salacious) detail.

It is instructive to compare such caricatural portrayals with Nadar's photograph of the same sitter, produced in 1855 (page 12). Here we see a robust, rather portly man who straddles (none too comfortably, we may surmise) a wooden stool with a low back.[7] We note the jovial plumpness of Dumas's cheeks and lips, his double chin, the bushiness of his hair. But already we are moving from caricature to character. This is, we realise, a sitter not afraid to beam at the photographer, whom we may suppose to be standing to one side of the camera. The sheen on Dumas's frock-coat and cravat, his head's jaunty tilt, the carefree clasping of his hands on the stool-back – these details signal the confidence and joviality of a successful man of the world, as much at ease in the studio as in the café or on the boulevard. Dumas is perfectly aware that his likeness – physical and intellectual – is being taken: he is not one wit put out by the fact, and has no fear of photographer or machine. He is weightily, uninhibitedly, *himself*. We imagine such a man will settle his bill promptly and without quibble. Sitter and cameraman are equals; each respects the other's work and knows him to be a successful technician. (It may be worth adding that, just as Nadar had several assistants, so Dumas ran a production-line of writers to expedite his output of historical novels.)

It is a minor irony that Balzac should have died in 1850, before Nadar had embraced his new career. That the master photographer would have loved to turn his lens upon the great novelist seems obvious from the fact

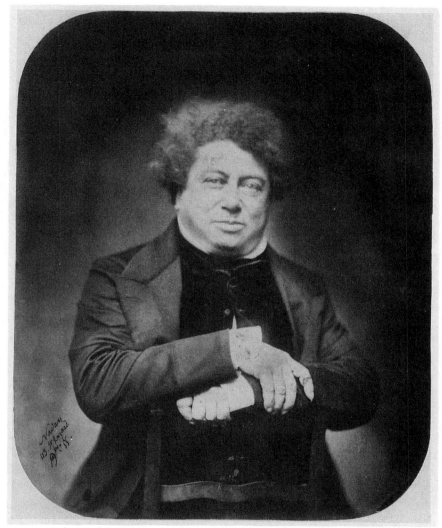

Félix Nadar, *Portrait of Alexandre Dumas the elder*, November 1855.

that he eagerly acquired the one known daguerreotype of Balzac, taken in
about 1845 by an unknown hand. It shows Balzac in visionary pose,
hand to breast as though vowing to undertake some superhuman task.
Nadar made his own photographic record of the daguerreotype as it
hung in its frame on the studio wall,[8] and used it as the model for the
Balzac sketch he made in preparing his *Panthéon*. Done in washes which
bring out contrasted zones of dark and light, this sketch clearly seeks to

enhance the daguerreotype's connotations of creative genius, rather than suggest anything at all comical. It is a perfect example of that sort of *portrait-charge* which accentuates an aspect of an individual's spiritual being and in no way involves grotesque distortion.

Though portrayed in several paintings and countless press caricatures, Balzac is known to have had an aversion to facing the camera. Indeed, in his memoirs, Nadar tells us that the novelist believed all natural bodies to be built up of spectral layers which would peel off at any exposure to the lens. Nadar pauses to ask whether Balzac might not have been pulling everyone's leg, but then himself extrapolates in terms just as quirky, evoking the supposed contemporary belief that there was indeed something fantastical, even diabolical, about the new invention: 'Night, cherished by the thaumaturges, reigned supreme in the sombre depths of the *camera obscura*, that place appointed for the Prince of Darkness' is one rhapsodic claim.[9]

Now, for all that Nadar's tongue is in his cheek, I feel it is worth reflecting that the early years of photography coincide with the heyday of French Romantic writing in the mode of the Fantastic.[10] Nadar would have been familiar with the ghost-stories of Charles Nodier and the pre-Realist 'shockers' of the younger Balzac, as well as the Romantic tales of his friends Théophile Gautier and Gérard de Nerval, in which solemn belief often subsists amid mocking incredulity. Such a confluence of contrary elements might further support my hypothesis of a link between the photographic portrait and the practice of caricature: at the very least it can be said that Nadar was working within a cultural climate that tolerated the simultaneous display of apparently conflicting impulses.

It was Nerval who provided Nadar with the opportunity to produce two of the earliest and most poignant images of his career, at a session held just two months or so before the former's suicide.[11] In two masterly images, the only known photographs of the poet, Nadar caught something profound and, I believe, veridical about the man. Those familiar with Nerval's work will know how obsessively it circles about themes of loss and yearning. Those who know of his life will be aware that he spent his last fifteen years fighting against mental illness: Nerval was twice in psychiatric care during 1853, and spent three months in 1854 at Dr Blanche's clinic in Passy. The poet's last texts are marked by mental disorientation, as witness his brooding sonnet 'El Desdichado', with its dark motto 'Je suis le Ténébreux' ('I am the Shadowy One') and its allusions to Hades, not to mention the harrowing confessional narrative *Aurélia*.

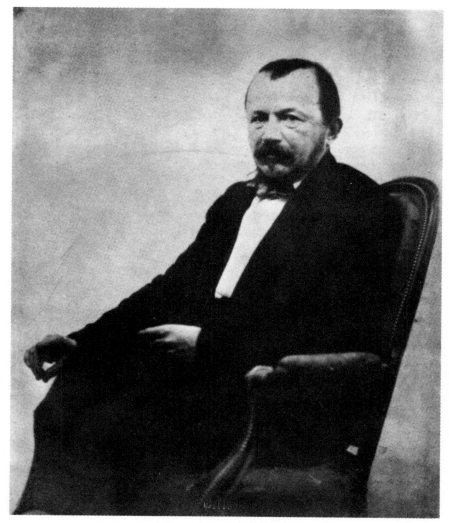

Félix Nadar, *Portrait of Gérard de Nerval, c.* 1854.

In the portrait illustrated here we look upon a man in his late forties who crosses his legs in a comfortable chair and looks patiently toward the lens. On the face of it, the posture is confident; yet there is something of an appeal about the eyes, an oddness in the way the third finger touches the thumb on his right hand (as if the poet were making a desperate secret sign), and a slight restiveness in the way Nerval holds himself, as though he were on the point of leave-taking. This is not, we may infer, a man

entirely at ease, and, meeting his gaze, we may recognise an expression of suffering and alienation. If we agree with Albert Béguin that the document communicates 'all the distress, all the grandeur, all the profound humanity of Nerval',[12] then it is hardly, I suggest, because we see someone adopting a calculated pose. Granted, Nerval was as capable as any Romantic of managing his image, as is clear from the way he constructs an artistic persona in his writings. But I am convinced that he is not putting on a wilful performance in this photograph: we are looking straightforwardly at a vulnerable human being.[13]

If we are prepared to assume that Nerval was at the time of the sitting unwilling or unable to project a controlled persona, we may be in a position to evaluate the cameraman's own investment in the image. It must be stressed that it was taken during Nadar's phase of transition between the *portrait-charge* and the photographic portrait. If we turn up the preparatory sketch Nadar had made of Nerval a few months before, or its replica on the *Panthéon* sheet itself, we see only a figure with dark moustaches on a chubby face, with a spherical body and squat legs, a bit like some chirpy robin. Nerval himself once referred to the sharp end of Nadar's pencil, and this piece of zoomorphic distortion is little more than droll. If it raises a smile, this seems meaningless beside what really matters – that which, conversely, is articulated within the photograph. If we try to imagine the circumstances of the photographic session, we may sense that Nadar was stumbling into an entirely new challenge. (Does Nerval breathe nervously, does he shift in the chair, does he mutter something in a strange tone?) Confronted by that haunted face, itself confronting the camera for the first and last time, Nadar loses all taste for comicalities: caricature is assuredly no longer an appropriate artistic strategy. It is not hard to conjecture that the portraitist himself was transfixed by the immediacy of a vibrant presence. If the portrait bears the mark of a sensibility at the end of its tether, it may also be tinged with something of the portraitist's co-vulnerability.

So, although the later Nadar was to play down any drama in his shift from caricature to portrait photography, he was in truth bound to wrestle with this very different medium. In his new capacity, Nadar emerges as a more serious and honest documenter of the cultural pantheon, one who can no longer pose as the Balzacian magus who controls all meaning and 'invents that which is true'. The features registered by the camera are no longer so submissive, so amenable to artistic schematisation. No longer can Nadar draw on the cultural code of the caricaturist – the topknots and the lank moustaches – but must

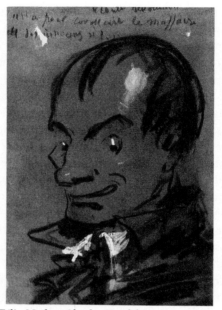

Félix Nadar, *Charles Baudelaire*. Preparatory
drawing for Nadar's *Panthéon*, c. 1850.

work with an actual face. Nerval's real-life moustache has an air of the
defensive about it; his thinning hair, brushed to a feeble quiff, tells us he is
ageing fast; a swollen vein at his temple indicates an emotional tautness,
as if his composure were about to disintegrate. A spiritual richness begins
to lay claim to the portraitist's attention, forcing him to stretch far
beyond the range of the caricaturist's pencil.

If indeed the portraits made by Nadar in his first decade of professional
camerawork count among his finest, then perhaps this is because their
authority derives from the photographer's exposure to qualities of the
veridical and the poignant whose previous impact had been filtered or
deflected by the tacit rules of caricature. With the notable exception of
the Balzac, Nadar's *Panthéon* sketches still rely on principles of dis-
tortion and extravagant comparison. Thus Gustave Courbet is drawn in
Egyptian profile, his black beard elongated like a stork's beak; Théophile
Gautier is shown as an Oriental pasha overrun by cats; Hector Berlioz
keeps a noble profile, but, his baton raised above massed trombones, he is
wittily compared to a general leading a charge; and Nadar's old pal, the
journalist Alphonse Karr, turns into a sharp-eared faun playing a set of
Pan's pipes. As for Charles Baudelaire, while Nadar's sketch is not

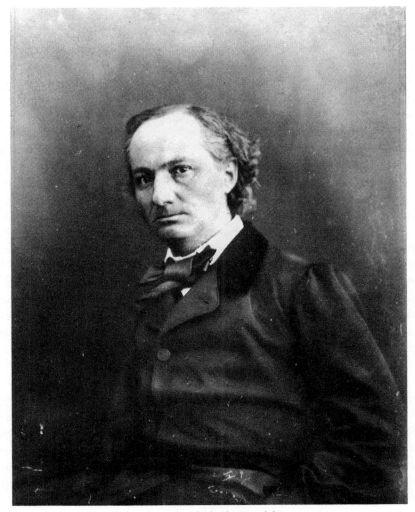

Félix Nadar, *Portrait of Charles Baudelaire, c.* 1860.

wholeheartedly zoomorphic, it does have qualities of the feral and the foxy about it, the eyes shrewd and cocky, the mouth curled in a snarl, the nose and cheekbone perversely pointed. One senses here that Nadar is keen to publicise his irreverence for a celebrity, unabashedly mocking a friend he had known since the mid-1840s, and whom he elsewhere dismisses as a 'young and nervous poet, bilious, irritable and irritating, often perfectly disagreeable in private life'.[14]

In turning finally to the photographic portraits which Nadar made of
Baudelaire, I want again to suggest that the immediacy of the studio
session provoked an entirely fresh order of responses. Baudelaire sat for
his friend on at least five occasions in the years 1855-62, which period
saw the publication (in 1857) of *Les Fleurs du mal*. Now valued for
complex aesthetic reasons, the collection gained its initial notoriety from
the court-case which condemned several poems as pornographic and led
to the book's mutilation. It is clear that Baudelaire himself took pains to
cultivate a persona in the way he dressed and behaved, as well as in many
acerbic writings. An admirer of Edgar Allan Poe (whom he translated),
Baudelaire fostered a post-Romantic myth of the artist as outsider, not
only a master craftsman but also a *maudit*, or something between a
criminal and a diabolical superman.

The confrontation between Baudelaire and Nadar in the photographic
studio seems to me to bear traces of a special tension. Where Dumas was
jovially amenable, and Nerval tragically meek, Baudelaire asserts a
presence which is self-aware, forceful, and perhaps dangerous. That these
portraits are so engrossing seems to me to point to a heightened
atmosphere almost reminiscent of a duel. From this set I have chosen a
masterly image produced around 1860. But before I turn to it, I wish first
to consider a portrait of Baudelaire made by Etienne Carjat only a year or
so later, since it offers such a telling contrast.[15]

Carjat's *carte-de-visite* presents a Baudelaire at obvious pains to
transmit the image of the misunderstood genius. He confronts the camera
with an air of wilful defiance, and a pained expression which seems to say:
'I am one who has much to reveal of the human heart and its sufferings.'
The entire figure is clearly and evenly lit, and faces the camera almost
head-on. There is tenseness in the eyes and an evocative sullenness about
the poet's compressed lips – and yet, I suggest, also a sense that he is not
quite equal to the occasion. Perhaps it is Baudelaire's cropped hair that
imparts an air of hesitancy, at odds with the intended effect of haunted
intensity. It is certainly not a bad portrait, yet one senses that Carjat was
not entirely equal to the poet's challenge, failing to construe his exorbitant
persona and to meet it in the electrifying way that Nadar does.

By contrast, Nadar's portrait seems to tell us that the photographer *has*
resolved to confront the challenge, identifying the image which Baude-
laire intensely seeks to communicate and then going on to measure this
intensity against his own responses. Nadar shows us only the top half of
his sitter's body; although it is hard to be sure, Baudelaire appears to be
seated, even very slightly slumped, in a posture redolent of world-

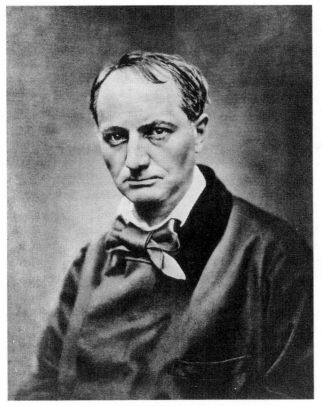

Etienne Carjat, *Portrait of Charles Baudelaire, c.* 1862.

weariness. Neither hand is visible. Indeed, so dark are the shadows about the figure that in some reproductions they merge with the background, making the poet's illuminated head and collar seem disembodied. (In some versions, pinpoints of white and other accidental discolourations encourage a Redon-like fantasy of a head floating in galactic space.) Baudelaire has turned slightly to his left to direct his stare at the camera. This implicit angling may be said to connote casualness, a resistance to the imperialism of the lens, if not actual aggression: a fighter eyes an opponent in a similar way so as to gauge the direction of an attack. The florid cravat and the longish hair, greying at the temple, signal the artist-dandy, the stylist of both art and living. The mouth closes in a characteristic half-pout, slightly more tight-lipped than in the Carjat, and with the chin ready to lift in challenge. We sense a propensity for irritation: this man suffers no fools gladly.

Having once met and measured the sitter's gaze, we begin to read some sort of expression therein; I cannot yet define this, though I am sure its tonality is not one of hesitancy. The right eye is marginally shaded, for Nadar had, exceptionally and with an artist's taste for the dramatic, shone a sidelight onto the left side of the face – presumably using one of his experimental bunsen lamps.[16] Within the left eye, set above an area of noticeably puffy cheek, the sharpness of the white of the eye emphasises the impenetrability of pupil and iris, which coalesce as a single bead of black. (In the original print, a tiny defect in the paper surface scores an uncanny horizontal white line across this blackness.) Baudelaire's eye, half icy, half smouldering, fastens on the lens, as if to meet any look unflinchingly. As viewers, we grapple with signals, and come up with speculations. Is Baudelaire clenching a hidden fist? Is he feigning aggression to conceal fear?[17] Does Nadar's ruddy health make him uneasy? Could it be said that, despite having another six years or so before syphilis catches up with him, Baudelaire already has 'his back to the wall'? What exactly is this man thinking – what do we dare to imagine he is thinking? I remain incapable of uncovering what is going on behind that luminous brow, yet it is this very uncertainty which enhances my sense of what I shall call the *authenticating vulnerability* which underlies and offsets the surface challenge of the face. This portrait of a cultural celebrity at the peak of his fame turns out, once again, to be also the record of a man 'all too human'. Perhaps, after all, there is something in Balzac's suggestion that the camera can unpeel a layer of one's being.

By the mid-1860s, Nadar's own career was at its zenith. The Baudelaire portrait we have examined was taken at the grandiose penthouse premises at 35 boulevard des Capucines to which the photographer had moved in 1860. He began to expand his production of *cartes-de-visite*, making portraits for anyone prepared to pay his fees, and enlarging his clientele far beyond his initial range of the cultural and artistic élite. Henceforth, Nadar's dedication to the photographic portrait is coloured by commercial imperatives which, I suggest, encouraged the stereotyping of a number of his images. (Interestingly, the memoirs reveal Nadar's irritation with his bourgeois sitters; he complains that many non-celebrities were infatuated with their self-image.) It should be remembered that Nadar was also occupied with other things, and the degree of his devotion to the studio must be gauged against his experiments in aerial photography, including military photography, and in heavier-than-air ballooning (which led to his adventurous flights in 'Le Géant'

during 1863-67, and the airmail service he provided during the Siege of Paris). In his laboratory, Nadar remained faithful to the process of taking positive prints from glass collodion negatives; however his son and apprentice, Paul, gradually became involved in processing what his father had shot, and introduced gelatin and silver-bromide prints into the family business. It is recognised that, while one ought to avoid too strict a division, the most authentic work of Félix Nadar himself extends up to the watershed of around 1880-85, with Paul Nadar assuming full responsibility thereafter, once his father had retired from the Paris business. In fact, Nadar senior ran a studio in Marseille from 1895 to 1900, finally retiring, at the age of eighty, to compose his memoirs.

Nadar's prominence in the field should not blind us to the fact that there were several other adepts of the photographic portrait in nineteenth-century France. A convenient way to scan them is to refer to Nadar's chapter 'Les Primitifs de la photographie', which evokes the struggle for commercial and artistic supremacy in Paris from the mid-century on. Given that Nadar may be said, in the long term, to have won out over his rivals in each of these respects (not to mention his outliving them all), his remarks are both historically informative and useful as a key to his personal criteria.

He refers to Mayer and Pierson, who opened one of the first studios in Paris in the 1850s, dismissing them as makers of ponderous and lacklustre images which ignore all nuances of lighting and expression. He gives a fuller account of the most successful portrait-maker of the age, André Adolphe-Eugène Disdéri, who patented the *carte-de-visite* in 1854 before becoming official photographer to Emperor Napoleon III. It is known that, by 1855, Disdéri had a team of no less than seventy-seven assistants, and was running a quasi-industrial operation with fixed poses and props, and exploiting a fast, cheap printing process which, Nadar informs us, offered twelve identical images for 20 francs or so – this at a time when a print might occasionally run as high as 100 francs. Fortunately Disdéri's commercial impact did not affect Nadar, but his low rates did decisively undercut those of less doughty rivals like the Bisson brothers and Gustave Le Gray (who had studios in the same building as Nadar). Nadar concedes that Disdéri made more money than he did; but, while acknowledging his 'active intelligence', he makes a point of referring to the repulsive personality and vulgar consumerism of this *nouveau riche* of the Second Empire. And Nadar cannot conceal his glee when it comes to relating the abrupt financial collapse of the Disdéri

business, as clients began to turn to studios offering more care over their product.[18]

Among the many other portraitists Nadar mentions are his close associate Gustave Le Gray, and Adam Salomon. The former, a painter, achieved fame with his combination-printed seascapes, but also took carefully composed portrait studies. The latter, a sculptor, insisted on a small format for his photographic works, such that the emphasis shifts from the sitters' faces to their assiduously draped bodies. He was an expert at retouching, a practice which Nadar abhorred, and it is amusing to hear Nadar give backhanded praise to Salomon for images which achieve 'the character and respectability of a Work of Art', before he launches into a verbal *portrait-charge* in the old caricatural manner, evoking 'a dried-up little man of disquieting aspect, even a bit sinister with his tiny eyes . . . and his rasping, shrill falsetto voice like some pruned cockerel, quite insupportable with his perfect diarrhoea of puns.'[19] This rollicking onslaught implies that Nadar saw his own aesthetic and cultural standards as based on an austere refusal of visual gimmickry.

Nadar has affectionate things to say of his friend Etienne Carjat (who, be it noted, was never a commercial rival, and even had to borrow money from Nadar). It is odd that he should refer respectfully to Camille de Silvy, who engineered a highly successful career in London as portrait-photographer to the British royal family. Silvy's work, with its fussy backgrounds, and general sweetness and sentimentality, could hardly be more different from that of Nadar, yet the latter – perhaps because geography kept them so far apart – declines to mark any aesthetic or personal distance in his remarks.

The only contemporary portrait photographers of calibre whom Nadar's chapter neglects are Victor Regnault and Charles Nègre. Regnault, first president of the Société Française de Photographie, is best remembered for his scientific photography, but he also made a number of calotype family portraits with poetic qualities.[20] Nègre was an artistic photographer of standing, and his approach offers us another instructive contrast. As a painter from the Midi, Nègre earned the praise of the poet-critic Gautier at the 1849 salon; a close friend of the landscape photographer Henri Le Secq, as well as of Le Gray, he later switched to the camera and proceeded to master the calotype and the heliographic engraving, before turning to wet collodion and the albumen negative. Nègre collated a fine, though unpublished, album of southern scenes, *Le Midi de la France*, and was known for his architectural and genre scenes.

The fact that he had no Paris studio may have accounted for his lack of metropolitan impact; yet today he emerges as a portraitist of considerable originality.[21]

What is distinctive about Nègre is that he shunned the fashionable and secure setting of the studio interior, preferring to lug his equipment out of doors and to ask his sitters to loll against interesting doorways on the Ile Saint-Louis, or sit on seats in the park, where the late afternoon sun might throw their features into decisive relief. Nègre allows his sitters generous latitude, depicting them full-length and in impromptu poses. This is also true of his self-portrait of about 1851, in which Nègre slouches with a hand tucked in his trouser pocket, or the 1851 study of his top-hatted father, viewed from the side as he sits gingerly on a weatherworn stone seat beside the Seine. Such *plein air* work is manifestly at odds with Nadar's strict formula of highlighting the lone celebrity within the controlled neutrality of the studio. (It also points to a more open and arguably more Balzacian concern to integrate character and habitat; overlapping with the category of the genre study, it equally alludes to the notion of *type*.)

A review of other comparisons should serve to fix our sense of Nadar's portrait aesthetic. Disdéri and Silvy tend to place their sitter in sumptuous settings and encourage them to dress up, generating redundant signals of social and financial prestige; Salomon actually drapes his sitters in a manner which subjugates personality to artistic effect; Carjat, more modestly, sticks to a plain background, yet may set his sitters in profile or ask them to raise an arm. Nadar, by contrast, maintained in his studio work, for over two decades, an impeccable commitment to head-on shots of people placed before entirely neutral backgrounds and with an absolute minimum of furniture. As for their sombre formal dress, one might almost suppose that Nadar let it be known he would tolerate no sitter turning up in frivolous garb.[22] Invariably hatless (with the exception of Théophile Gautier, who was granted the concession of a Bohemian beret), his sitters are seen sitting or standing, rarely full-length, and never making dramatic or portentous gestures. Nadar's priority seems to have been to ensure that light, whether natural or artificial, should call forth the prominent features of the face. Is this priority a function of the caricaturist's concern with the Balzacian physiognomic model? Though it is true that Nadar's work originated in caricature, I feel that, in the final analysis, the subtle accentuations of his photographs go far beyond the cruder aesthetic of the *portrait-charge*, especially given that they entirely lack the acerbic note typical of his caricatures, both

visual and verbal. It is as though, in that gradually evolving second and more striking pantheon of Parisian celebrities which is the cumulative outcome of his photographic *oeuvre*, Nadar found a way to transcend the seductive simplifications of the first *Panthéon*, renouncing all gimmickry and almost all artifice, and addressing the sitter's undistorted features as an incisive and singular challenge.

There is about Nadar's mature practice a distinct abstemiousness, a scrupulous quarrying of a narrow vein, which sets him apart from his contemporaries and even suggests a classical streak in this adventurous participant in the Romantic and post-Romantic eras. It seems that, paradoxically, it was the insistence upon an outwardly cautious, almost ritual formula which proved to be the facilitating condition for an event of genuine understanding – that moment of contact when a shaft of feeling lays bare human authenticity. And if Nadar's work can be said to have brought out the best in his sitters, it can equally be said that it brought out the best in Nadar: journalist, caricaturist, balloonist, businessman and busybody, he was never so serious, and never so eloquent, as when he stepped behind the camera.

2
Erased Physiognomy:
Théodore Géricault, Paul Strand
and Garry Winogrand

STEPHEN BANN

I want to ground this essay in one of the oddest groups of portrait images that I know, and one that, by the traditional standards of art historical scholarship, least is known about. This is the group of paintings of the insane (aliénés) completed by the French artist Théodore Géricault at a date which still appears open to doubt: either in late 1819/early 1820 when Géricault had recently undergone the harrowing experience of the equivocal reception of his *Raft of the Medusa* (shown at the Salon of 1819) and was himself under treatment for a severe depressive condition; or a couple of years later, which would place the project between his return from a visit to England in 1821 and the time of his premature death from a wasting disease in 1824.[1]

Quite apart from the question of their dates, nothing is easy about these paintings, which number at least five (and possibly six) extant examples out of an original total of ten, and are dispersed throughout the museum world, in France, Belgium, Switzerland and the United States. I do not claim to have resolved any of the historical problems which have constellated around them. What I intend to do is to interrogate these images, or a selection of them, within a perspective which stretches from the 'classic age' of academic painting to the documentary photography of the present period. The question I intend to ask, prompted initially by these disquieting icons of the Romantic epoch, is: what is there to be read in a face?

This question breaks down, however, into more specific items of interrogation. What is *given to be read*, within a specific cultural and epistemological configuration? In what sense does the portrait image, itself the result of a transaction between technical and cultural processes, offer a new knowledge about the world in which it is set? In case these initial questions seem to be spiralling out of control already, let me

emphasise that my investigation is limited to that uneasy sub-genre of portraiture in which the subject is always more or less anonymous. These faces, which are by comparison with the fully coded and socially situated values of traditional portraiture stricken with poverty, are by the same token rich in their subversive psychological and (I would hold) epistemological potential.

To start with Géricault is to be placed straightaway at a watershed in the history of image production, the significance of which I can only hope to tease out a little at a time. The *Raft of the Medusa*, which may well have been the immediate predecessor of the paintings considered here, is a great work that makes manifest the classic procedures of studio practice: this welter of extinct and suffering bodies has been assembled as a result of painstaking individual studies of the living and the dead. It is appropriate to speak here of what the linguists call the principle of double articulation, since the work can be read not only on the manifest level of its subject matter – the well-documented story of the suffering ensuing upon the shipwreck of a French vessel off the African coast – but also in terms of the signifying units which have been assembled syntagmatically to create that particular *signified*. A contemporary English reviewer knowingly invokes that 'other scene' which Géricault has had to visit in order to familiarise himself with the anatomy of corpses: 'The Morgue seems to have been studied as far as it could without exciting horror; the head of a father is perhaps the worst, a dead negro the best thing in the production.'[2] This criticism neatly clarifies the conditions of communication. To have painted the Morgue, with its quota of corpses, would simply have provoked 'horror', which is a reaction transgressing the bounds of legitimate aesthetic experience.[3] But Géricault has appropriately raised his subject matter to a secondary level: the 'head of a father' and the 'dead negro' invite discussion not on the basis of their fidelity to a putative model, but as a measure of their expressive functions within the whole composition.

It is in this context that the studies of the insane show a decisive break with academic practice. In this case, it is the 'other scene' that is also the scene of the image. The hospital of Bicêtre, where Géricault's friend Dr Etienne-Jean Georget worked and the painter was himself possibly treated, yields up a quota of models who are represented in their own right and, one might say, without further semantic articulation – except that the very act of proffering these transgressive images impels us to ask a series of questions about their function and status. What are they for? We can probably dismiss straight away the simplest answer, which

appears to cut short all further speculation: that they were intended as a series of models to illustrate the published work of Dr Georget. Denise Aimé-Adam, Géricault's sympathetic biographer, makes the reasonable point that he was a consummate master of the art of lithography by this stage, and would have had no difficulty in producing prints that were suitable for reproduction, if that had been his brief. She herself prefers the explanation that the set of ten works was painted by Géricault in acknowledgement of medical services rendered to him by the young doctor, who perhaps refused any more formal payment.[4] This is an attractive idea, but it does not advance us very far in understanding the artistic and epistemological status of these images.

Lorenz Eitner, the leading specialist on Géricault's work in the English-speaking world, concludes that the explanation that 'probably comes closest to the truth' is a severely pragmatic one: the images of the insane were intended 'as demonstration material for lectures'.[5] The implications of this view are, of course, very far-reaching, since they imply that Géricault's paintings were in some essential way tributary to the systems of classification established within the hospitals and asylums of post-revolutionary France by Georget and his two predecessors in the treatment of the insane, Pinel and Esquirol. So are Géricault's images no more than demonstrative signs, used to substantiate Georget's clinical discourse? Since the publication of Foucault's *Histoire de la folie* it has been impossible to think about the transition from the eighteenth-century treatment of the insane to the 'enlightened' surveillance of the nineteenth in the same comfortable way as before. It would indeed be a depressing conclusion if we had to convict Géricault of conniving at the operations of oppressive reason, and grinding down the identity of his subjects beneath the weight of a diagnosis that was not open to challenge.

This conclusion has to be faced, but its implications are perhaps not quite so categorical. In the first place, it has to be admitted that the paintings do indeed (as far as the cognitive claims implied by their titles go) belong within a specific conjuncture in the classification of types of mental illness. Pinel offered a tripartite division of the general field of madness, and Esquirol in his turn divided his patients into five groups corresponding to different types of symptom, one of them being the affliction of *monomanie* (monomania). The characteristic of monomania was the attachment of the patient to one particular object, or overriding delusion, which appeared to govern all of their behaviour. It is recorded that this condition, giving rise to a diagnosis that would of course be questioned today, was particularly rife in the turbulent years of the

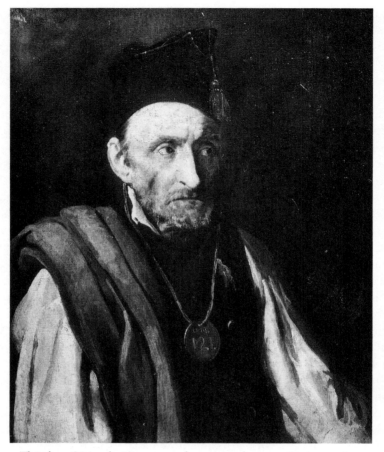

Théodore Géricault, *Monomane du commandement militaire*, *c.* 1820,
oil on canvas. Oskar Reinhart Collection, Winterthur.

Empire and its immediate aftermath;[6] and given the historical circum-
stances of the Restoration period, there is a certain suitability in the
Monomane du commandement militaire (*Portrait of a Man Suffering
from Delusions of Military Rank*, Winterthur, Oskar Reinhart Collec-
tion). Géricault's five surviving definite works from the series are all
provided with titles, and despite the fact that they were never exhibited in
the Salon and owe these titles to the link with Georget, they do indeed
appear to reflect the categorisation of a pre-existing medical discourse.
But this is a circular argument, and to break out of it, we have to ask a
more focused question: what is there to be seen in the images themselves?

The point is that these images are simply not transparent to the

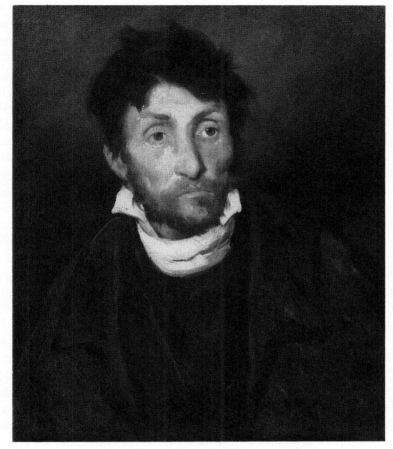

Théodore Géricault, *Monomane du vol*, c. 1820, oil on canvas.
Museum voor Schone Kunsten, Ghent.

classificatory discourse. And this places severe doubt over the question of how they could have been used as 'demonstration material', quite irrespective of the issue of whether they were intended so to be used. This point is well taken by Jan Goldstein, whose study *Console and Classify* faithfully reflects Foucault's project by tracing the coercive techniques of the French psychiatric profession in the nineteenth century. Goldstein takes it for granted that Georget 'commissioned the painter Géricault' to do works which 'reflected their patron's scientific concerns'.[7] However, when the harrowing image of one of the works is illustrated, the caption records in all honesty a 'powerful inner agitation held back, momentarily, from active expression'.[8] Goldstein can tell the difference between

hack work which is indeed devised for exegetic purposes – on the adjacent page is featured the work of 'an obscure draughtsman' who did sketches for Esquirol – and the work of Géricault, whose phenomeno-logical effect is quite different.

The painting that Goldstein illustrates is indeed a difficult work to contemplate. In the collection of the Musée des Beaux Arts, Ghent, it is usually referred to by the title, *Monomane du vol* (*Portrait of a Kleptomaniac*), though an alternative title, *Le fou assassin* (*The Mad Murderer*) has also been applied. The second, without any doubt, is an apocryphal title, bearing no connections with the clinical precision of Georget's code of monomania, and simply serving to neutralise through an excess of evocative language the mute challenge of the intolerable face. But the very fact that both titles have been used alerts us to a crucial point about the painting. It does not really matter whether we are told that this man is an obsessive thief or a mad murderer, because the painter's project is to record the obdurate resistance of this physiognomy to any form of signification. The previous work, in which the subject is supposedly obsessed with delusions of military rank, at least has various trappings that suggest a kind of acting out of the fantasy of command: the tasselled cap and the large medallion incongruously bearing the number '121'. But even in this case there is a discontinuity between the accessories, which may or may not speak of the delusion, and the expression and carriage of the head itself. What Géricault seems intent on conveying is the idea that physiognomy cannot be coded in the way that the titles suggest. It is precisely because of this fact that the subjects shown were the object of specialised medical research. They are a site of ignorance, and obviously the mission of a dedicated doctor like Georget was to bring the light of knowledge to illuminate their obscurities. But the painter, I would suggest, occupies a neutral place – not because he necessarily misunder-stands or disputes the codes which the doctor is seeking to elucidate, but because his image is designed to elude and transgress those codes. Géricault's work evades the typology of *monomanie* by virtue of its own ontological status. The painting is also, to put it in simple terms, a primary document.

There are several tracks which one could take in trying to put this claim in context. I do not think it is by any means irrelevant that the years to which Géricault's series belongs are also the years that culminated in Leopold von Ranke's celebrated Preface to the *History of the Latin and Teutonic Nations*, where the distinction between primary and secondary sources is formulated for this first time as the essential prerequisite of

historical research. Nor is it irrelevant that a French historian like Prosper de Barante, though far removed from Ranke in his conception of method, could also envisage his task as the achievement of a neutral, 'degree zero' of historical narrative from which all subsequent commentary or ideological distortion had been removed. In historiography, the Romantic reaction against eighteenth-century philosophical discourse led to a determination to exclude all rationalisation or typification of the brute materials of the past, whether this was conceived essentially as a literary task, geared to the receptivity of a contemporary audience, or as a scientific task, to be handed on to a new, critically aware generation of historians. Géricault, whose major paintings had almost exclusively been concerned with inverting the codes of heroism established in David's studio, fits well with this subversive strain of Romanticism, which is nicely epitomised by the decision of the French historian Augustin Thierry to take the downtrodden Saxons as the heroes of his *Norman Conquest*.[9] Géricault's portraits of the insane could be seen as part of this antinomian Romanticism, with the poor inmates of the asylum being given the same chance of self-manifestation as Barante's Joan of Arc, or Thierry's Thomas à Becket.

Yet to pursue this analogy too far results in an apparent difficulty. If we want to claim that this is more than a mere rhetorical inversion – the last being made first, and the low changing places with the high – then the notion of the document must be seen from its ontological aspect. In drawing a distinction between primary and secondary materials, or documents proper and subsequent commentaries, Ranke was indeed isolating a category of materials that were crucially different in their status. The original documents did not, of themselves, tell the truth. But, if properly interrogated, they could be used to establish the truth of the past *wie es eigentlich gewesen* (as it really happened). In the case of Géricault's paintings, however, nothing can alter the fact that these are works of art, and are thus the fruit of both the artist's technical skill and (presumably) of his own determining cultural conception. Surely, in consequence, there is no valid reason for viewing the *monomanie* studies as primary documents? At the most, one might credit Géricault with achieving – as Barante did in his scrupulous avoidance of the intrusive signs of modern judgement – a kind of *documentary effect*.

I will not push my claim further than this for the moment, preferring to introduce the visual domain that gives this essay its special focus and direction. Roland Barthes has expressed with memorable concreteness the terms of the 'anthropological revolution' of photography which

resulted in the establishment of a new type of visual communication. The photograph is, for Barthes, a 'message without a code', and this implies the corollary that other types of images (and typically those in the tradition of Western painting since the Renaissance) are inevitably and irretrievably coded.[10] Despite all that has been said about the coded character of photographic communication, Barthes' point remains valid on a level which is not merely that of a truism. The photograph has, by virtue of its ontological status, the character of a document, whether it is a vehicle for codes, or whether it subverts them: its status as a trace, or in Peirce's terms an *index*, implies a level of meaning that communicates irrespective of the photographer's contrivance. But in what way is this feature relevant to Géricault's images of the insane?

This question needs, perhaps, a wider frame of reference. To view Géricault's works proleptically, in relation to the imminent development of photography, is less useful a strategy than to set both media within a more extended historical development. It goes without saying that Géricault worked in, or possibly against, the conventions of a painterly tradition. What is less obvious is the extent to which photography also, not in terms of its subject matter but in terms of its characteristic set to the phenomenal world, inherits the conventions and the transformations of this established tradition of image-making.

Here it is particularly useful to look at Michael Fried's conception of the development of Western painting from the eighteenth century onwards, which he has analysed in terms of the dialectical opposition between 'theatrical' and 'absorptive' modes.[11] In this argument, Fried views the works of painters as diverse as Chardin, Greuze and David as testifying to a common preoccupation with the possibilities of 'absorptive' subject matter: that is to say, with scenes in which the participants are concentrating hard on their own activities, or alternatively barred from us by a physical impediment like blindness. In an aside that is specially relevant here, Fried looks forward to the *Raft of the Medusa* as a crucial further stage in this evolving process, since, for the first time, the whole emphasis of the composition is slewed round, from a theatrical space in which the players confront their audience, to one in which every attention is devoted to the tiny sail which appears on the remote horizon. In this crucial repudiation of direct address to the spectator, Géricault's work is seen as asserting the autonomy of the picture and its self-enclosed space, which our empathetic projections cannot quite succeed in colonising.

Michael Fried has returned to Géricault in his recently published study of Courbet, which includes a long preamble on Courbet's precursors. As Fried puts it, 'Géricault's masterly portraits of the insane have justly been admired for combining scientific detachment with sympathetic identification in equal measure . . . But what I want to stress is that persons afflicted with the illness then known as monomania were described by a leading medical authority . . . not only as wholly absorbed in various obsessive delusions but also as seeking to flee their fellows, either to escape being seen by them or "to entrench themselves all the more securely in their own manner of looking".'[12] Georget's phrase does indeed come in strikingly useful in connection with Fried's analysis of the absorptive mode. And Fried's further adumbration of the conflict between theatricality and absorption in the period preceding Courbet even suggests that the invention of photography formed a constitutive stage in this process. He quotes Disdéri, inventor of the *carte-de-visite* portrait photograph, as saying that photographers must strive to combat the element of theatricality which is implicit in the medium, since the process itself is liable to show us 'the actor where we believed we put the man, the theatrical action where we attempted to place the natural action'.[13] In this remark, as Fried rightly stresses, it becomes obvious that photography, in spite of its novel technology, inherits a problematic that was formulated for painting at least as early as Diderot.

So Géricault's studies of the insane are worthy of note not only because of their distinctive subject matter, but also because of the way in which that subject matter encourages and reinforces a special kind of pictorial effect. He has chosen not the artless image of a child at play, as Chardin did, nor yet the sightless subject cherished by David, among others, in his work involving the blind general Belisarius. He has chosen a group of figures who *see without seeing*. That is to say, they cannot possibly meet our gaze, because the focus of their attention is the delusory object or imagined status which they have adopted so single-mindedly. They 'entrench themselves . . . in their own manner of looking'. Even in a comparatively sober portrayal like the woman addicted to gambling (*Monomane du jeu*, Louvre), this condition of utter other-directedness is indeed the most striking feature. This blandly staring face, simply bonneted and framed with appurtenances like the capacious cloak and the incongruous crutch, is devoid of any features which might lead us to associate it with this particular addiction. It is a representation of an otherness which is all the more striking for not making any use of the alienating devices of the eighteenth-century painter. I am led, irresistibly,

Théodore Géricault, *Monomane du jeu, c.* 1820,
oil on canvas. Musée du Louvre, Paris.

to compare it to a photograph – but a photograph taken before the emergence of that implicit contract between photographer and subject which Disdéri saw as arousing the threat of theatricality. Fox Talbot's early photograph of his mother, Lady Elisabeth Fox Strangeways, shows just the same dissociation between the rhetoric implicit in the medium, and the subject's unconscious power to subvert it. The painting on the path of absorptive autonomy shares this distinctive trait with the photograph as document.

Yet Géricault's series is not simply a fortuitous junction point between the contrivance of absorption and the ontological autonomy of the photograph as document. It also gains historical significance from its crucial relevance to a pictorial tradition that developed in the seventeenth century, and dominated the academic practice of French painters until it was conclusively forced out over the course of the nineteenth century. (In what ways this can be linked with the rise of photography I shall hope to argue at a later stage.) This is the tradition of physiognomy, or the use of

Henry Fox Talbot, *Lady Elisabeth Feilding*
(*née Fox Strangeways*), *c.* 1843-4.

face and gesture to constitute the human body as an amalgam of clearly legible signs. Norman Bryson refers in *Word and Image* to the achievement of the French seventeenth-century artist Charles Le Brun, whom he credits with 'the most prolonged meditation in European art on the meaning of the human face'.[14] Le Brun succeeded in loading the human body (particularly the face) with a multiplicity of differential meanings. These meanings were not so much derived from empirical observation as formally constituted as a vocabulary, by means of which emotions and states of mind would 'speak' from the legible visage with as little possibility of confusion as could be managed by the artist's graphic and analytic skill. For Bryson, who begins *Word and Image* with a discussion centring on Masaccio and is particularly concerned to question the view that the painters of Renaissance Florence instituted a distinctive new realism, the role of Le Brun is exemplary, since the painter perfects a discursive coding of the human figure, and so extracts it from any lingering entanglement with the myth of the 'essential copy':

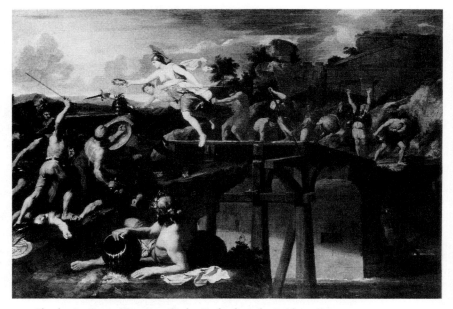

Charles Le Brun, *Horatius Cocles Defending the Bridge*, oil on canvas, 1642-5.

The kind of discursivity to which Le Brun submits his painting is entirely conscious, and is nothing to do with naturalism. Before Le Brun, since no lexicon of the body exists to be consulted, except the virtually useless treatise by della Porta, the significance of the body seems to have no source, and in the absence of source there develops an effect of the real, as with the Masaccio earlier discussed.[15]

I need to summarise the implications of what is being argued here. Bryson is suggesting that the Renaissance paintings of Masaccio provide, or could be misinterpreted as providing (the difference is not wholly clear, but need not detain us) an effect of the real. Le Brun, on the other hand, succeeds in codifying painting as a discursive practice, in accordance with which the different expressions of the human face make up a kind of alphabet, hardly less clear in its individual and distinguishable messages than the constituents of language itself, provided we give a minimum of care to studying it.[16]

Where then does this leave Géricault's studies of *monomanie*? What I have been suggesting is that their *documentary effect*, and their status as absorptive paintings in Fried's sense of the term, work in conjunction to signal a mutation in the status of the image which is equally determining for the visual arts and for the new technique of photography. In Bryson's

Garry Winogrand, *El Morocco, New York*, 1955.

terms, this may seem like welcoming realism through the front door when it has just been expelled from the back! But there is a crucial difference. For in the misreading of Masaccio to which Bryson alludes, the effect of the real is achieved through a deliberate confusion between real space and the artificially constructed space of perspective.[17] In my own argument, applied to the specific example of Géricault's *mono-manes*, the documentary effect is established through the systematic erasure of the code of physiognomy. How this hypothesis may be tested in a context which includes both the work of Le Brun and the recent productions of documentary photography remains to be seen.

Let us then take as an example Le Brun's painting *Horatius Cocles Defending the Bridge*. An early work, completed during his three decisive years at Rome (1642-45), this displays Le Brun's considerable debt to Poussin as well as indicating the features of his mature style. Like the rustic bridge which forms its major structural element, it is constructed throughout in an exemplary way. It articulates the passions of warfare, exemplified by the courageous stand of Horatius, using a rhetoric of positivity and negativity: the code must have its 'degree zero' in order that the departures from zero may have their maximum potency and explicitness. Hence the calm figure of the goddess Roma who, as

protecting deity, floats above the conflict, proffering the laurel wreath in a graceful gesture, whilst those directly involved in the conflict display contorted expressions and extreme gestures. A most striking device is the conspicuous presence in the foreground of the river god, symbolic guardian of the Tiber, whose untroubled bulk contrasts sharply with the frenzied activity of the warriors. Le Brun had diligently sought the help of his Classical predecessors in putting together his composition: the figure of Roma, for example, derives from a Minerva in the Vatican collections, whilst the armour of Horatius originates on Trajan's Column.[18] But as far as gesture and expression go, he has had to invent his own system of equilibrium, balancing the expressive against the neutral elements. The river god, with his averted visage, is like a ground bass that assures the harmonic structure of the composition.

One of Garry Winogrand's most well-known photographs functions, at first sight, in a similar way (page 37). It is worth developing the comparison between the seventeenth-century painting and the mid-twentieth-century photograph, however far-fetched this may seem, because of an apparent community in their rhetorical strategies. In Winogrand's case, it hardly needs to be said, the historical milieu is not constituted by historical research: it is a given, granted by the indexical status of the photographic print which, as it becomes more and more distant in time from its original referent, inevitably transforms the signs of the contemporary into historically significant details – a hair-cut, the style of a suit, the special features of 1950s make-up. This being said, the effect of the image is dependent, once again, on a very specific kind of rhetorical manipulation: the excess of expression on the face of the female dancer is balanced and, so to speak, facilitated by the expression-lessness of her partner. His unemphatic back, his averted face and lost gaze are, so to speak, the springboard from which the frenetic jollity of his companion's face and the nervous tension of her spatulate fingers take their emotional impulsion.

It may seem that I am reading Winogrand's photograph against the grain, by invoking the precedent of Le Brun's physiognomic coding. For Winogrand was committed, in a public and polemical way, to a systematic form of documentary investigation whereby the eventual photograph was predicated as a kind of fortuitous discovery, and not a pre-planned composition. At his recently circulated retrospective exhibition, there were prominent displays of blown-up contact sheets, with the many images consigned to oblivion vastly outnumbering the chosen few that embodied, for their author, a new knowledge of the world.

Winogrand himself once claimed, in a remark that has become famous, that he photographed things precisely in order 'to see what they would look like as photographs'. This may appear an innocent enough aim, but its implications are significant, when measured against the classic strategies of pictorial composition. For he is asserting that the type of knowledge offered by photography is simply not to be obtained from the phenomenal world: it demands that special effect of distancing which is obtained by the instantaneous click of the shutter. Am I then accusing Winogrand of self-deception when I insist on the comparability of the classic painting and the contemporary photograph?

I have no wish to argue such a case. Certainly, we can talk about the effect of his rhetoric in such traditional ways. But it is equally clear that this is not the end of the matter. Winogrand's photographs of the Zoo, juxtaposing animals and visitors in ways which we are amused to think of as significant, rely on a type of juxtaposition that is fundamental to Le Brun's theory of human facial typology.[19] Le Brun demonstrates through his drawings that in order to characterise faces in the most legible way it is helpful to have a cat, or an ox, or a pig as a model: the human face then gains expressive features from being modelled on the clearly defined features of the animal world. But where Le Brun advocates a complicated (perhaps over-complicated) method, Winogrand simply notes a chance conjunction of human and non-human features. And in this way, the amusement we derive from the photograph inevitably produces a moment of recoil. For although we cannot fail to compare the bulky, summer-clad matron and the lumpish beasts which are sparring in the background, we are also bound to feel that a cheap advantage has been taken of an old woman who could be anybody's granny.

This is not just a sentimental reaction to the manipulative rhetoric of the photographer. What I am suggesting is that the ontology of the photographic image implies this moment of dissent from the constraining codes. Walter Benjamin memorably expressed this possibility when he noted: 'in that fish-wife from Newhaven, who casts her eyes down with such casual, seductive shame, there remains something that does not merely testify to the art of Hill the photographer, but something that cannot be silenced, that impudently demands the name of the person who lived at the time and who, remaining real even now, will never yield herself up entirely into art.'[20] Yet one might wish to rephrase Benjamin's judgement in order to make it cohere with the argument of this essay. Does she cast down her eyes with 'casual, seductive shame'? The idea is a delightful one, but it is almost wholly the result of our own projection.

Does the 'something that cannot be silenced' – which we take to be the ontological insistence of the photographic document – really demand the *name* of the anonymous fish-wife? Does it really require that we supply a civil status for that reticent body? Let us suppose that we found out, through a small miracle of archival research, that she was called Mary Macpherson. Would that in any way palliate the mute challenge of the image?

The result of this line of questioning is to ask again, in the case of David Octavius Hill or Garry Winogrand as representative examples of the photographic portraitist, if the real enemy is indeed the 'art' which Benjamin by implication stigmatises. Having spoken of the classic tradition of facial typology, as it can be found in Le Brun and his successors, I have been taking it for granted that this tradition is exhausted by the beginning of the nineteenth century – and that Géricault's studies of *monomanie* represent, in a sense, its systematic erasure. But hardly has art relinquished its claim to provide a prescriptive code for representing the inner emotions as legible signs on the human face, when science takes up the challenge, and this time the implications are much more ominous. Jan Goldstein rightly refers in *Console and Classify* to the role played by drawings, and later photographs, in establishing the classification of types of mental illness, and other authors have insisted on the important role played by photography in the development of techniques of police surveillance. A potent reminder of the way in which science reinvigorates the physiognomic tradition can be found in the illustrated publication, *The Expression of the Emotions in Man and Animals*, by no less a figure than Charles Darwin. Darwin refers at the outset to Sir Charles Bell, who 'laid the foundations of the anatomy and philosophy of "Expression" as a branch of science'.[21] The point is, of course, that, while Le Brun worked simply to create a coded system of signs, Bell and Darwin assert a physiological basis for their findings, in 'the intimate relation which exists between the movements of expression and those of respiration'. But when we come to the illustrated plates by the photographer Oscar G. Rejlander, we are not so sure. 'The accompanying photograph', writes Darwin, '. . . shows this form of disdain. It represents a young lady who is supposed to be tearing up the photograph of a despised lover.'[22] Now that we are supplied with the anecdote, we see the point, of course. But it is the anecdote that carries the burden of expression, rather than the ambiguous visage in the photograph.

My reason for challenging the terms of Benjamin's famous statement must surely now be clear. It is not 'art' which provides the resistance against which the ontology of the image asserts itself. Or at least it is not art in the sense of the tradition of Western painting. In fact, it is something very much more widely diffused through the culture, which takes the form of a prescriptive code (Le Brun's physiognomy and Darwin's philosophy of expression), or indeed of a narrative extrapolation from the image. So far from being synonymous with 'art', these secondary rhetorical transformations of the image are, in the development of Western painting, specifically contested and eradicated. I am thinking of Manet's last great picture, the *Bar at the Folies-Bergères* (1881), which presents the majestically centralised barmaid with an impassivity of expression that is deeply reminiscent of photographic portraiture. Indeed, if we are to accept T.J. Clark's ingenious reading, the purpose of this work is to confute any lingering cultural assumption that interiority can be broadcast through the lineaments of the human face. The barmaid's social role, which inevitably implies discordance between the respectable exterior and the dubious nature of her calling, is expressed through the visual mismatch between the frontal figure and its oblique reflection.[23] By contrast with the sophisticated manipulation of pictorial space, physiognomy has simply been erased.

This indication of how the documentary effect can be retained in painting has further interesting implications. I have already written about the way in which Manet's *Execution of the Emperor Maximilian* incorporates an expression of instantaneity which seems to be integrally bound up with the technical possibilities of photography.[24] With the *Bar at the Folies-Bergères*, the significant point is that the barmaid's identity is expressed not in terms of an implied narrative (as with the innumerable fallen women in the Victorian repertoire) but in terms of a spatial dislocation. In this respect, Manet remains true to the documentary effect. It is interesting to speculate, with this point in mind, on the way in which painting and photography, on the one hand, preserve that effect more forcefully than the cinema, which has to strive against the grain, so to speak, in order to rescue the image from the fantastic projections of narrative. An early biograph film, *Photographing a Female Crook* (1904), makes this point most effectively.[25] The project is to photograph (and thus to classify) a person previously designated as criminal. It is therefore implicitly to fix an image of criminality, in the way that the Italian criminologist Lombroso had attempted to do. But the 'female crook' will not submit patiently to the ministrations of science and

Théodore Géricault, *Le Vendéen*, oil on canvas, *c.* 1820, Musée du Louvre, Paris.

surveillance. She has to be held down by force, and even the combined attentions of her captors cannot stop her from screwing her face into the most hideously creative contortions. She is, one assumes, an actor. But this short film is nonetheless a kind of allegory of the way in which physiognomy can be deconstructed, before our very eyes, by the strategy of expressionistic excess.

What I have been writing about throughout this essay has been the erasure of physiognomy: that is to say, the occurrence of a type of image which rejects or deflects interpretation according to a pre-constraining code. In my account of the studies of *monomanie* by Géricault, I accepted Michael Fried's implication that these were absorptive works: that they

Paul Strand, *Young Boy, Gondeville, Charente, France*, 1951.

resisted the imposed diagnosis through 'entrenching themselves . . . in their own manner of looking'. Yet the apparent paradox is that, with the 'female crook', as with Winogrand's dancing woman, physiognomy is erased precisely through an excess of expression. Winogrand's subjects are, indeed, technically absorptive for the most part as they have no awareness that they are being photographed. The 'female crook', however, plays to the camera, and dramatises in an almost painful way the condition of refusing to signify. In order to conclude this investigation, I have to argue a further point that overrides the distinction between classic (painterly) and modern (photographic) examples once again, while taking into account in some way the incontrovertible fact of the invention of photography.

A comparatively recent recruit to the paintings by Géricault held in the Louvre is the haunting portrait which is known under the title of *Le Vendéen (The Vendéen)*. A face gazes abstractedly from the portrait past our left shoulder, as if unconcerned by our potential presence; in the absence of eye contact, we begin to itemise the properties of the subject's sparse wardrobe: a capacious blue greatcoat with turned-back lapels, a striped waistcoat with brass buttons, a scrumpled and asymmetrically arranged shirt, and above all that an enormous hat which dominates the

figure and casts the averted eyes into shadow. It is the hat which is
responsible for the recent titling of the picture, since this type of headgear
betrays an inhabitant of the Vendée region of France, the conservative
and royalist North West. In painting this portrait, Géricault was surely
bearing in mind the important series of commissioned works represent-
ing the aristocratic heroes who had led the Vendée peasants in their
insurrection against the Republic in the 1790s – heroes who had been
retrospectively covered with prestige when the Empire fell and the
Bourbon dynasty returned to rule over a chastened France.[26] But
Géricault, who had himself celebrated the incipient end of the Empire
with a painting of a *Wounded Cuirassier* in the Salon of 1814, is not
disposed to perpetuate the memory of the insurrectionary generals: La
Rochejaquelein, Bonchamps and Charette. Instead, he records the
character of the Vendée peasant, reserved, distant from Paris and the
modern world – the very epitome of all those peasants who took part in
the doomed but glorious rebellion of the North West.

Or does he? One of the most fascinating possibilities that arises in
relation to this portrait is the suggestion that it may be a further addition
to the studies of the insane, one of the five examples which are believed to
have been lost. In this perspective, the subject is not a Vendéen, but a
person possessed by the *monomanie* of being a Vendéen. We have
already had the case of the patient obsessed by delusions of military rank,
and here is an example of someone who signals pathetically, through his
wide-brimmed hat, the message that he is an authentic Vendée peasant,
and thus a participant in the glorious campaigns that kept the flame of
royalism alive throughout the early years of the French Republic.

Of course there is no way of concluding this dilemma. But I would
suggest that it is precisely the intrinsic character of Géricault's image, and
its demonstrable relationship to the known images of *monomanie*, that
justifies this equivocation. In other words, we are not simply dealing with
an issue of lost documentary evidence and inaccurate titling, which could
potentially be resolved if the necessary new evidence came to light. What
seems to interest Géricault is precisely the human face upon which the
legible signs have been effaced, so that the coding of significant detail in
dress and appurtenances inevitably takes on the character of a charade.
The examples of *monomanie* may be clinically classifiable as people
pretending to be this or that, or obsessively devoted to this or that
activity. But Géricault, as we have seen, is not concerned with producing
an overdetermined interpretation which duplicates the diagnosis. On the
contrary, he is trying to demonstrate that there is an unknowable absence

which doubles the delusory presence. To this extent, the Vendéen – whether he is under an individual delusion, or under the mass delusion which once caused him and his fellows to rise against the central government – exactly fits the exegetic scheme. The painting strives for a pure documentary effect, which implies a kind of overriding of the contrivance which has brought it into existence.

If we finally make the comparison between Géricault's *Vendéen* and one of the most well-known photographs of Paul Strand, it becomes clear just how far the contract between artist and model has altered, and how far it remains the same. Strand's quasi-sociological title, *Young Boy, Gondeville, Charente, France* (1951), locates the subject epistemologically as if offering a telescope to the viewer's eye.[27] We advance through diminishing circles of intelligibility, as it were, from the national theatre through to the region, the obscure village and the unnamed figure who finally meets our gaze. Like Géricault's Vendée peasant, the boy exhibits the signs of provinciality and low agrarian status: the studded wood partition in the background connotes the farmyard, and from the straps and metal appurtenances of his overalls we can almost extrapolate to the spade or pitchfork in his calloused hand. But these aspects are of minor importance compared to the intense stare which grips our attention. Géricault's paintings of the *monomanes* represent the unknowability of the human expression in terms of an irrecoverable straying of the sitter's attention. Individuals are, so to speak, alone with their thoughts, and this is appropriate for the lengthy, unforced character of the sitting, when no immediate physical response is provoked by the artist's physical placement before his model. Strand's arrival as the man with the camera has, by contrast, resulted in a direct physical confrontation, in which the knowledge of what a photographic portrait is like informs the resolution of the model not to give anything away. This is a crucial difference. But it does not alter the essential connection: in each case, it is the excess of unknowable physiognomy over the signs of status, the self-manifestation of a body refusing to be read, that constitutes the special effect of authenticity.

I should, in conclusion, underline the general bearing of what has been argued here, as a contribution to the accumulating history of visual representation, which needs to be approached by small steps. My specific theme has been the relationship between the history of painting and the history of photography, and the possibility of introducing some form of mediation into the two supposedly autonomous sequences. I referred earlier to Bryson's argument in *Word and Image*, and the way in which he

situates Le Brun's coding of the 'legible body' in the context of a Renaissance tradition too preoccupied with 'effects of the real'. What I have been tracing is the way in which a documentary effect emerges through the deconstruction of Le Brun's legible system, not only in photography (where it can indeed be taken for granted) but in the studies of *monomanie* undertaken by Géricault. Significantly, Géricault chose both to select a type of subject matter in which the expressive signs are by definition delusory, and to anchor these erased physiognomies within the tradition of portraiture.

For I am in no doubt that the success of these works depends, in the final instance, on their superb quality as paintings. In an influential exhibition not so long ago, Peter Galassi put forward the proposition that the early development of photography could be seen as being integrally related to the existing tradition of the oil sketch – a phenomenon of the late eighteenth and early nineteenth centuries found in a number of European countries.[28] I prefer to argue that photography participates in a more central genealogy – that which Fried associates with the tendency towards 'absorptive' subject matter and a corresponding sense of pictorial autonomy. In these terms, it can hardly be seen as surprising that the autonomy of painting was being secured, by a process of dialectical transformation, in the very period when the invention of photography, so to speak, ratified the documentary effect. Paul Strand's equally well-known photograph from 1917 shows us a blind woman. She is labelled blind, and in addition we want to say that she *is* blind. But she is also the ultimate absorptive subject, lost behind her unseeing gaze. Does it change our reaction to know that Strand took this photograph with the aid of a prism lens, which leaves open the possibility that he has surprised a furtive glance by a beggar who is only pretending to be blind?[29] Not really – any more than it affects our awareness of Géricault's series to know that, in the hospital where he himself was probably receiving treatment, the difference between pretence and delusion could not easily be discerned. The Vendéen may be true or false, in strict documentary terms, but the authority of his image is vested elsewhere.

3
Julia Margaret Cameron:
A Triumph over Criticism

PAM ROBERTS

Julia Margaret Cameron discovered photography in 1863 at the age of 48, and was passionately consumed by the art for 16 years, until her death in 1879. Between 1864 and 1875, working in primitive conditions, she seems to have produced around 2000 negatives, and perhaps 500 of these date to the first couple of years. She was the first amateur photographer actively to exploit the media to gain publicity and sales. Once seen, her photographs and unique style are never forgotten. In the 1860s, a period of photographic conformity, she went against convention and was 'bold with the bravery of the unsuspecting venturer'.[1]

Cameron was born in Calcutta in 1815, the third daughter of James Pattle and Adeline de l'Étang, and one of seven children. Her father was an English civil servant, while her mother was of somewhat romantic French descent. She was educated in France and England, the family having had connections at Versailles in pre-Revolutionary France. In 1835, whilst convalescing at the Cape of Good Hope, she met Sir John Herschel (1792–1871), the astronomer and scientist, who became a lifelong friend, correspondent, photographic mentor and eventual sitter. She also met Charles Hay Cameron (1794–1880), whom she married in 1838 when she was 22 and he was 45. Cameron, a jurist and legal member of the Council of India, was also a progressive liberal thinker and reformer with Benthamite views.

Married life in Calcutta must have been much to Mrs Cameron's liking, as she acted for ten years as social hostess and leader of the English contingent, helping the Governor General, Lord Hardinge, whose wife remained in England. Charles Cameron rose to become President of the Calcutta Council of Education and a member of the Indian Supreme Council. Mrs Cameron wrote and translated poetry and involved herself, with an enthusiasm and an indefatigable energy that was to become famous, in the life, art and culture of the Raj in the heady days before the

Mutiny. She had an unstoppable desire to help her fellow man in every conceivable way, and a steamroller-like attitude to objections.

In 1848, Charles Cameron took early retirement. The Camerons, now with five sons and one daughter, moved to England, staying in various towns and villages around London in order to be near friends. They finally settled with Julia's sister, Sara, who had married another East India Company man, Thoby Prinsep. Sara Prinsep had established an artistic and literary salon at Little Holland House, with G.F. Watts as 'painter in residence'. The Prinseps, known for their lively soirées and good food, attracted a host of hungry and publicity-conscious Pre-Raphaelites and writers such as Millais, Rossetti, Burne-Jones and Holman Hunt. Julia Margaret Cameron, with her generosity, her lively and extrovert nature and her tendency to hero-worship and lion-hunt, soon became known in the most significant English cultural circles.

In 1860, Charles Cameron travelled to his estates in Ceylon. Left to her own devices, Mrs Cameron visited her friend Tennyson at Farringford on the Isle of Wight, an island enjoying new popularity because of the building of Osborne House for Queen Victoria and Prince Albert. Mrs Cameron saw two empty cottages within walking distance from Farringford, bought them, and christened them 'Dimbola' after the estate in Ceylon.

In 1863 the Camerons' only daughter, Julia, married and left home. Three of the sons were away on the Ceylonese estates, with another at Oxford, leaving only one son at home. Charles Cameron was often away in Ceylon. After a lifetime of family concerns, Mrs Cameron suddenly found herself with time on her hands.

However, when Julia left home, she gave her mother a sliding box camera, saying, 'It may amuse you, Mother, to try to photograph during your solitude at Freshwater'.[2] By January 1864, after months of mastering the complex chemical and physical processes involved, Cameron was finally satisfied with a photograph that she produced of Annie Philpot, a local orphan. She wrote underneath every copy, 'Annie — my first success'.

Photography enabled Cameron to express her 'deeply seated love of the beautiful':

I longed to arrest all beauty that came before me, and at length the longing has been satisfied. Its difficulty enhanced the value of the pursuit. I began with no knowledge of the art. I did not know where to place my dark box, how to focus my sitter, and my first picture I effaced to my consternation by rubbing my hand over the filmy side of the glass.[3]

Having spent all her life admiring beauty created by others, she was now in a position to create beauty herself.

Photography in the mid-1860s was remarkably cumbersome. Practitioners used a large and heavy wooden sliding box camera, a variable and heavy brass lens, and large glass plates (up to 16" × 20"). These plates had to be cleaned and polished, and then hand-coated with a viscous solution of collodion, made up of a mixture of nitrocellulose, or gun cotton, dissolved in ethyl ether and ethyl alcohol in which were dissolved bromide and iodide salts. If the collodion was not rapidly and evenly distributed over the glass plate as the ether evaporated, it was liable to set in streaks and blobs, rendering the plate unusable and necessitating the repetition of the whole process. The coated plate then had to be sensitised in a bath of acidified silver nitrate for about three minutes, forming silver iodide or silver bromo-iodide in the collodion, before being exposed, whilst still wet, and thus apt to attract every speck of dust and dirt in the immediate vicinity.

Exposure times were long, stretching from three to eight minutes, depending on the available daylight and how Cameron chose to direct and slant it. The exposed negative had then to be developed with ferrous sulphate or with pyrogallic acid; fixed in a saturated solution of sodium thiosulphate (hypo); washed; and then varnished, with further risks of specks of dirt and dust, and the likelihood that, if the varnish was too hot when applied, it would craze the layer of collodion emulsion on the glass plate.

Printing of the exposed negative was on hand-prepared albumen paper. This was good quality thin writing paper, coated with an egg white and salt solution, sensitised with silver nitrate, and left to dry in the dark. The prepared paper was placed against the glass negative, fastened into a printing frame, and exposed to the sun. Exposure time depended on weather and light conditions, and the density of the original negative. The printing process needed regular checking to ensure a correct exposure. Finally, the print was bathed in a mixture of hypo and gold chloride to both fix the print and remove surface grains of silver; this prevented tarnishing and gave the finished print a rich aubergine-brown colour.

Each print needed washing with nine buckets of well water, drawn by the long-suffering Mary Hillier, Cameron's maid, model and photographic assistant.

Flushed with success, Cameron converted her glazed hen house into a studio and her coal bunker into a darkroom. She threw herself into

photography with the fervour of a convert, apparently with the enthusiastic support of her family:

My husband, from first to last, has watched every picture with delight; and it is my daily habit to run to him with every glass upon which a fresh glory is newly stamped and to elicit his enthusiastic applause. This habit of running into the dining room with my wet pictures has stained such an immense quantity of table linen with nitrate of silver, indelible stains, that I should have been banished from any less indulgent household.[4]

From 1864 onwards, her family, friends, employees, and complete strangers were cajoled, persuaded, bullied, threatened, and, when all else failed, even paid, to pose for her extraordinary photographs. A local Freshwater farmer, Farmer Rice, who reminded Cameron of Henry Bolingbroke, was paid half a crown an hour to pose for her, apparently for several hours – a considerable modelling fee when some of her photographs were only selling for three shillings each. From remaining memoirs and letters, none of her sitters seems to have enjoyed their time before the lens, but all agreed that the end results were dramatic and often beautiful.

As her work progressed, Cameron had several aims in view. First, she wanted to document the lives of her family and friends and commemorate their beauty, nobility of character, and very essence for posterity. The fact that she happened to have famous friends was obviously a bonus. Second, it was her aim to make money from her photographs. She never had any false modesty about the quality of her work, and always believed it to be saleable. Indeed she arranged concessions with Colnaghi, Spooner and the Autotype Company in London, as well as selling through Lambert in the Isle of Wight. The Camerons were never overly wealthy and the Ceylonese estates were doing badly. In 1866, loans from Lord Overstone (a lifelong friend of her husband) may have gone to fund Cameron's photography which, because of her prolific production, must have been a major household expense. Third, Cameron wished to ennoble photography to the status of high art, and she regarded her recording of the 'beauty' of young women and the cultural nobility of men and women in her social circle as a worthy pursuance of her ambition.

Undoubtedly Cameron also hungered for acclaim and respect from her contemporaries. She rapidly realised that the more publicity she attracted the better, so she exhibited tirelessly. She incessantly lobbied her well-connected friends to get reviews of her work in *The Times* and other

heavyweight newspapers, and sent parcels of her photographs to influential and respected people.

When she began experimenting with photography in 1863, Cameron seems to have been curiously immune to the influence of any of her contemporaries, apart from the painter and portrait photographer David Wilkie Wynfield. Wynfield, from whom Cameron took tuition, was one of the founder members of the St John's Wood Clique. In 1863 he had produced a series of portraits of artists dressed in historical costumes to resemble an artistic style and period. Thus, John Everett Millais is dressed as Dante, Frederick Walker as a young Florentine painter, etc. Wynfield used an 'out of focus' effect to suggest the softer outline of a painting, rather than the sharpness and precision of a photograph. Cameron also admired the work of the professional portrait, art and genre photographer, O.G. Rejlander, and that of her brother-in-law, Lord Somers, a keen amateur photographer. There are also similarities with the work of the professional portrait photographer, Herbert Watkins, but, as Cameron never mentions him, this must remain conjecture.

An amazing wealth of work had been produced in the 1850s, engendered by the success of the International Exhibition at Crystal Palace in 1851. The decade saw the formation of photographic societies and clubs, and the emergence of such photographers as Roger Fenton, Francis Frith, Hugh Welch Diamond, Lewis Carroll, and Philip Henry Delamotte, as well as the astounding growth of the miniature and stereotyped perfection of the *carte-de-visite*. The 1860s was a quieter decade, with the emphasis settling onto pictorial photography, led by H.P. Robinson and O.G. Rejlander, and the formation of more pictorially inclined clubs and groups such as the Amateur Photographic Association and the Architectural Photographic Association. The emphasis shifted from the exploration of photography's artistic and subjective possibilities to a heavy involvement with its objective technicalities and the perfect print.

In retrospect, Cameron seems to have sprung, ready formed, from nowhere, her influences coming from Renaissance and Pre-Raphaelite art, from her immense reading, and from the circle of free-thinking intelligentsia with whom she surrounded herself, rather than from any desire to emulate and improve on the work of contemporary photographers. Her early work in 1864-5 was largely of a religious and Renaissance bent, heavily influenced by the paintings of Reni, Giotto, Perugino and Raphael. She used children and her servants, house guests, and adopted orphans as models, and produced studies of the Holy

Family, of Madonnas and recreated biblical scenes, for example *The Wise and Foolish Virgins* and *The Adoration*. She was elected to the membership of The Photographic Society (later The Royal Photographic Society) in June, 1864, and was a member until her death, exhibiting in most of the Society's annual exhibitions. Her early work was criticised for its lack of technical expertise:

She should not let herself be misled by the indiscriminating praise bestowed upon her by the non-photographic press and she would do much better when she has learnt the proper use of her apparatus.[5]

But it also received praise for her artistic imagination. The *Photographic News*, in particular, seems to have appreciated that Cameron was producing startlingly different work, and was worth watching:

A lady, Julia Margaret Cameron, sends some rather extraordinary specimens of portraiture, very daring in style, and treading on the debateable ground which may lead to grand results or issue in complete failure.[6]

Undaunted, Cameron showed work over Christmas 1864-5 at the exhibition of The Photographic Society of Scotland, and gained a rather puzzled but enthusiastic review from the same journal:

Mrs Cameron sends some remarkable portraits and symbolical embodiments of the cardinal virtues. This lady evidently possesses considerable artistic feeling, but we fear she is aiming to obtain from photography other results than those in which its strength lies. It would be little praise to the miniature painter to say that he secured on ivory the broad and suggestive effects, without detail, of the scene painter. There is a weird suggestiveness about Mrs Cameron's pictures, and a skilful massing of lights and shadows that show considerable knowledge of art, scarcely well applied, however, in securing photographs in which almost all that constitutes the charm of a photograph, faultlessly minute detail and truth, are carefully eliminated.[7]

However, by 1865 the photographic press was gunning for Cameron. They seem to have been incensed by the adulatory reviews that her portraits in the Photographic Society's annual exhibition received from *The Illustrated London News* and *The Athenaeum*. Both *The Photographic Journal* and *The British Journal of Photography* were determined to put Cameron in her place:

The (Exhibition) Committee cannot concur in the lavish praise which has been bestowed on her productions by the non-photographic press, feeling convinced that she will herself adopt an entirely different mode of representing her poetic ideas when she has made herself acquainted with the capabilities of the art, – no

sacrifice of pictorial beauty being demanded by nice attention to skilful manipulation and care in the selection of properly adjusted optical instruments.[8]

And again, from *The British Journal of Photography*:

The staple of her subjects are a lady in night habiliments with a couple of children in a state of nudity and these she manages to arrange very artistically, very gracefully indeed; would that we could impress on Mrs Cameron that . . . good posing does not compensate for slovenliness of manipulation . . . It would have been well had the fair artist paid some attention to the mechanical portion of our art-science. A piece of collodion torn off the shoulder of Agnes (who otherwise, by the way, is hard and patchy); a broad fringe of stain three inches in length over the arm of James Spedding; brilliant comets flashing across Alfred Tennyson; tears chasing each other not only down the cheeks, but the brows, the arms, the noses, and the backgrounds of many of her best arranged subjects; – these, and many other defects of a similar nature, compel us to say that it is a subject for regret that this lady does not secure the services of an efficient operator to enable her productions to be given to the public in a more presentable form. Her varied works may be held out to the young photographer as both a warning and an example.[9]

Cameron seems to have acquired for herself the unalloyed critical services of the *British Journal of Photography*'s resident misogynist. The sneering, patronising and condescending tone of this article, and others in years to come, amplified by several uses of the word 'lady' and phrases like 'the fair artist', must have affected Cameron, but her written reaction to the barrage of criticism that came her way was characteristically unperturbed. She pronounced the comment 'too manifestly unjust for me to attend to it'.[10]

Individuals whose judgement Cameron revered continued to inscribe laudatory comments on the bottom of her portraits. Charles Darwin wrote, 'I like this portrait very much better than any other which has been taken of me' (1869); G.F. Watts wrote 'I wish I could paint such a picture as this' underneath a photograph of Florence Fisher (1872) and 'Quite Divine' underneath Mary Hillier as *The Dream* (1869). As she read this praise, the artist's heart 'leapt up like a rainbow in the sky.'[11]

In 1865 Cameron had nine photographs accepted by the British Museum, and 93 were either given to or bought by the Victoria and Albert Museum. Her work was shown in both public exhibitions in Berlin, Dublin, and at the Victoria and Albert Museum, and (privately) at Colnaghi and the French Gallery in Pall Mall, London. Her first collected presentation album of photographs in 1864 had been given to her artistic mentor, G.F. Watts; the second, also in 1864, to her photographic guru, Sir John Herschel; and the third, in 1865, went to Lord Overstone.

Even the most exasperated reviewer, berating Cameron's photographs for 'woolliness and indistinctness', was forced to admit that her works were 'more popular among the higher classes of art patrons than any others, and have been made the subject of important articles . . . and have won medals and been highly and warmly praised.'[12] In an eighteen month period, Cameron had thus made her style of photography widely popular with a certain section of the art-loving public, despite the general aversion of the photographic press.

By 1866 Cameron had embarked on a series of large heads, taken direct, life-size, without enlargement, which achieved praise when exhibited at The Photographic Society's annual soirées. She even began to win over the photographic press, who found her pictures were becoming 'more perfect in photographic technicalities'.[13] Her artistry was also complimented:

Some of the large heads, in which the definition was quite sufficiently precise for the subjects, were exceedingly charming, and possessed artistic qualities rarely seen in photographs . . . the beautiful head of a little boy . . . which was perfect in drawing and modelling, admirable in expression, grand in massing of light and shade, and sunny and transparent in a rare degree.[14]

This was probably one of the series of Freddy Gould, the 'angelic' child whom Cameron used most often in her studies of children.

The combination of size and focus was deliberately chosen to emphasise the 'from Life' aspect stressed in Cameron's work. She had begun her photographic career with an 11″ × 9″ sliding box camera, fitted with a French Jamin lens, with a focal length of 12″ and a diameter of 3″. She later graduated to a camera that took 15″ × 12″ plates and contact-printed all her negatives, despite the availability of solar camera enlarging. By 1866, she was using a new 18″ × 22″ Dallmeyer Rapid Rectilinear lens with a focal length of 30″, and worked at an aperture of F8, which enabled whole head close-ups (she had previously concentrated on half and three-quarter length studies), with an exposure time of up to five minutes working on wide aperture. For the next four years, encouraged by G.F. Watts, whose own work was usually far larger than life-size, she concentrated on these larger than life-size heads of men, women and children, and produced some of the most stunning and unforgettable portraits ever taken.

This concentration on the head of the sitter meant that the portraits have no discernible background or period detail, and thus seem timeless. The usual studio props, chairs, tables, fireplaces, painted in backdrops etc., served two purposes. They provided extra detail and a feeling of

familiarity for both sitter and viewer alike, but, along with the unseen neck supports placed behind the sitter to hold the head still, they were a means of stopping undue movement during a long exposure. Cameron swept away these aids to the sitter, demanding, but never getting, complete immobility from her subjects. The blurred effect is the result of her long exposures, of up to ten minutes, when even the best model would move.

Although Cameron later used a stunning array of home-produced props for her Arthurian and genre photographs, she discarded personal accoutrements at an early stage in her photographic career. Women rarely wear any jewellery or other forms of personal adornment, unless absolutely necessary for the establishment of their character. They are only allowed the purely natural effects of cascading hair, or Nature itself in the form of a garden background or a symbolic lily or two. Fussy contemporary clothing with buttons, bows, furbelows and frills is replaced with softly draped, very plain, levelling material, throwing all the emphasis back onto the character of the sitter.

Similarly, with men, collars, ties and lapels are covered over with swathed rugs and velvet curtains in toga or robe fashion. Heroes did not wear collars and ties. Their nobility is often emphasised with a velvet beret, or, as with the women, with emphasis on the hair and the light diffusing through the hair. The disembodied heads float in space and are three-dimensional in their projection. Sir John Herschel (page 57) seems to be adrift in infinite blackness, rushing towards the camera like a meteor, a living embodiment of his portrait's title: *The Astronomer*. (Herschel, in a letter to Cameron dated 25 September 1866, writes of the photograph *The Mountain Nymph, 'Sweet Liberty'*, that it was 'a most *astonishing* piece of high relief. She is absolutely *alive* and thrusting out her head from the paper into the air.' The same is true of his own portrait a year later.) Carlyle appears disembodied but intensely dynamic, and the huge close-ups of children's heads are very confrontational. The numerous studies of Mary Hillier, Cameron's long-suffering maid and favourite model, have an air of otherworldliness and rhapsodic mystery about them.

The 'out of focus' aspect of her work was intentional: 'When focusing and coming to something which, to my eye, was very beautiful, I stopped there instead of screwing on the lens to the more definite focus which all other photographers insist upon.'[15] In a letter to Sir John Herschel, she insisted that her style of focusing was deliberate, and not because of lack of ability: 'What is focus – and who has the right to say what focus is the legitimate focus?' She wanted her photographs to be seen as High Art, as

things of Truth and Beauty mirroring the souls of her sitters, and as portraits of ideas and not things – all qualities which she admired in the paintings of her artistic guru, G.F. Watts.

She was steadily acquiring a vocal band of international admirers, amongst them Victor Hugo, Herschel (who was a generous and constructive critic of her work), and the ever faithful Tennyson. She presented gifts of photographs to these admirers, as well as to Dante Gabriel Rossetti and George Eliot in the hope that they might sit for her once they had seen how her photographs could immortalise them – but they continued to resist her advances.

A private exhibition in January–February, 1868, at the German Gallery in Bond Street was, even by today's standards, extremely large. Cameron had between 240 and 280 photographs on show, all for sale at prices ranging from three shillings for *The Infant Samuel* and other child studies, to a guinea for each of two photographs of Mrs Herbert Duckworth (Mrs Cameron's niece, Julia Jackson and, later, Mrs Leslie Stephen and the mother of Virginia Woolf and Vanessa Bell) and an autographed Lord Tennyson. Cameron considered her photographs of Julia Jackson as amongst her best work.

Other prints included autographed copies of Sir John Herschel and Robert Browning for twenty shillings, and a non-autographed, but exotic, Captain Speedy with Prince Theodore of Ethiopia on his lap, also for twenty shillings. The majority of prints, divided into 'Fancy Subjects', 'Groups' and 'Portraits', were selling for an average of ten shillings. Most of these photographs had been registered for copyright at Stationer's Hall, at a cost of a shilling each. With the cost of photographic materials, time, travel, and gallery rental, it is fairly easy to calculate that Cameron needed to sell a fair number of photographs in order to make any profit. Regrettably, the volume of sales is unknown.[16]

Reviews were, as usual, mixed. One critic went so far as to claim that one 'portrait of the Poet Laureate (Tennyson) presents him in a guise which would be sufficient to convict him, if he were charged as a rogue and vagabond, before any bench of magistrates in the kingdom.'[17]

Cameron's determined placing of her photographs under the public's eye attracted criticism from H.P. Robinson, the father of pictorial and art photography. After a lengthy diatribe against her technique he announced that 'it is not the mission of photography to produce smudges'.[18]

Cameron used Colnaghi in Pall Mall and Spooner in the Strand as agents in London. If the negative was broken or damaged, and the

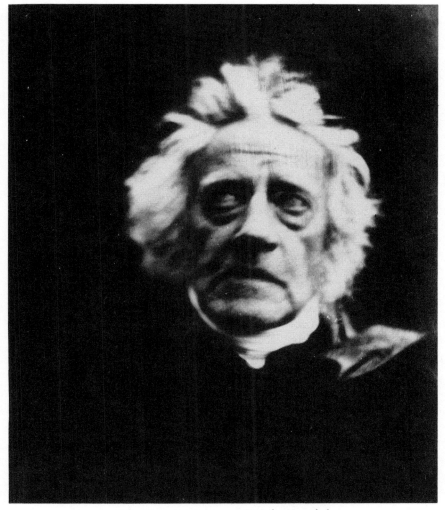

Julia Margaret Cameron, *Sir John Herschel,*
'The Astronomer', 1867, albumen print.

remaining print was thus unique, she charged two guineas, a very early
form of limited edition selling. Some of her more suitable photographs
were made up as *cartes-de-visite* and cabinet cards, despite the obvious
incompatibility of her grandiose style with the miniature format.

At a meeting of The Photographic Society in May, 1869,[19] Cameron
asked about the cause of the appearance of cracks in some of her
negatives, particularly portraits of Sir John Herschel and Tennyson, but

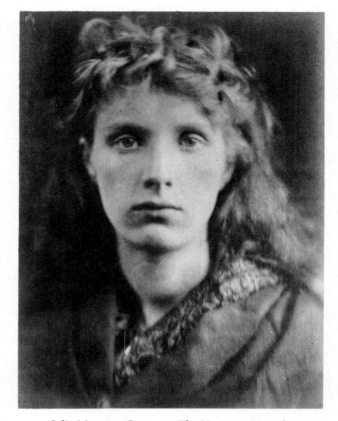

Julia Margaret Cameron, *The Mountain Nymph*,
'*Sweet Liberty*', 1866, albumen print.

also *The Mountain Nymph, 'Sweet Liberty'*. Altogether, about forty-five of her negatives had been affected with a surface crazing of fine cracks, manifested at all seasons of the year, despite storage in plate boxes. (Similar crazing marks can be seen on the negatives of Roger Fenton, bought in 1862 and printed by Francis Frith.) At this stage, Cameron was using the thicker collodion manufactured for large plates, and had tried samples from Mr R.W. Thomas and Mr Brading of Newport, Perry's collodion being too thin to work on large plates.

Her negatives were generally coated with Soehnée varnish. The comments of other members at the meeting, as to how Mrs Cameron could solve these problems, are surprisingly modern in tone and show a remarkable early awareness of conservation techniques. Mrs Cameron

was told to make sure her glass plates were perfectly clean and dry before coating, as dust or moisture could cause the crazing; to wrap all her negatives in paper and to keep them away from the corrosive and salt-laden air of the Isle of Wight. She was also advised to fill in all the cracks in the emulsion with lamp-black prior to every printing.

In the early 1870s, Cameron almost abandoned her large head studies and concentrated on half and three-quarter length portraits and genre scenes. Instead of isolated heads floating in a rich purply brown void, she began to fill her backgrounds with gardens and studio props, the latter possibly influenced by the series of domestic interiors created by H.P. Robinson. Photographs from this period include those of Alice Liddell as *Pomona* and *Alethea*, and Mary Hillier as *Maud* and *In the Garden*. The focus becomes sharper as the camera draws away from the subject matter. Domestic interiors like *Pray God, Bring Father Safely Home*, and the illustrations to Tennyson's *Idylls of the King*, have lost the misty out-of-focus aspect of the large heads. The prints are cooler, crisper, and largely blemish free. But they have also lost their mystery.

Whilst working on these new photographs, Cameron seems to have kept on exhibiting her old material, which was obviously, from the snide comments in the photographic press, getting somewhat dog-eared. Her work from the late 1860s crops up in a variety of exhibitions in Paris, in Derby, in the International and the Photographic Society's Annual Exhibition, and the lack of innovation and the general familiarity of the material starts to engender sarcastic criticism. Cameron's honeymoon period was over, and she once again received a lot of patronising press:

These photographs are now so well known – and, indeed, those before us have evidently done so much duty . . . that we should be rather inclined to pass them 'sub silentio'. One cannot help asking, nevertheless, how it is that they have had such a reputation? . . . Smudged, torn, dirty, undefined, and, in some cases, almost unreadable, there is hardly one of them that ought not to have been washed off the plate as soon as its image had appeared . . . We cannot but think that this lady's highly imaginative and artistic efforts might be supplemented by the judicious employment of a small boy with a wash leather, and a lens screwed a trifle less out of accurate definition.[20]

It would seem that Cameron's hard-won reputation began to wane during these years. Her photographic output is not as intense, with less than 100 photographs registered for copyright in the period 1870–5. An attempt at producing one of the newly popular carbon photographs burnt in onto enamel proved unsuccessful, and was ridiculed in *The British Journal of Photography*.[21] The same journal poked fun at

Cameron's studies of saints and goddesses, saying her model appeared 'decidedly uncomfortable'.[22] At least one review bears all the hallmarks of the *Journal*'s Cameron-hating misogynist, who wasted no opportunity to denigrate her work:

For Mrs Cameron's heads there must be some excuse made for their being the work of a woman . . . To expend serious criticism on them is a waste of words.[23]

Cameron published a new series of portraits, with Colnaghi, in early January, 1873. Reviews appeared in *The Illustrated London News* and *The Graphic*. The latter, quoted by Cameron in her next exhibition catalogue, is very complimentary: 'Those who have seen some of Mrs Cameron's portraits, and have also seen the persons portrayed, cannot but think that there is a power in Photography to reveal some mysteries of the being, which flesh and blood cannot reveal.'[24]

New portraits include *Pomona* and *Alathea* (sic), two of Cameron's strongest portraits, both using Alice Liddell as model and probably taken very close together, 'the latter after the manner of Gainsborough'. Cameron only registered two photographs for copyright at Stationer's Hall in 1873, the downturn in production possibly occasioned by the death in childbirth of her only daughter, Julia, who had introduced her mother to photography.

Some of these new photographs, and old favourites, about seventy in all, were displayed at another private exhibition of 'Mrs Cameron's Gallery of Photographs', held, to catch the Christmas market, from November 1873 until January 1874, in London. It was the usual mix of male portraits of Tennyson, Darwin, Herschel, Taylor and Watts as well as female portraits of Maria Spartali, May Prinsep, Mrs Ewen Cameron and subjects such as *Adriana* and *The Kiss of Peace*. A sixteen-page leaflet, probably privately printed by Cameron, quoted purple prose from a variety of newspapers, some describing her work in general, others the exhibition in particular.

In 1874, Cameron started to write her autobiography *Annals of my Glass House*, a rambling, anecdotal and highly amusing account of her photographic career which was, regrettably, never finished. Having spent so much time working on the photographs for *Illustrations to Tennyson's 'Idylls of the King'* (the first volume of which was published in 1875 by Henry S. King and Company of London) and on similar works inspired by Shakespeare and other popular literature of the time, Cameron arranged to have her negatives, and the prints for which the negatives were broken, printed-up by the Autotype Company as carbon prints,

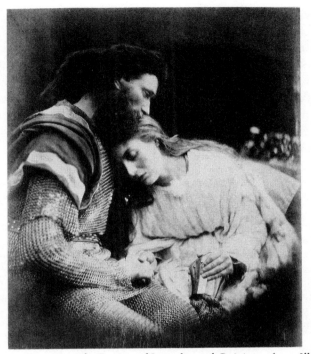

Julia Margaret Cameron, *The Parting of Lancelot and Guinivere*, from *Illustrations to Tennyson's 'Idylls of the King'*, 1874, albumen print.

prior to her departure to Ceylon in 1875. The Company produced retouched and refined versions of her work, removing most of the appealing idiosyncracies caused by the streaks and blobs in the original negatives. Although these sold reasonably well, Cameron gave away as many as were sold. She had invested these works with as much passion and energy as she had her portraits, although the difficulties of finding the perfect models, arranging the poses and then getting the whole group to hold the pose for several minutes often proved frustrating. *The Parting of Lancelot and Guinevere* took forty-two attempts before she was satisfied. Cameron's illustrated *Idylls* sold for six guineas a set, but was not a financial success. Volume II was published later in 1875.

In 1875 Charles Cameron decided to move back to Ceylon for the sake of his health, so the Camerons left Freshwater for the fishing village of Kalutara, later moving up to the mountains at Lindoola. In letters written in September and October 1875 to Miss Moseley,[25] a few weeks before leaving, Mrs Cameron sounds less than happy about the imminent move,

but she was apparently still desperately sending out her travelling portfolio of photographs to make last minute sales.

Cameron took all her photographic equipment with her to Ceylon and produced some sympathetic and lyrical photographs of local peasants, posed in a leisurely manner. Any visiting celebrities who came her way, like the flower painter and traveller Marianne North (who passed through in 1877), were also photographed, but these prints were not exhibited. Marianne North was much taken with Cameron's exuberant enthusiasm:

Her oddities were most refreshing, after the 'don't care' people I usually meet in tropical countries. She made up her mind at once that she would photograph me, and for three days, she kept herself in a fever of excitement, but the results have not been approved of at home since. She dressed me up in flowing draperies of cashmere wool, let down my hair and made me stand with spiky cocoa-nut branches running into my head, the noonday sun's rays dodging my eyes between the leaves as the slight breeze moved them, and told me to look perfectly natural (with a thermometer standing at 96)! Then she tried me with a background of breadfruit leaves and fruit, nailed flat against a window shutter, and told *them* to look natural, but both failed; and though she wasted twelve plates, and an enormous amount of trouble, it was all in vain, she could only get a perfectly uninteresting and commonplace person on her glasses, which refused to flatter.[26]

She showed the Autotype Company's carbon prints of Arthurian subjects from the *Idylls* in England, and her standard exhibition portfolio in the Centennial Exhibition in Philadelphia, both in 1876.

Once in Ceylon Charles Hay Cameron's physical and mental health dramatically improved, and Mrs Cameron's own tendency towards bronchitis, which had been exacerbated by the British climate, diminished. She made a brief trip back to England in 1878, but then caught a severe cold whilst nursing her son Hardinge. She died on 26 January 1879, at Glencairn, Dikoya, Ceylon, aged 63, allegedly with the word 'beautiful' on her lips. Charles Cameron died, aged 85, the following year. Obituaries appeared in *The Times*, *The Athenaeum*, and all the photographic press. The woman once scourged for her 'out of focus' photography suddenly became a prophetic forerunner of the new theories of 'diffusion of focus', as later espoused with great vehemence by P.H. Emerson, George Davison and others: 'Her celebrated photographs, which elicited such a variety of criticisms, favourable and otherwise, will be remembered as the first attempts to secure softness by means of what has been termed "diffusion of focus".'[27]

Her son, Henry Herschel Hay Cameron, himself a competent and successful portrait photographer, kept her name alive after her death,

publishing her uncompleted autobiography in 1889, and exhibiting her photographs with his own in a variety of exhibitions. The Autotype Company steadily sold carbon prints of her work. In the next twenty years, Cameron's work received further publicity and a new measure of respect from the Secession Movement, brought into existence through dissatisfaction with the established photographic societies. Like Julia Margaret Cameron, almost thirty years previously, the Movement believed that photography should be accepted as a subjective art form and not an objective science. It objected to the emphasis put on sharpness, clarity and technical perfection at the expense of aesthetic vision. Cameron's work, with its intense belief in the High Art possibilities of photography, was once again exhibited, this time with all of the admiration and none of the dissent of the 1860s. P.H. Emerson awarded her a posthumous medal for photographic achievement, and wrote glowingly of her work in *Sun Artists* (5 October 1890).

H.H.H. Cameron was an early member of The Linked Ring Brotherhood (the group of British Secession photographers) and, in 1893, published a book *Alfred Lord Tennyson and His Friends; a Series of 25 Portraits . . . from the Negatives of Mrs Julia Margaret Cameron and Mr H.H.H. Cameron*. Cameron further pushed his mother's reputation by exhibiting her photographs along with his own, at the Royal Photographic Society's International Exhibition at Crystal Palace in 1898, and, ironically, in the gallery of *The British Journal of Photography* in 1906. The *Journal* now accepted that Cameron's work 'belongs to the modern movement in photography', and that she was a precursor of 'the revolt against the stereotyped professional portraiture of the "curtain, pillar and vase" type'.[28]

The first one-woman exhibition of Cameron's work was held at The Serendipity Gallery, 118 Westbourne Grove, London, from June 23rd-July 31st, 1904. A small catalogue,[29] with an introduction by Alice Meynell, poet, essayist and critic, lists 46 prints, including four extra added by hand in ink. Many were for sale at prices not much beyond Cameron's own fifty years earlier.

After a long period of neglect, a permanent display of Cameron's photographs in the 'Little Gallery', actually the waiting-room of Brockenhurst Station in the New Forest, was refurbished and reframed.[30] From this period Cameron's work has been exhibited on a regular basis.

Alvin Langdon Coburn, a member of both the English Linked Ring and the American Secession Groups, produced a series of platinum prints, possibly from Cameron's own negatives, or from copy negatives,

which were exhibited in a mixed exhibition at the Hammersmith House Photographic Society in 1916.[31] One of the first great photographic collectors, Coburn bought Cameron's work whenever he saw it, eventually donating a large part of his collection, including over a hundred of her prints, to The Royal Photographic Society in 1930. Two years earlier, he had given Cameron's Jamin lens to the Society. Coburn's own portraiture was much influenced by Cameron's style of confrontational close-ups, uncluttered and hazy backgrounds and a concentration on the inner essence of the sitter. Another admirer, Alfred Stieglitz, in his pioneering photographic art publication, *Camera Work*, printed five Cameron images in photogravure.

In 1926, Virginia Woolf, herself a great niece of Cameron, and Roger Fry, compiled *Victorian Photographs of Famous Men and Fair Women*, an affectionate and admiring view of Cameron's work. The Royal Photographic Society showed the first of a series of Cameron retrospectives (which have continued on a regular basis in the century since her death) in 1927.[32]

Since then, Cameron has become the most written about of nineteenth-century photographers, with a plethora of books and articles in the 1980s. Her work has never been ignored because it seizes the imagination of the viewer in a very personal way. It embodies those key Victorian qualities of enthusiasm, confidence, religion and culture.

There is no twentieth-century hesitancy in Cameron's work, strongly overlaid as it is with her basic beliefs in beauty, religion, truth and the need to communicate a personal vision. Comparison of a standard studio portrait (photographic, pencil or paint) of Tennyson, Browning, or Carlyle with one of Cameron's portraits, using chiaroscuro lighting to reveal the subject's soul, is a salutary experience. Cameron seeks the vibrancy and dynamism that she saw in her sitters. As she said, 'When I have had such men before my camera my whole soul has endeavoured to do its duty towards them in recording faithfully the greatness of the inner as well as the features of the outer man'.[33]

A comparison of Cameron's two heroic 1867 portraits of Thomas Carlyle (who published essays in 1841 'On Heroes, and Hero-Worship, and the Heroic in History' that Cameron had probably read) in both profile and full face, with a G.F. Watts painting of 1868-9, show some acute differences in perception. Cameron's Carlyle is massy, craggy, and of imposing bearing. The noble white head and beard are strongly lit and are thrown to the forefront of the photograph; the eyes are shadowed and deep set, suggesting powerful intellect. The background is void, drawing

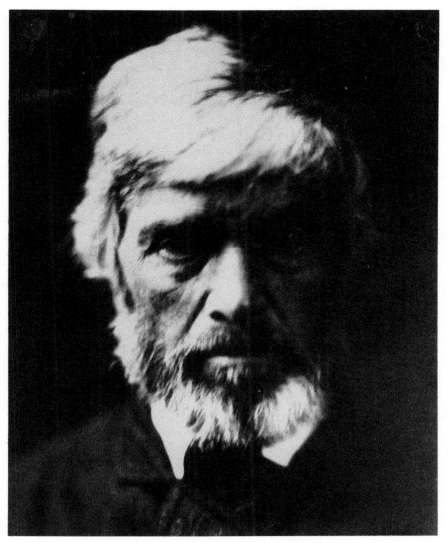

Julia Margaret Cameron, *Thomas Carlyle*, 1867, albumen print.

the eye straight into the image. However, Watt's painting of Carlyle, which Carlyle himself hated, has a Neanderthal forehead and a Hapsburg chin, and could easily be mistaken for some laudanum-addicted vagrant.

Cameron's portraits of women divide into three categories: allegorical (of quality, trait or emotion); historical or mythical; and straight, identified portraits of real women as themselves. In the first category, women are immortalised as a celebration of feminine truths such as Innocence, Love or Goodness. These portraits, on the whole, tend to be the least successful, the sitters often finding it difficult, after the tedium of several hours of on-and-off posing, to match their facial expressions to the suggested theme. Sensibly, Cameron also depicted *Despair* and *First Sorrow* and, in these cases, the facial expressions suit the chosen titles.

When Cameron matched aspects of her sitters' personalities to those of historical or mythical personages, the results are far more impressive. May Prinsep as *Beatrice Cenci* and *Elaine, the Lily Maid of Astolat*; Alice Liddell as *Pomona* and *Alethea*, and Mary Hillier as *The Angel at the Sepulchre* and a whole host of Madonnas, are all forceful images because the qualities Cameron imagined existed in the named subject-matter are amplified by her sitters' own peculiar characteristics.

Mary Hillier, with all her ethereal beauty, her hooded and slightly exophthalmic eyes, is rarely allowed to look straight at the camera. Usually, she is gazing raptly into the middle distance, displaying a perfect Classical profile, or she looks up at the camera from a lower position, suggesting an attitude of submission suffused with startling knowing-ness. The blank gaze equates perfectly with the 'mind-on-higher-things' expression expected of a Madonna or an angel at Christ's tomb. Hillier in *Call, I Follow, I Follow, Let Me Die!* is one of Cameron's strongest images. The perfect profile is illuminated, whilst the cascading hair and the body, swathed in a dark drape, flow into the background. The whole impetus of the photograph is of the face pushing out forcefully, as if propelled by the streaming hair.

The real Mary Hillier was a woman of strong personality and great beauty. On those occasions, as in *Lucia*, when she looks knowingly, with the experience of a long-term model, into the camera, the focus of the whole photograph is her eyes. Apparently Mrs Cameron surrounded herself with beautiful women:

Even more than photography, female beauty was Mrs Cameron's passion; her household staff was a dream of fair women. Some ten years ago Mrs Cameron had an exhibition of her photographs at the Dudley Gallery; and the taker of the shillings, the vendor of the catalogues, and the guardian of the umbrellas were

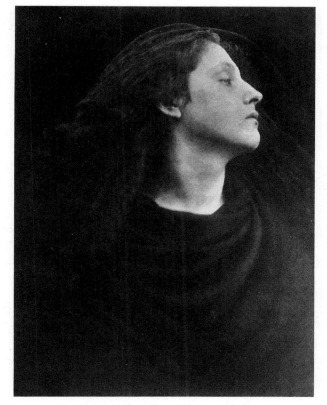

Julia Margaret Cameron, *Call, I Follow, I Follow, Let Me Die!*
(Mary Hillier), c. 1872, albumen print.

girls of whom the memory haunts me still. She herself was charmingly, hopelessly, pathetically plain, and knew it.[34]

In the straight portraits of women like Julia Jackson, Cyllena Wilson, Alice Liddell, May Prinsep, and Mary Hillier, when they are allowed to be themselves and illustrate their independence, strength and sensuousness through the camera lens, it is obvious that Cameron did not surround herself with 'yes' women. It is difficult to see any signs of submission when they face the camera with a challenging eye that verges on the equivocal. It is also a constant shock to be reminded of how beautiful and desirable many of them were.

Julia Jackson was never photographed as anyone other than herself, although she is usually given her husband's name: Mrs Herbert Duckworth. Cameron did not see her strong-minded niece (whose beauty she

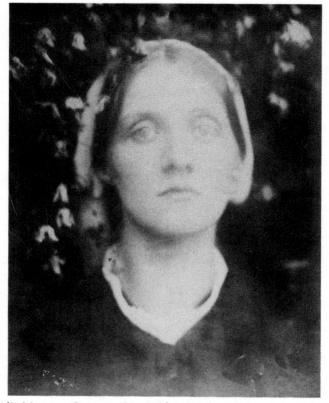

Julia Margaret Cameron, *Mrs Herbert Duckworth (née Julia Jackson)*,
June 1872, albumen print.

revered) as Madonna material, a perception confirmed by Virginia
Woolf's portrait of her mother as Mrs Ramsay in *To the Lighthouse*. The
rigid strength of character, overlaid with stunning beauty, ensured that
Julia was always photographed on her own terms, wearing her own
clothes. It is inconceivable to think of her pretending to be anyone else.
She is also not included in any group photographs, apart from one with
three children (her niece, nephew and son) where again she is very much
herself rather than any disembodied ideal of Motherhood.

Cameron's allegorical and genre studies are difficult for a twentieth-
century viewer to appreciate. The strong influence of G.H. Watts, whose
huge allegorical paintings were an inspiration to Cameron, dictated that
allegory and historical interpretation were the highest forms of art. But
then, the pleasure of play-acting was a daily activity in the Cameron

Julia Margaret Cameron, *The Nestling Angel*, 1867, albumen print.

household. Living in our present age of visual saturation, it is difficult for us to appreciate a form of entertainment that involved nothing more complicated than dressing-up and enacting scenes from the Bible, Shakespeare, and contemporary classics of poetry and prose. It is true that the success of Cameron's work diminished as the number of props and background details grew, but her illustrations for Tennyson's *Idylls of the King* were attuned to the poetry, and satisfied photographer and poet equally.

Her studies of young naked children decked out as cupids, cherubs and angels, are to modern eyes a strange, uneasy mixture of the pure and the suggestive. The squirming children were press-ganged into posing:

We were at once pressed into the service of the camera. Our roles were no less than two Angels of the Nativity, and to sustain them we were scantily clad and each had a pair of heavy swan wings fastened to her narrow shoulders, while Aunt Julia, with ungentle hand, touzled our hair to get rid of its prim, nursery look. No wonder those old photographs of us leaning over imaginary ramparts of heaven, look anxious and wistful. This is how we felt.[35]

Cameron intended her photographs to celebrate the beauty, purity and intrinsic innocence of children, but many of her young subjects manage

to stamp their own characters indelibly on the viewer's imagination — characters which were far removed from the soulful cherubs they were portraying. Florence Fisher as herself, a malevolent glint in her eyes, has such an aspect of the naughty child that it seems wilful of Cameron to make her pose as St John the Baptist. Florence makes no attempt to even remotely resemble the blessed saint, but looks very much like the concentrated essence of Florence Fisher, as she clutches her fringed rug, doubling as an animal skin, to her body. She portrays a Florence Fisher who has been cowed by the whole situation, redolent of boredom, tedium and apathy. One cannot help but like the child, whilst at the same time wanting to smack her.

In the end Cameron's photographs are visual representations of high Victorian ideals, dealing with contemporary philosophies of Beauty, Truth and Art. In short, they are portraits of ideas. It seems unlikely that she ever made any real money from her work, and, despite her constant attempts to achieve this, it seems equally unlikely that she eventually cared. It is obvious that she was in love with photography, the love glowing through the streaks, blobs and spots on her photographs.

Her obituary writers remembered her as one of the most original women of her time, but her reputation has now transcended that time, unlike that of the heroes she sought to immortalise. Cameron would have scoffed at the idea of her reputation outliving that of Henry Taylor, of G.F. Watts, or of her husband, Charles Hay Cameron, all of whom were lauded in their day, whilst she received plaudits and brickbats in equal measure. Yet that is what has happened, and they and many others live on only through Cameron's photographs.

4

Public Faces, Private Lives:
August Sander and the Social Typology
of the Portrait Photograph

GRAHAM CLARKE

More than anything else, physiognomy means an understanding of human nature . . . We know that people are formed by light and air, their inherited traits, and their actions, and we recognise people and distinguish one from another by their appearance. We can tell from appearance the work someone does or does not do; we can read in his face whether he is happy or troubled, for life unavoidably leaves its trace there. A well-known poem says that every person's story is written plainly on his face, though not everyone can read it. These are tunes of a new, but also ancient, language . . .[1]

Thus August Sander commented on photography in relation to his great subject: the portrait. Sander claimed that it was an essential element of his own task that 'the photographer with his camera can grasp the physiognomic image of his time'. His two central projects: *Face of Our Time* (1929) and *Citizens of the Twentieth Century* seek to reflect Sander's claim that 'it is possible to record the historical physiognomic image of a whole generation and . . . to make that image speak in photographs.'[2] The word 'record' has about it a sense of the objective: a belief in the efficacy of what is *seen* as a primary integer of social definition and difference. And indeed one sense of the Sander *oeuvre* is the seemingly 'real' accumulative image of an entire social order; what has been called (in its total effect) 'a systematic inventory of society'.[3]

Certainly this is the underlying structure of *Menschen des 20 Jahrhunderts* (Citizens [or people] of the Twentieth Century). Sander literally envisaged a photographic index of the Weimar Republic: each image part of a collective social order codified by the camera. Each portrait photograph was thus offered in relation to a larger, and definitive classification: a social hierarchy fixed through a series of objective, almost scientific, images of representative figures or types. To look at Sander's portraits then, is to view a social order – a public world of individuals defined through their public roles. The individual is viewed as a representative figure (of a group,

of a profession, of a class) and figures are 'fixed' amidst a series of complex social codes. Identity is, therefore, insistently public.[4]

And yet Sander equally sought what he declared as 'simple, natural portraits that show the subjects in an environment corresponding to their own individuality'.[5] 'Individuality' has about it a problematic status, just as 'own' suggests ownership, of property but more obviously of self. Thus Sander's portraits speak to the general, to a public social world, but seek an individual, private self. This seeming paradox, I want to argue, underlies Sander's entire photographic project, and does so in relation to a continuing tension (within the photograph) between public and private selves; between, in short, a private identity and its definition and representation in a social context. Far from offering a series of fixed 'faces' of the time, the photographs reveal an implicit splitting of identity. The objective surface imagery hides a subjective condition which at any point threatens to split open its public construction. In brief, there is at work within a Sander image a continuing dialectic between the two: a continuing questioning of the terms of portrayal and, by implication, the public image which hides the interior itself.

Ostensibly then, Sander photographed the individual as a type – part of an 'historical physiognomy' which reflected a social index validated by the social theory implicit in his schema. As he declared, 'photography is like a mosaic that becomes a synthesis only when it is presented en masse. That is the way I used photography in my work *Face of Our Time*.'[6] As distinct from, say the *carte-de-visite* or the family portrait, Sander's individual portraits were related consistently to a wider social frame of reference. The *carte-de-visite* was almost a signature of the individual – a trace of the unique personality which had left its mark (or sign) of identity. Sander's portraits relegate the individual trace to a larger whole, and establish notability through their representative status and difference within a specific social order. Thus Sander's 'plan' for *Citizens of the Twentieth Century* is akin to a social map: a hierarchy of social position and status within the dominant culture. Individuals (as types) are 'placed' within a vertical scale of significance. A 1929 draft, for example,[7] suggests seven sections, and forty-five portfolios, each of which would contain twelve photographs. The groups are as follows: The Farmer, The Craftsman, The Woman, The Professions, The Artist, The City and The Last People. The internal order of the sections was dependent upon what has been called 'a sociological arc'. Sander thus begins with the 'earthbound man', moves upwards to the 'artist' and thence descends to the city and a series of increasingly marginal social types. Like Spengler's

Decline of the West (which Sander knew) his schema places the rural over the urban. Indeed part of its mythology is to 'root' the ideal social order in a rural world of continuity and tradition.

This, in turn, is reflected in Sander's hierarchy of professions. The group entitled 'The Professions', for example, identifies 'The Student', 'The Scholar', 'The Official', 'The Doctor', 'The Soldier', 'The Clergy-man', 'The Politician', etc., just as 'The Craftsman' group includes a series of traditional rural occupations. In part Sander's hierarchy and labelling is similar to a medieval guild structure, and it has been noted how much his photographs resemble such texts as the medieval and Renaissance *Standebuch* or *Book of Trades*: 'types' which were imaged as part of a special social organisation based on a fixed hierarchy of significance. In this context figures are photographed consistently in relation to their place within an assumed social order: at once traditional, rural and conservative. Individuals are sanctioned in relation to their social standing, and centrality, within the status quo. Their public status is thus the essential frame of reference by which they are portrayed. 'The Landowner' is imaged as secure, confident and knowing; 'The Farmer' as an authentic figure within a larger rural myth of work, and so on until we reach the final group, 'The Last People'. These are 'The idiots, sick, insane' and 'beggars' – marginal groups who have no social status, no function within the status quo.

Yet I want to suggest that, far from being marginal, this last group puts into context the terms by which the 'official' culture is imaged. Taken together the images represent an underside which both questions and challenges the codes and values – the representation of self (to use Goffman's phrase) – by which the culture renders and portrays the individual. Within the ostensible organising principle this group is at the very bottom of the social scale: displaced, it has no identifying function. But its very presence establishes an alternative register of meaning. Thus it establishes a psychological index – an interior picturing which at every level punctures the surface of the achieved objectivity of the official social index. In this sense Sander makes the invisible, visible: a public exterior gives way to a private interior.

Once we admit this 'other' into Sander's schema, the question of what is portrayed becomes increasingly problematic. There is an uneasy relationship between the individual presence and the social 'label'. The photographs image individuals amidst a palpable and wonderfully detailed social frame, but they do so as part of a questioning rather than affirming process of definition. As John Tagg has noted, 'The portrait is

. . . a sign whose purpose is both the description of an individual and the inscription of social identity'.[8] Sander's images bring the social identity into the foreground, but they do so as part of this reciprocal and invariably dialectical relationship between private selves and public lives. Thus the space of the portrait surrounds the individual as part of a larger (and dominant) social space. The portraits are full of visual codes in which social identity and position at once establish significance and declare status: clothes, of course, but equally rings and medals; the merest detail is often a sign of a collective code affirming significance. Detail reflects a complex play of meaning in which surface imagery frames and fixes the public self: a pervasive condition of how we are 'seen'. As Walter Benjamin has noted, 'whether one is left or right, one will have to get used to being looked at in terms of one's provenance. And one will have to look at others the same way. Sander's work however is more than a picture book. It is a training manual.' In Sander, if social identity is all, it is also problematic. For all their objective clarity, his photographic portraits contrive to ask both what lies *under* the surface and, in turn, what 'lies' are imaged on the surface.

Sander's 1937 self-portrait, for example, is a telling icon of this problematic, and can be read as a visual essay on the terms by which Sander's portraits establish their meanings within what I have suggested is the underlying conflict between public and private selves. In relation to his life at the time it is a poignant but ambiguous image. In 1934, for example, his son Erich had been sentenced to ten years in prison by the Nazis just as Sander's photographic plates for *Face of Our Time* had been destroyed by Hitler's 'Ministry of Culture'. Indeed, since 1935 Sander had been forced to abandon work on *Citizens of the Twentieth Century*, and was photographing landscapes as an anodyne alternative. Sander was thus in a dangerous position and, like other groups (most obviously Jews and gypsies) was *socially* identified as a potentially dangerous element to the values of the Reich. More than ever Sander had to suppress his individuality, almost make himself anonymous and invisible. As a separate individual he was seen as alien to the claims of a state which sanctioned the photographic portrait only as an official document of identity or as a representative image of Nazi idealism. In the context of his own life, then, this is a significant image, but it equally speaks directly to his photographic taxonomy, and the relative claims of public and private selves within a highly structured 'official' social world.

Thus the 1937 portrait is as anonymous as it can be. It suggests little of a 'private' individual, just as it says little of Sander's status and

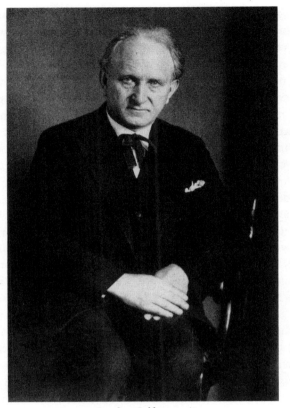

August Sander, *Self-portrait*, 1937.

occupation. Indeed it almost purposefully denies Sander the *photographer*, especially in relation to his portraits of such figures as 'The Artist' and 'The Writer'. We end by asking not just who is the person before us, but what he does. For once there *is* no declared social function or frame of reference by which a seemingly respectable figure is to be defined. Equally the image is uncharacteristically empty of significant detail. As I have noted, the detail in a Sander photograph is always part of a dense texture of complex social codes, motifs and signification. Look at Sander's suit, for example. It is as plain as could be. It lacks any identifying marks or insignia and reflects nothing more than the most general of social mores and codes of dress. At every level the image neutralises photographic space. It reverses, indeed denies, any of the sense of provenance so basic to the Sander image.

This is made more obvious by the absence of what Walter Benjamin

has referred to as 'the spell of personality'.⁹ Think, for example, of how other 'portrait' photographers have had themselves portrayed: Abbott's image of Atget, Brassaï's 'self-portrait', Edward Steichen's tellingly aesthetic invocation of himself 'with brush and palette' (1908), or even the seminal portrait of Fox Talbot by Moffatt (1864).¹⁰ These all, in their different ways, codify the photographers in relation to their photography and suggest a specific style and aesthetic in the image of the self by the camera. Atget, for example, exists as a marginal figure of the street; Brassaï is playful and yet disconcerting, as he looks at us as the voyeur. Sander's image, in contrast, is anodyne.

Yet, as we continue to look at it the very lack of an 'aura'¹¹ begins to establish a definitive sense of Sander's act of portraiture. The anonymity and supposed neutrality make themselves felt as a faked (and forced) objectivity. The lack of expression on the face suggests a comment on the very social world he has pictured and which he, as an *individual*, is forced to exist within. Sander has rendered his individual self in terms of surface. His history and private life, and any hint of emotion and feeling, have been hidden from our gaze. The image declares that 'this is me', but it also states that 'this is not me'. Paradoxically, in having his portrait taken Sander is denying the very act of portrayal. The ostensible assured 'surface' of the photographic space gives way not so much to a fully-rendered social being as to a 'self' caught amidst presence and absence. If the face says 'You will not know who I am', it equally says that 'You cannot *see* who I am, nor how I feel'. Posing for the camera has become both a diffident and problematic act.

There is, however, one area of the photograph which hints at a different history and register of meaning – the hands. A typology of the body as social index is basic to Sander's complex code of social identity. Posture and stance, for example, reflect part of a larger mapping of the body in relation to public status and self-confidence. In any number of Sander's portraits the hands especially are key integers of social meaning. The photographic image makes them available to us as a signifier of difference and definition: a worker's hands, a bank official's hands, etc. In Sander's image the hands are devoid of detail, of any visual clue as to the 'life' they represent. Once again there are (unusually) no rings, no shirt cuffs, no marks of identity. And yet their presence is made central. The right hand seems to deliberately cover (or hide) the left hand. The effect is to suggest that the hidden hand contains a 'mark' which resists our gaze. The hands thus suggest both the absence and presence of a hidden 'text' that is not made public. In so doing they offer a symbolic

imaging of the play between public and private; between the hidden and the exposed. Thus here the hands declare a *physical* presence which relates to the body as a private condition and history – to its marked physical state stripped, as it were, of social paraphernalia. In other words, they suggest a different private index and history. If the right hand was removed we might see a scar, a tattoo, a missing finger or (in the context of the period) a number from a concentration camp. Such detail would re-constitute the terms of definition, and open up the image to a different order of meaning and a different register of private significance. Such 'marks' or signs suggest an anti-text to the public history pictured: clues to a private history, an interior register which the social self represses. The hands thus offer what Barthes has termed a *punctum* of significance:[12] a detail which, in its problematic presence, disturbs the general codes and assumptions of the image as a whole (the *studium*). Sander's *punctums* presage an interior condition which, paradoxically, renders the photographic portrait as part of a surface signification. Paradoxically, of course, the interior he 'seeks' has, by the 1930s, become a fundamental aspect of non-representational art. But equally, for all their assumed mimetic self-assurance, the photographs lay claim to a very different map of the self.

The hand constitutes an extraordinary significance in Sander's taxonomy of German society. It is, of course, part of a public presentation of the body (hands and faces) just as the physical (and of course sexual) dimension is masked by social dress and costume. But once again the signification of the hands is problematic. The portraits of farmers, for example, play upon the obvious physical aspects of their work but, in so doing, insist on the hands as almost sacred icons of a life cycle based on the land and nature. Their hands will be gnarled, textured, and often with dirt ('soil') beneath the finger-nails. Hands, in this context, will hold significant items: a Bible, a tool, a walking stick. All of these form part of a seamless system of codes that underpins an assumed mythology of social recognition and value.

Hands, in this instance, have equal status with the face as integers of the individuals before our gaze. The degree to which they are imaged in such detail establishes them as part of a primary index of significance for the 'self'. And yet, as in Sander's portrait, they are invariably ambivalent. If they announce themselves as evidence of social position, so they also suggest an interior condition. Thus they equally suggest an emotional register – of pain, isolation, and self-consciousness. As hands hold, clutch, retain, unite, and/or lay passive to the eye, so their position (and

'mood') evinces both social meaning and an inner emotional *map* of feeling. Look, for example, at *Three Generations of a Farming Family* – a definitive group portrait of Sander's rural ideal in which the hands of the five subjects are central. In comparison feet are invariably invisible. In another, *Farm Woman*, the hands dominate the image. Characteristically (as in many of the rural personalities) the hands (on the surface) are positive icons which hold and unify.

Yet as Sander's 'citizens' move through his scale of social significance, so hands as integers of the 'self' become increasingly difficult and diffident with regard to their declared meanings. For 'small town citizens' they are accoutrements. The hand strikes a pose, as part of a larger pantomime in a series of gestures that seek an image of social importance. Thus citizens grasp objects in an attempt to gain kudos – pathetic tokens of a supposed (but embarrassingly misplaced) social substance (a book, a glass, etc). In a different but similar way, the marvellously evocative *Boxers* (1928) places the social significance of hands within a ruthless context. One boxer has bandaged hands, the second wears boxing gloves: their hands are rendered invisible, as mere extensions of an existence based on physical energy or direction. Perversely the boxers 'lack' hands as integers of private meaning, just as they lack hands as a reflection of social importance. Their hands are now machines – extentions of a marginalised but brutally anonymous spectacle.

In a different way hands are given a central significance to craftsmen and trades, be it potter, cobbler, cook or saddler. Thus *The Master Tiler* is an exemplary image of the way in which Sander's photographs establish meaning within a social context that is at once hierarchical and self-referential. The visual iconography, characteristically, signifies through what Umberto Eco has called codes of recognition and, more obviously, iconic codes: 'codes of taste and sensibility' and 'rhetorical codes'.[13] All are part of a larger social mapping – an alphabet of meaning in which physiognomy at all levels is pictured within an ideological frame of mutual reference. As Victor Burgin reminds us:

In the very moment of their being perceived, objects are *placed* within an intelligible system of relationships . . . They take their position, that is to say, within an *ideology*. By ideology we mean, in its broadest sense, a complex of propositions about the natural and social world which would be generally accepted in a given society as describing the actual, indeed necessary, nature of the world and its events.[14]

In a Sander image nothing is 'neutral'. Each detail resonates in relation to larger codes of significance amidst which the 'self' is displaced. Individ-

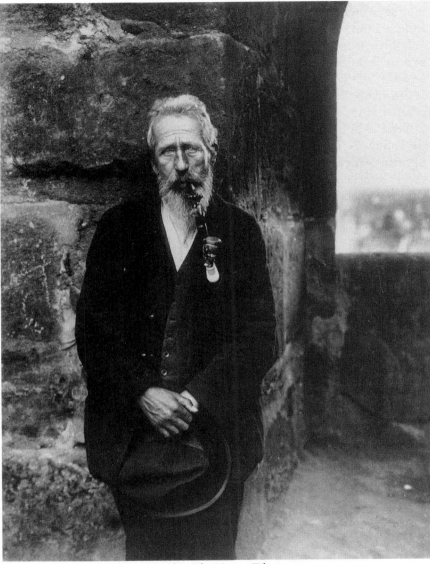

August Sander, *The Master Tiler*, c. 1932.

uals are centred as social beings amidst an assumed social unity – they are given significance within a sanctioned hierarchy of difference. *The Master Tiler* fulfils this system of recognition in an almost archetypal way. This is a figure whose assumed 'identity' is imaged almost wholly as a representative social type. There is a seamless unity between his public image and what it portends about a private self. The hands, for example, rest but also attract attention. They stress physical elegance and crafts-manlike grace. The suit, in turn, fixes the social position, but does so in terms of a myth of labour rather than through any sense of deprivation. To add substance to his general well-being, the stone background signifies skill, weight, and longevity; in other words a tradition and knowledge which feed the substance of his 'life'. In short this is a 'guild figure', rich in association and fixed amidst what has become a 'natural' order of social difference. What the tiler does reflects what he is.

On its own this image appears wholly self-contained. But its terms of reference are placed in contrast if one looks at *Unemployed Man*; one of the images from *The Last People* which increasingly question the terms of reference by which the characteristic Sander world establishes mean-ing. The master tiler is imaged as part of a solid, established and stable culture based on tradition and a deeply-rooted rural hierarchy. Status accrues from his trade in so far as it sustains this social myth. His face reflects this: it looks directly at the camera out of its self-assured social validation: 'I am a master tiler'. *Unemployed Man*, however, has none of this substance. The figure is denuded; brutally cut off from the ground on which it stands. Equally, the figure has been marginalised and is at the side of the image. Nor does the subject face the camera. His eyes stare from an 'empty' interior: they advertise a lack. To be unemployed here is to be without status and, more problematically, identity.

And yet the differences between these two images suggest not so much that the status of one individual is socially above the other, as that there exists a problematic photographic space of the interior and *private* self. Both figures lean against walls, both have their hands together, both hold hats, both wear similar suits, waistcoats, and shirts; yet these similarities constitute an increasing play of difference, so that what is imaged here is little more than a *surface* picturing. The faces, for example, signify their individual terms of reference. The unemployed man, denied economic and social status, is denied individual significance. The face here reflects not so much a private history as a lack of social importance or definition. In contrast the master tiler is seemingly celebrated: hair, beard, eyes, nose, and facial marks are part of a declared 'history'. The unemployed

August Sander, *Unemployed Man*, 1928.

man is deprived of hair, just as his face is stripped of any relevant detail. The 'self' has been stripped bare, and yet, paradoxically, the more bare it becomes so the more it suggests the very interior which the surface detail hides. The mouth, for example, could not contain the tiler's pipe – nor could it hold it (advertise it) as a 'trophy' and synecdoche of a contented and rich life. In addition the hats are mirror images of the different 'selves'. The tiler holds his hat as an image of respectability. The unemployed man *clutches* his (it is also battered, discoloured and without the band). And so the contrasts expand: one suit has buttons which are shining and solid, the other has only one button; one suit 'fits', the other does not. One could continue to labour the point. If detail forms the essence of a Sander portrait, so equally *difference* is central to identity. As we move through the 'gallery' of images, social status is assumed through an interplay of codes, each of which has a distinct (if shifting) significance as it validates the self-identity of the subject. And yet there is an implicit *critique* of the public self suggested precisely through that *difference*. In other words Sander exposes as he images, and renders problematic what he photographs with such assured definition. He lays bare the codifying practices and, in turn, insists on the private lives beneath. While he seeks 'types', he celebrates individuals.

There is an extraordinary detail about a Sander image; but as I have argued, such detail is problematic. The camera seemingly images a distinct social world, but does so through the play of presence and absence; once again, of *difference*. The suit, for example, is a basic integer of social significance (as is obvious in the image of Sander, of the tiler, and of the unemployed man), and has a taxonomy of its own. And yet, paradoxically, the more the suit achieves significance so the more the private 'self' that wears it is lost. The suit places the *body* within a vertical scale of social meaning. John Berger has commented upon this aspect of the suit in a brilliant essay in which he discusses Sander's image of *Young Farmers on their Way to a Dance*. Berger's interest is in the way the suits appear (as ungainly, ill-fitting and bulging) in relation to the farmers' day-time exertions and, simultaneously, the terms by which the suit has established itself as a controlling signifier of social identity and rank:

The suit, as we know it today, developed in Europe as a professional ruling class costume in the last third of the 19th century. Almost anonymous as a uniform, it was the first ruling class costume to idealise purely *sedentary* power. The power of the administration and conference table. Essentially the suit was made for the gestures of talking and calculating abstractly.[15]

The suit dominates Sander's taxonomy of male presentation and identifi-
cation, and fixes individuals in relation to codes of vertical or hierarchical
difference. Thus the 'farmers' on their way to a dance have adopted dress
beyond their social selves. They have, literally, dressed-up according to
an imagined social scale. In a similar way the carefully besuited figure in
the *Butcher's Assistant* is 'exposed' in an attempt to move between and
across social differences. He wears a new suit, a bowler hat, a tie, a stud
and so on in a wholly adopted pose. The figure is thus framed through an
assumed identity which the *suit* announces as alien to the ironic title of
the photograph. Social pretension is exposed in relation to status, but so
is a private need for that status. Here, the individual attempt to gain
substance is made pathetic.

In contrast, there are images of 'bodies' within suits in which power is
clearly conferred by the suit's presence as an extension of its 'wearer'.
Manufacturers and industrialists, professionals and landowners, for
example, all wear suits as symbols of power and ease. Yet in this context
the merest crumple of a jacket collar signifies a loss of status – a crease
inserts an historical and, as it were, *actual* trace (or mark) of its wearer's
identity, and suggests that 'this is what I have been doing rather than this
is how I want to be seen'. As such, a crease, rather than a fold, edges
towards the negative index embedded in 'unemployed man': an inverse
code of the unkempt, the unclean, and the unsuccessful. An historical and
individual 'self' rather than an imagined and projected image. The suit is,
thus imaged, once again part of a double index of significance. It is
pictured within a set and defined social hierarchy as a central integer of
'self' identity and becomes part of a wider uniform of public dress (and
one notes how basic 'uniform' is to the Sander effect: be it an official,
soldier, cook, porter, or doorman). But the 'suit' has a further index of
difference: of taste, style, quality, weight, etc. The distinctions are endless
but, once again, move between public meaning and, as it were, private
intention.

In a similar sense posture is crucial to the public pose in a Sander
image, and is equivalent to the suit as an 'emblem' of public affirmation.
The confident individuals (and types) sit *in* their clothes; just as those
'natural' trades reflect their 'being' through the work clothes they wear.
As part of a genetic register of meaning clothes and posture are pervasive
– but once again they suggest (indeed announce) their significance
through *difference*. Landowners and aristocrats thus 'reflect' an entire
cluster of self-assured images and icons based on a material index.
Beneath their assured status lies an entire culture of increasing margin-

ality. *Small Town Citizen* (1906), for example, suggests a limited social and private existence. The title is equivocal: at once decisive (this *is* a small town citizen) and derisive (the underlying irony of the subject's pretentiousness). Once again this is an ambivalent image. It simultaneously announces status, and yet exposes the attempt at status in relation to an individual condition. In the context the image is both pathetic and poignant: why and how should an expression of self-significance be so dependent upon the needful copying of stereotype and assumed 'worth'?

Perhaps this is why, when one looks at a Sander portrait, there is an underlying sense of the nineteenth-century novel. Indeed, in many ways the nineteenth century is basic to the social world Sander depicts. In part, his photographs reflect a static social world – complacent and assured in its objective verification. But the photographs equally suggest a fundamental questioning of the terms of verification – of the way we identify and read the image of an *individual* subject. As John Tagg has noted (in relation to the nineteenth century), 'To "have one's portrait done" was one of the symbolic acts by which individuals from the rising social classes made their ascent visible to themselves and others, and classed themselves among those who enjoyed social status.'[16] The portrait was, above all, a public affirmation of significance. In one sense the portrait photograph extended the social terms of the portrait in oil painting; but it also democratised the availability of the portrait as an object of identity. Thus everyone could be of significance, but only in so far as they reflected their place within the culture's codes of status and significance.

In one sense, of course, Sander seemingly reflects the fixed social code and closed 'realist' aesthetic. And yet he does so in a period in which the very basis of 'portraiture' was increasingly and radically questioned in relation to the way an 'identity' was to be portrayed. One thinks, for example, of James's *The Portrait of a Lady*, or of Joyce's *A Portrait of the Artist as a Young Man*, as much as of any 'portrait' by Picasso and Braque in their Cubist phase. But in a less radical, but no less compulsive, sense, we can see a similar process at work in *Mansfield Park* and *Middlemarch*, in *The Mill on the Floss* and *Great Expectations*. Sander's portraits reflect a nineteenth-century world within a twentieth-century ideology; they hover between two worlds and inscribe into their 'realist' imagery an incipient critique of a public and exterior world.

Indeed *Great Expectations* is a useful example of a text which reflects the terms by which we 'read' a Sander image. The novel is full of a social world undermined by a narrator who misleadingly 'reads' it according to

an assumed public scale of values. What he (Pip) learns is the value of a *private* world, separate from any public life and invisible to public gaze. In the novel the character of Wemmick is the epitome of this split. His insistence that 'the office is one thing, and private life is another' underpins precisely the conflict in Sander's images. Thus, 'at home' Wemmick is his 'own' engineer, gardener, carpenter and plumber. He is a 'Jack of all Trades': an ideogram, so to speak, of Sander types. In similar terms, Pip reads the world that he experiences much as one might read the surface appearance of a Sander photograph. Individuals are imaged (and judged) according to a fixed hierarchy of difference. Thus the visit by Joe (Gargery) to Pip's London rooms when Pip is embarrassed by Joe's lack of social 'grace':

As to his shirt-collar; and his coat-collar, they were perplexing to reflect upon – insoluble mysteries both. Why should a man scrape himself to that extent, before he could consider himself full dressed? Why should he suppose it necessary to be purified by suffering for his holiday dress? (Chapter 27)

We might ask similar questions about any number of Sander portraits. In *Great Expectations* emphasis is placed consistently on the *visual* judging of a private condition that has only been offered in relation to a public context. Just as Pip judges (or reads) his 'coarse hands' and 'common boots' as evidence of his own lack of gentility, so equally he seeks to adopt the pose of an English gentleman. Pip, of course, redresses his mistaken assumptions, but his response is endemic to the social world he inhabits. The *eye*, as it were, is basic to the way the 'I' is judged. Characters are consistently read according to their outward appearance in the context of a novel that seeks both to define the split between public and private lives (and space), and to affirm the private *over* the public. In *Great Expectations* public life and appearance, despite its despotic insistence, is revealed as little more than a necessary sham.

I find *Great Expectations* an exemplary text in relation to Sander's photographic portraits. The fixed and assured titles of the portraits seemingly define the individual condition; once again consigning the picture's subject to a general condition: a blacksmith, a carpenter, a gardener, a 'gentleman'. And yet the compulsive problematic (as for Pip) is on what terms such individual types are to be named and classified. Thus the consistent irony, or paradox, of a Sander portrait. When it is at its most static in terms of the 'identity', so it is at its most shifting and problematic. The 'fixed' identity hovers on a fine line between social sanctioning and private confusion. Everyone presents themselves accord-

ing to fixed social codes. In *Great Expectations* Pip learns to read these as part of a map of deception – exposing them as masking interior states of feeling, and being: the 'self' that is never visualised. Sander's photographic images render a similar dialectic; at once picturing the dominant ideology, but doing so in relation to an implied critique of its terms of reference. The seemingly objective representation by the camera establishes the subjects as a series of *fixed* exhibits – but also offers them to the eye as a critique of their terms of reference and meaning. Susan Sontag felt that in his attempt to reflect a 'comprehensive taxonomy' of German society Sander 'unself-consciously adjusted his style to the rank of the person he was photographing.'[17] But he does so like Pip – reflecting the world on its own terms of reference, but representing it according to an 'eye' which questions rather than sanctions it at every level.

Thus the representation of a figure in relation to the surrounding space within the frame is paramount. In a Sander image photographic space is never neutral; it is part of a larger social space in which the physical presence of an individual is codified according to an external index of public significance. 'Space' thus signifies status. Invariably individuals are imaged according to their own sense of 'space': they are, so to speak, framed through their own terms of definition. The 'frame' thus reflects a public status and, simultaneously, a private condition. Individuals are imaged according to the terms by which they seek, or assume, public identity. The extent to which they inhabit the space and frame of the photograph extols a psychological register of an inner self.

Figures, if they are confident, assertive, or central to the social hierarchy, will centre themselves *within* the frame. They dominate the space of the photograph as an aspect of social significance. The more marginal a figure is, so the less he or she will occupy the space of the photographic frame. The landowner *owns* the space of his representation. The unemployed man confirms his invisibility by his very lack of space – he is marginal. 'Space' is, as it were, one more index of social significance and individual reference: a graph of public and private bearing. The figure in the centre of a photographic frame is obvious; but figures displaced on either side join a larger graph of difference, just as there is a distinct contrast between full-length and mid-length portraits of subjects who confront or are embarrassed by the camera. Space, in this sense, *grounds* the question of social identity and exposes the conflict between a public life and a private history. The camera, through its formal procedures, registers that space but (through difference) establishes a critique of its use and meaning as an index of the self.

In this sense 'space' establishes one fulcrum (or '*punctum*') about which Sander's photographic images turn. On a surface level they reflect social codes of reference by which the individual is pictured. But there hovers an alternative index of meaning in which the 'identity' portrayed is at once questioned and deferred to a wider alternative social code of reference. Paradoxically the surface typology of Sander's *oeuvre* resonates against a disruptive secondary index of meaning which, to my eye, increasingly asserts its presence. These are the terms by which Sander might be compared to a very different portrait photographer: Diane Arbus. Ultimately Sander's images, like those of Arbus, are visual exercises on how we see and seek to show ourselves as public beings. Their social detail and social space is all. And yet this is invariably offered as a *surface* representation only. Visually in both Sander and Arbus there is a secondary register of meaning which brings into the foreground the *private* self. In Arbus of course, this is implicit. In Sander it is more equivocal: inferred through the disruption, or questioning, of the dominant social codes of representation.

Erving Goffman is significant in this context, for we can view his sense of 'social identity' in relation to his definition of 'stigma': 'bodily signs designed to expose something unusual or bad about the moral status of the signifier. The signs [are] cut or burnt into the body.'[18] Stigma displace, as they allow us to separate the subject from the dominant cultural codes. But 'stigma', in Goffman's definition, equally suggest traces (or signs) of an individual, even subversive, identity. Thus the insistence on the *body*. These signs relate specifically to the individual. They have nothing to do with the social masks and accoutrements of an adopted identity. Stigma are, in this context, marks *of* the individual — signatures of difference as a unique condition rather than in relation to a social scale of meaning. In Sander the more we concentrate on this 'signature' of being, the more the individual portraits insist on their presence as private rather than public selves. They bulge with implied interiors. And as we read a Sander image, so the eye punctures the surface 'self' to expose that interior condition.

In suggesting a parallel with Diane Arbus I am seeking a visual equivalent to the way Sander approaches the question of public and private identity. I find this most obviously in relation to Sander's supposed lowest point of his social hierarchy: 'The Last People'. From one viewpoint these are representative figures of a lumpenproletariat. They formed the 'new' underclass of the city, as urban life displaced traditional codes and values based on a cyclical rural system of labour. In

a different context, however, they suggest themselves as representative of that 'other' which questions the dominant Sander image. As a displaced underclass, these individuals share nothing of the dominant ideology or *social* mapping of the majority of Sander's images. And yet, paradoxically, they increasingly suggest themselves as central to the *oeuvre*. The so-called idiots, unemployed, circus people, diseased and deprived figures in these images constitute not so much a 'weird' world as an anti-text to social identity. They are basic to Sander's frame of reference.

The work of Diane Arbus pulls this group into the open. It allows us to *see* their condition through a distinct understanding of the outsider's plight; but it also suggests that these 'individuals' are an implicit aspect of those fixed, respectable images which constitute *Citizens of the Twentieth Century*. Thus they exist as part of a larger critique of surface definition. Whereas the dominant Sander image advertises ownership, these suggest the opposite: *Disabled Man, Man Selling Matches, Recipient of Welfare Assistance, Beggar, Beggars, Vagrant*. In all these images a sense of the *body* is uppermost, as is the sense of private lives. Publicly invisible, they gain in status as an alternative register of meaning. Indeed we can perhaps measure this significance if we compare them to another uncharacteristic group of Sander images – *Verfolgte Juden* ('persecuted Jews'). For once, this last group were given their *names*: Mrs Oppenheim, Mr Fleek, Mr Leubsdorf, Dr Phillip, and Mr Kats (all circa 1938). And from thence to *Letzte Menschen* – 'The Last People': blind children, blind adults, midgets, and the overwhelming 'victim of an explosion'. We are now in 'familiar' Arbus country – indeed, the blind images are redolent of the photographs she took at Vineland in 1971.

In his introduction to *August Sander: Citizens of the Twentieth Century*, Ulrich Keller is critical of Arbus in relation to Sander's achievement. Thus, 'In her portraits the people appear as isolated and pinned down as butterflies in a glass case: they are presented to us as freaky *a priori*.'[19] As distinct from Sander, Arbus 'identified herself with nothing – above all, with no social order'. This seems to me quite misplaced. It misses the whole context by which Arbus parallels Sander's social mapping and exposes the distinction between private and public selves. Where Arbus exposes and mines 'masks' of identity, so Sander implies their presence, but he does so through the very presence of a group of photographic images (i.e. 'The Last People') which explicitly exposes the terms by which a *social* world confirms (and defines) social significance.

In one sense, of course, the world of Arbus is the direct opposite of

August Sander, *Farm Girls*, 1928.

Sander's. But in another sense it is not so much the opposition as the *underside* of his project. There is in Sander the very private context which Arbus consistently portrays as basic to her view of identity. Thus, where Sander privileges 'trades', so Arbus privileges foibles of individual taste. At every level Arbus empties the assumed social codes of significant *public* meaning. The photography turns inside out a public world in favour of its private and individual other.

But this, in an extreme form, is precisely what Sander seeks. The 'Last People', in this context, are not so much marginal as an *other* to the assumed surface imagery of the self. By comparing them to Arbus we can establish their reference (their significance) as *anti-texts* within the Sander frame of meaning. Take, for example, *Identical Twins* (1967) by Arbus and *Farm Girls* (1928) by Sander.[20] Arbus, as we expect, makes the question of identity basic to the photograph, as is underlined by the title. Sander, in contrast, lays claim to the social position of his 'twins'. Personal identity, superficially at least, defers to social position. The Arbus image draws attention to *difference*. The dresses are the same – in

length, in pattern, in decoration. And yet one twin is both taller and fatter than the other. Sander's 'farm girls' are equally the same but different. Their watches are identical; the shoes are not, nor are their feet or hands. One holds a flower, one does not; one smiles, one does not. The hair is similar but *different*. Like the Arbus image, so the more we look at this photograph, so the differences between two similar identities widen. On a surface level the social reference appears fundamental; yet the more we observe, and the more we relate these 'twins' to the Arbus image, so the more they insist on *their* difference as individuals. Paradoxically, an anodyne image of sameness insists on its unique qualities. The social index, so basic to Sander's meaning, has all but been made invisible.

Midgets (1906) has a similar significance.[21] Sander here uses an image characteristic of Arbus's world. *Midgets* is distinct in its effect precisely because of its focus on the figure as a physical presence. And yet this is a difficult image. There is no background, no social context within which to frame the individual figures. In turn, Sander has, peculiarly, halved the photographic space. There is a perverse formality about this image – it questions those 'portraits' from an assumed 'natural' public world. This, by comparison, is an aberration. *Midgets*, as much as anything in Arbus, exposes difference; but difference here (*à la* Arbus) is in relation to an individual condition, not a social frame.

I want to offer one final comparison between Arbus and Sander, and I do so to stress both the *underside* of the Sander project, but also to suggest how problematic the terms of his social picturing are in relation to individuals, as distinct from his general imaging of identity. The two images I have chosen are, to my mind, especially provocative and problematic, not least because they recall another significant image: Paul Strand's *Blind Woman*. One distinct difference, however, is that these are *announced* portraits of the subjects. Both are aware of the camera and yet, of course, both are 'victims'. They confront the lens through their acknowledged absence of any public identity. Arbus explicitly questions that identity. As a 'victim' the subject confirms that status, and exists through, once again, a declared social difference. Here there is no assumed public self. Rather the social codes are reversed: the image is of a private condition made public. And thus Arbus plays consistently on masks, on the hidden, and on the ambiguity between public and private lives. But her imagery of the deformed and ill breaks such distinctions. Sander's images, however, always *return* to a definitive social world – and yet his 'Arbus' images suggest precisely the same condition as her photographs.

August Sander, *Victim of an Explosion, c.* 1930.

Arbus's *Masked Woman in a Wheelchair* and Sander's *Victim of an Explosion* (*c.* 1930) offer parallel images of 'victims'. Yet significantly, the Sander image is of a *social* victim – of an explosion. The figure has been disfigured by social effects – just like all those other figures in Sander's world of types and individuals. This is an extraordinary photograph; at once compelling in its realism and profound in its emotional sub-text. It is, in essence, an anti-text to the surface definition of Sander's photographic world. It is, in another context, Sander 'as' Arbus. The dress, for example, suggests a series of vertical or horizontal 'grids' which fix or define the Sander world. And yet the sense of the physical body and its 'face' empties such a public register of significance.

August Sander, *Secretary (Cologne)*, 1931.

What this maps is an image of feeling: an *interior* condition which undercuts the surface identity of so many Sander *exteriors*.

One might object that this is an extreme Sander image, on the very edge of the culture he sought to image in definitive and central terms. But then look at *Secretary (Cologne)*. Once again, this announces identity only to dislodge its significance. Looking at this image we ask in what ways this is an image of a 'Secretary'. The title is increasingly arbitrary. In turn the face, for example, portends not so much a female 'look' as a male image. Indeed it is made more incongruous by the richly decorated satin dress. In a different context this could be an Arbus portrait of a New York transvestite; such a possibility underlies the extent to which the casual title (*Secretary*) belies the *individual* context. As distinct from 'notary', for example, this splits away from any assured sense of social meaning. Furthermore, the figure is cramped, and the 'body' cut-off from the left-hand side. At every level this is an ambiguous and problematic image. The cigarette, for example, suggests an affectation more appropriate in a Sander portrait of an artist or revolutionary, and yet it returns us to the ambivalent nature of sexual identity, and this ambivalence echoes through the settled world of the Weimer portraits. It portrays the 'Secretary' as overwhelmingly individual, and in that sense this is an exemplary Sander image – not so much because it images social or sexual difference, but because it *admits* to difference and, ultimately, to the fact that portraiture is ambivalent. There is no 'uniform' here. A private life takes its place within a public space, but it does so (as in Arbus) from its individual self. For once a private, not public, identity inhabits the Sander frame.

5
Duchamp's Masquerades

DAWN ADES

The numerous photographs of Duchamp by friends and admirers inhabit a curious and ambiguous space in relation to his work. Although not technically his, the photos have begun to command a regular place in books and catalogues about him. In many, there is a high degree of connivance between Duchamp and the photographer. Duchamp was clearly instrumental in the conception of the photographs and stage-managed their effects. Some, like Man Ray's shots of Duchamp *en femme* dressed as Rrose Sélavy, have with obvious justification been discussed more frequently in the context of Duchamp's art than in the context of Man Ray's. A few photographs were incorporated into a specific work: Man Ray's image of Duchamp with shaving soap in his hair, for instance, which was used in Duchamp's *Monte Carlo Bond*, or the shot of Duchamp dressed as a woman which was incorporated into the Assisted Readymade *Belle Haleine*, and reproduced on the cover of *New York Dada*. But the level of engagement and, in some sense, of manipulation, remains high even in casual snapshots.

Duchamp posed willingly all his life for photographs, but there is a particular concentration of energy in his involvement with the camera in the period during and just after the First World War; significantly, two of the most interesting series – the shaving-soap portraits and the second set of Rrose Sélavy pictures mentioned above, date from 1923–24, the year following his final abandonment of work on the *Large Glass*, and his decision to give up art for chess. It was a period in which he was able fully to indulge his interest in the camera – in both photography and film – as a consequence of his close collaborative friendship with Man Ray. His practical involvement, however, seems to have gone no further than taking a few lessons from Man Ray, and once contemplating becoming an assistant cameraman. In fact his interest in photography has some parallels with the Readymades, in that he partly saw it as a new way of realising ideas outside the exercise of traditional skills. Although in this

sense relishing photography's 'automatism', it is also clear from his notes that he was fascinated by the technical side of the craft.

Evidently, the photographs we are talking about are portraits, in the elastic sense of the term (that is, not confining the term to studio poses). However, the conventional sense in which a portrait must bear a likeness to the sitter quickly comes under uncomfortable scrutiny. A comparison between the photo-portraits in question and other contemporary instances of the practice of portraiture highlights the ambiguity of Duchamp's self-presentations in photographs.

During the period we have been discussing, *c.* 1917–1924, Duchamp was the subject of portraits in a variety of mediums apart from photographs, some conventional, others not. Several were by women friends. Florine Stettheimer painted him; Elsa von Freytag-Loringhoven constructed her *Portrait of Marcel Duchamp* out of feathers and other found materials which sprout from a goblet.[1] This object seems to emerge from a marriage between the readymade and that odd family of dada portraits whose most famous examples include Picabia's object-portraits of his friends (Steiglitz as a camera, his wife Gabrielle as a windscreen, and so on). But the fact that it is constructed of objects fragmented and re-combined rather than being a single object bearing a symbolic relationship to the person represented, in the manner of Picabia's portraits, results in a suggestiveness that has more in common with the surrealist object.

Equally remarkable, though in a more conventional avant-garde mode, is Katherine Dreier's abstract painted portrait of Duchamp. Dreier, a close friend and patron, reproduced this portrait in her study of Western art, published in 1922, to provide a contrast with an 'old style' portrait of Duchamp in silverpoint by Joseph Stella (page 96). In the new style, she argues, the painter tries to express the character of the sitter through 'abstract form and colour': 'Thus through the balance of curves, angles and squares, through broken or straight lines, or harmoniously flowing ones, through colour harmony or discord, through vibrant or subdued tones, cold or warm, there arises a representation of the character which suggests clearly the person in question, and brings more pleasure to those who understand, than would an ordinary portrait representing only the figure and face.'[2] Dreier's rather over-anxious assertion of faith in the psychological potential of the painted portrait, provided the modern portrait painter possessed the deeper knowledge of psychology necessary in order to 'make a more profound study of his subject', attempts to recoup for painting the area that photography above all had usurped: the likeness, but now expressed in terms of abstractions inimitable by

Katherine S. Dreier, *Portrait of Marcel Duchamp*, 1922, oil on canvas.

Joseph Stella, *Portrait of Duchamp*, 1922, silverpoint.

photography. This claim that abstract painting can be more psychologi-
cally true than photography might have helped provoke Duchamp's ironic
response, in using photography as a disguise or mask to construct
alternative identities. Dreier's text, though, certainly indicates that the
question of psychological likeness in portraiture was still being debated, in
this case in terms of the expressive potential of abstraction.

The photographs of Duchamp that we are discussing challenge, in
different ways and with different consequences, precisely those assump-
tions made by Dreier about the potential of a portrait to summon up a
sitter, and reveal the 'truth' about him or her, whether physical or
psychological. Indeed they seem to declare the whole debate about
'likeness', as touched on above by Dreier, to be no longer relevant – or
perhaps, more correctly, to be exploitable in ways that shift the centre of
interest away from the sitter/subject and towards the mode of represen-
tation. Rather than revealing a unitary nugget of identity, these photo-
graphs disguise, dissolve, multiply and contradict.

Photography was the ideal alibi for changes of identity. In apparently
introducing a measure of authenticity, it was also prone to the kind of
paradox Duchamp enjoyed – as in the altered *Wanted* poster, to which
Duchamp added two mug shots, full-face and profile, smudgy and almost
illegible in the heavy tonal contrast, as though to demonstrate how
drained of identity even identity photos can be.[3]

Both Duchamp and Man Ray dressed up before the camera to change
identity. Duchamp masqueraded as his female alter ego; Man Ray, in
photographic self-portraits, posed both as a woman, and also as a priest.
(In the surrealist circles in which Man Ray moved his priest pose was a
deliberate act of sacrilege, a challenge to the social order to be understood
as parallel to the reversal of gender.)

Sometimes Duchamp used pose or props to suggest mythological or
legendary associations, Classical or modern. Robert Lebel mentions St
Sebastian, 'ce patron des artistes dont il a pris ironiquement la pose dans
une photographie de 1942';[4] Duchamp acephalic on his eighty-first
birthday and 'se couvrant à son niveau pubien d'un "birthday cake"
planté de bougies érectiles';[5] and the series of photographs taken in
London in 1937 with Mary Reynolds, in which Duchamp is mysteriously
swathed in a towel, only his head visible, like a shaved Medusa, with a
tape measure round his neck or protruding from his mouth.

These photo-portraits – almost self-portraits – are not a fixed group,
merging as they do at one end with the bona fide works and at the other

with family snapshots, but they constitute an arena in which Duchamp's interest in gender and in representation intersect.

I

Photo: Wall (morning)
 : My portrait in the bathroom mirror[6]

There is no satisfactory solution to the problem of how to photograph oneself looking at oneself in the mirror – that is, if the photographic apparatus is to remain concealed or an awkwardly angled shot is to be avoided. Such a photograph would, however, be the best way to represent Duchamp's observation that:

(see)
one can look at seeing
one can't hear hearing[7]

Duchamp hints, by giving alternative words to the action (*voir, regarder*), that although doubled it may not be identical. To photograph oneself and retain the look, to separate that look from the camera's eye, is evidently impossible. To be photographed looking into and in a mirror is possible.

Duchamp and his friend Henri-Pierre Roché discovered one version of a photographic mirror-trick in the popular photo-booths in Manhattan in 1917. With the aid of mirrors, and with the photographer and his apparatus concealed in the darkness behind the subject, 'as if the latter were the "mask" projected on the print', multiple simultaneous views were produced on a single negative.[8] However, it is rather the absence of the mirror plane than its presence that is remarkable here. Duchamp appears to be looking at himself, but not at himself looking at himself.

Duchamp's interest in the problem of the mirror self-portrait was shared by a number of photographers in the 1920s. But instead of experimenting with the kinds of technical and formal artifice or the games with reflection and reality practised by someone like Florence Henri, Duchamp sometimes chose to have himself photographed by his friend Man Ray in poses and guises that imply the presence of a mirror. There is no mirror visible, but the presence of one is a necessary component of the staging. The implied, but not actual, presence of the mirror also allows, as we shall see, a metaphorical dimension to the image to emerge.

In one such series of photographs (pages 100 and 101), Duchamp posed for Man Ray with shaving soap rising messily up from its

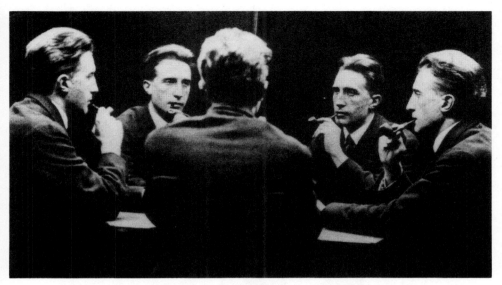

Henri-Pierre Roché, *Mirrored Multiple Photograph of Marcel Duchamp*, 1917.

accustomed place to cover his hair and lift it into wings. One shot from this series was used by Duchamp for his *Monte Carlo Bond* in 1924. Another has him staring fiercely straight ahead, not unlike a battered Wagnerian hero, in a pose which is in creepy contrast to the fluffy white soap.[9]

The image must have sprung from the idea of the 'self-portrait in the bathroom mirror' that Duchamp proposed, in his notes, as a possible subject for a photo – the place is specific and the action, the shaver's intimate scrutiny of his reflection, private. The bathroom mirror is the male counterpart to the dressing-table looking-glass, and in another group of photographs by Man Ray which also, I would argue, imply (perhaps less obviously) the presence of a mirror, Duchamp presents himself dressed as his female alter ego, Rrose Sélavy. Although not the first time Man Ray recorded Duchamp on film dressed as a woman, this particular set of images are the most emphatically self-admiring. They were taken in 1924, the same year as the male shaving-soap images, to which they act in quite direct ways as pendants. In the Rrose Sélavy photos, everything that signifies conventional femininity is emphasised, and the gaze at the camera lens operates as a replay of the mirror's confirmation of beauty.

There is a hidden linguistic pun which supplements the visual connection between these two photo-portraits. There was, Duchamp once

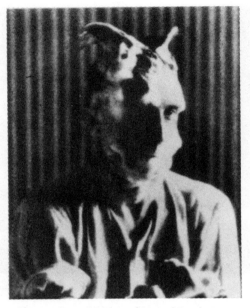

Man Ray, *Shaving Soap Portrait of Marcel Duchamp, c.* 1923–24.

noted, a '*femmes-savantes*' side to Rrose Sélavy: her male counterpart, then, would be an '*homme-savant/savon*', or soap-man.

This pair – the '*homme savon*' and the '*femme savante*' – are counterparts to one another. But are they just generated from linguistic games *à la* Roussel? Or do they represent one possible pair of poles out of which the male/female elements of the personality are constructed? Could they reveal hidden aspects of the subject?

The rendering strange in a mirror, though not quite obliterating likeness, invites speculation about recognition and identity. 'For the *imagos* – whose veiled faces it is our privilege to see in outline in our daily experience and in the penumbra of symbolic efficacity – the mirror image would seem to be the threshold of the visible world.'[10] The mirror enables the double to appear, 'in which psychical realities, however hetero-geneous, are manifested',[11] and Duchamp forces the mirror to realise those other identities, or psychical realities, fragmentary, ghostly, bizarre as they may be, which would usually only be accessible through those dreams or hallucinations which present us with what Lacan called the 'imago of one's own body'.

Duchamp's lathered head, about to be shaved (another portrait shows him with closely shaven head, and yet another with a star shaved into his

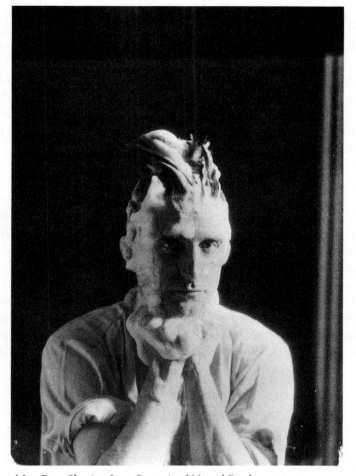

Man Ray, *Shaving Soap Portrait of Marcel Duchamp, c.* 1923–24.

hair), penitentially inverts his own whiskering of the Mona Lisa in *LHOOQ*, though it simultaneously demonstrates that the inversion or reversal cannot work – to shave a male does not reverse the bearding of a female.[12] But it de-sexualises/re-sexualises if understood as a symbolic equivalent to the castrative blinding of Oedipus.

These pendant photo-portraits, of the '*homme savon*' and Rrose Sélavy, hint at the Classical myths connected with mirrors and reflections – the myths of Medusa[13] and Narcissus. Each of these stories is laden with sexual ambiguity and threat. The myth of Medusa explores the threat of death by looking, concealing by one horror the other primal fear; in the

other legend the hero brings about his own death by falling in love with his reflection in a pool. In the *'homme savon'*, the soapy hair rising into wings at the side of the head resembles certain images of Medusa or the Gorgon's head, which have, above their snake curls, wings.

Duchamp, although aware certainly of Freud's spectacular and then still scandalous modernisation of ancient myths as bearers of his theories about primordial sexual complexes, was equally aware of the rupture between the modern world and the Classical tradition, a gap he signals by the comic and derisory translation of snakes into soap.

'We have an imperfect idea', Breton wrote in *Littérature* in 1920, 'of the Seven Wonders of the ancient world. In our times, a few wise men: Lautréamont, Apollinaire, have offered the umbrella, the sewing machine, the top hat, to universal wonder . . . With the belief that nothing is incomprehensible, and that anything, if necessary, can serve as symbol, we expend treasures of the imagination . . . I reckon that a true modern mythology is in the course of being formed.'[14]

More sceptical perhaps than Breton, Duchamp's photographs seem to relate to a modern mythology whose text is lacking or partial. They hint at fragments of a modern version of myths of sexuality and gender, man and machine, chance and order, identity and loss of identity, memory and forgetting ('make an allegory of forgetting', Duchamp once noted).

II

Il y a celui qui fait le photographe et celle qui
a de l'haleine en dessous[15]

In the version of the pun, 'Il y a celui qui fait le photographe et celle qui a de l'haleine en dessous', published by Breton in his *Anthologie d'humour noir*, Duchamp harks back to the title of his first appearance 'en femme', *Belle Haleine, eau de voilette* ('Beautiful Breath, Veil of Water'), with its overtones of concealment and death. The pun genders the relationship between photographer and sitter. 'There is he who acts as photographer, and she who has breath/wool beneath.'

The issue of gender identity was at the origin of the scandal created by Duchamp's *Nu descendant un escalier*. An interview in New York in 1916 under the headline 'Cubist Depicts Love in Brass and Glass: More Art in Rubbers than in Pretty Girl!' reported the following exchange between Duchamp and the woman interviewer: ' "Is it a woman?" this young but very world-weary Frenchman repeated after me . . . "No. Is it

a man? No . . . The Nude descending a staircase is an abstraction of movement." '16

Duchamp later gave a less teasing explanation of the significance of the nude's motion: 'The origin (of the painting) is the nude itself. To make a nude different from the classical nude, lying down, standing up, and set it in motion.' In motion, the nude loses the passive quality necessary for it to be an object of erotic contemplation.

It was precisely at this point of his interest in studies of movement, that photography first became important to him, in the form of the chrono-photography of Marey. After 1912, when, as he said, 'my hand became my enemy', photography became a resort, like the mechanical drawing he adopted at the same time, 'against the easy splashing way' of oil painting. The rigour, precision and impersonality of mechanical drawing was a corrective against the sentimental expenditure of pigment; on several occasions Duchamp implicated painting as a male activity whose 'splashing' way metaphorised so readily. He wrote to Stieglitz: 'You know exactly how I feel about photography. I would like to see it make people despise painting until something else will make photography unbearable.'17

In the major work on which Duchamp was still sporadically engaged until 1923, *La Mariée mise à nu par ses célibataires, même* (The Bride Stripped Bare by her Bachelors, Even), commonly known as *The Large Glass*, photography is implicated, utilised or posited at many levels.18 This cynical commentary, as Breton called it, on love, an elaborate metaphor of eroticism and passion, plays with ideas of sacrilege, art and the machine, through, among other things, active and passive modes. This tension between active and passive is one of the arenas in which photography is brought into play. In *The Green Box Notes* Duchamp described the whole thus: 'in the dark, we shall determine (the condition for) the extra rapid exposition (allegorical appearance) of several collisions seemingly strictly to succeed each other according to certain laws.'19 In the end, the contrast between the painstaking and labour-intensive methods used to transfer the planned images onto the glass surface, and the theoretical possibilities of the (extra rapid) photographic imprint, perhaps contributed to its final abandonment. The notes also indicate an oscillation between the notion of photographic plate and mirror, this analogy leaking into the very texture of the glass (part of the glass was silvered, and Duchamp referred to tarnish, or rust, appearing through the ground glass). 'Photograph', he suggests, 'mirror effects . . .'.

Many of the more specific references to photography in the notes to the

Marcel Duchamp, *Belle Haleine*, 1921.

Large Glass relate to the upper half, the domain of the Bride; Duchamp planned, in fact, to transfer the image of the Bride from his painting of 1912 photographically onto the glass.[20] This proving impractical, he painted it on in black and white. Photography is, in a sense, to the upper half of the *Large Glass* what mirrors and moulds are to the lower half. Photography, mirrors and moulds are all methods of reproduction:

Given the object, considered in its physical appearance (Color, mass, form).
 Define (graphically i.e. by means of pictorial conventions) the mould of the object.
 By mould is meant: from the point of view of form and colour, the negative (photographic); from the point of view of mass a plane.[21]

Thus, the very format and material of the *Large Glass* is a photographic analogue – two huge glass plates mounted above one another which recall the plate cameras using glass negatives that were still the normal mode at the time for portrait photography. In fact, the suspicion that the two halves of the glass are in some way self-portraits seems more and more relevant in the context of the photographs under discussion. The fact that Duchamp presented himself as both male and female in photographs

Marcel Duchamp, *Belle Haleine*, 1921 (cover of *New York Dada*).

might allow us to identify the Bride with Rrose Sélavy, the Bachelors with the male artist. This is in no way intended as an exclusive reading, but suggests a further dimension to the closed circuit of the work.

<div align="center">III</div>

> P.C : *When you were only twenty-five years old people already called you the 'bachelor'. You had a well-established anti-feminist attitude.*
>
> M.D : *No, anti-marriage but not anti-feminist. On the contrary I was normal to the highest degree! I had, rather, anti-social ideas . . .*[22]

Duchamp explained to Pierre Cabanne the genesis of Rrose Sélavy as follows:

I wanted in effect to change identity and the first idea that came to me was to take a Jewish name. I was catholic and it would be quite a change to pass from one religion to another! I didn't find a Jewish name I liked or found tempting, and suddenly I had an idea: why not change sex? It's much simpler! So, that was the origin of the name of Rrose Sélavy. Nowadays it may be alright, christian names change over time, but Rose was a really stupid name in 1920. The double R came from Francis Picabia's picture, you know, *L'Oeil Cacodylate* which Francis asked all his friends to sign . . . I think I put Pi Qu'habilla Rrose – arrose needs two R's, and I liked the second R that I added – Pi Qu'habilla Rrose Sélavy.
 It was all word games.[23]

In the 1960s, asked whether Rrose Sélavy made her last appearance with the *Jeux de mots* published by G.L.M. in 1939, Duchamp replied 'She's still alive; manifests herself little or not at all.'[24] Rrose Sélavy occasionally signed works, but her most prominent manifestations were through the photographs; as the female mannequin dressed in Duchamp's jacket and hat in the street leading to the International Surrealist Exhibition in Paris in 1938; and as the author of the puns whose double meanings are paralleled in Duchamp's own double identity.[25]

 These female masquerades have been discussed in terms of Duchamp's interest in the creative androgyne.[26] Arturo Schwarz, for example, quotes Lebel's comment that 'Man Ray made several photographic studies for this image which might suggest, in particular, the artist's inherent androgyny in the manner of Leonardo da Vinci, to whom Duchamp had paid homage in his own way by providing the Mona Lisa with masculine attributes',[27] and goes on to draw on Henry Lowenfeld, Freud and Jung to support his contention that Duchamp's apparent bisexuality is (as with

other great artists) the symbol of a creative union of opposites. Schwarz quotes from *Archetypes and the Collective Unconscious* as follows:

'As civilization develops, the bisexual primordial being turns into a symbol of the unity of personality, a symbol of the self, where the war of opposites finds peace. In this way the primordial being becomes the distant goal of man's self-development, having been from the very beginning a projection of his unconscious wholeness. Wholeness consists in the union of the conscious and the unconscious personality. Just as every individual derives from masculine and feminine genes, and the sex is determined by the predominance of the corresponding genes, so in the psyche it is only the conscious mind, in a man, that has the masculine sign, while the unconscious is by nature feminine.'[28]

There is no denying the force of the Leonardo comparison, and there is plenty of evidence to support Duchamp's recurring interest in the alchemical androgyne. However, before accepting this rather final blanketing of Duchamp's interest in gender under the heading of androgyny, I would like to consider some supplementary possibilities in connection with these particular photographs, which link them to a more extensive and pointed interest in contemporary debates about identity and gender difference. The androgyne is defined as uniting the physical characteristics of both sexes, or hermaphroditic. But, unlike Tiresias with his/her withered dugs, or the suspicious bulge Lyotard[29] claims to see in the groin of the splayed nude of Duchamp's *Étant donnés: 1. Le gaz d'éclairage, 2. La chute d'eau*, there is no evident dual sexuality in the photographs of Rrose Sélavy. Rather, pains seems to have been taken to disguise his gender, though with what success may be a different issue. If she is intended to 'reveal' the female side of the man, how far does this conform to the Jungian notion of the equation of the female and the unconscious? Are these the appropriate terms with which to approach these images? Or were there contemporary socio-anthropological debates in which Duchamp's transvestism could be seen as engaging with sexual difference in ways that challenge those stereotypes?

The first photographs Man Ray took of Duchamp dressed as a woman were part of the brief dada campaign in New York in 1921. The oval photograph in Duchamp's collection that was used for *Belle Haleine, eau de voilette*, is described on the back 'Marcel Duchamp en femme pour New York Dada (photo Man Ray) Spring 1921'.

From the start, then, this image was intended as a public manifestation in the context of dada. The chosen photograph was added to an altered perfume label and pasted onto a glass bottle, which was then photographed for the cover of *New York Dada*.[30] The title of the single issue of

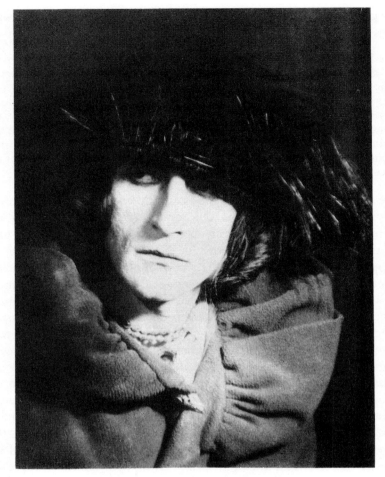

Man Ray, *Marcel Duchamp en femme*, 1921.

this review was then printed repeatedly upside down, giving an effect not unlike elegant wallpaper. This *monde renversé* trope is continued in the mock 'statement, authorisation' by Tristan Tzara, standing in for an editorial, whose addressee is consistently female. 'Therefore, Madam, be on your guard and realize that a really dada product is a different thing from a glossy label.' Dada's irritant iconoclasm and subversion is hilariously presented in this 'authorisation' as an article of intimate hygiene in a running metaphor drawn from fashion magazines: 'you need look no further than to the use of articles prepared without Dada to account for the fact that the skin of your heart is chapped; that the so

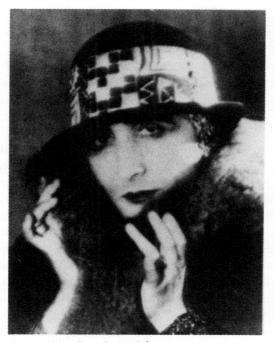

Man Ray, *Rrose Sélavy*, c. 1923–24.

precious enamel of your intelligence is cracking; also for the presence of those tiny wrinkles still imperceptible but nevertheless disquieting.'

The photograph of Duchamp as a fashionable woman recalls the frequent use of fashion as metaphor among dada artists ('change your ideas as you would a pair of trousers', as Picabia said), which both signals the ephemerality of taste and parodies the importance of fashion in the construction of the 'new woman' and the 'new man'.[31]

Duchamp was not the only dadaist to play with gender changes in self-portraits. Both Johannes Baargeld, member of the Cologne dada group, and Erwin Blumenfeld constructed photomontages in which their own head is placed on a female torso – in Baargeld's case, atop a Classical stone Venus, in Blumenfeld's, his own naked but veiled torso terminates in the lower half of a female nude. Neither attempts a full disguise, emphasising rather the comic of the impossible conjunction. By including references to the Classic female nude, however, they evidently allude to an artistic tradition whose dignity and superiority dada specifically sought to undermine ('Dada has given the Venus de Milo an enema', as Arp said[32]). In the dada context, a similar intention could be posited for

Duchamp. In his case it can be traced back through a long and combative engagement with the Nude of high art, whose classic double role as bearer of the ideal and of the erotic he progressively undermines. Photography was to play a part in this engagement at a number of levels.

The 1921 versions of 'Duchamp en femme' are not obviously transvestite images in the pantomine dame sense; anything monstrous in them derives rather from what Bataille called the anti-humanism of out-dated masquerades.[33]

In the photographic portraits taken a little later[34] of Rrose Sélavy, again by Man Ray, the image is more finely crafted, the pose no longer the awkward head-on view, but seductively modulated, hands framing the face or stroking the fur. The hands were, in fact, those of Germaine Everling, Picabia's companion. Francis Naumann has mentioned Charlie Chaplin's film *A Woman*, in which Chaplin 'impersonates a woman in order to gain entrance to the boarding house where his girlfriend lives',[35] as a likely inspiration for this photograph. This is quite convincing, but the pose and manner also bear a striking resemblance to the portrait studies of actresses and international beauties that alternated in the pages of *Vanity Fair* with articles by Gertrude Stein, Robert Benchley, Dorothy Parker and so on. Man Ray, who had taken up portrait photography in 1922, was now well-established in the social and intellectual world epitomised at the time by *Vanity Fair*.[36]

Naumann comments on Rrose's 'affected manner and poorly disguised identity', but in fact her manner/pose relates closely to fashion/theatre portraits in *Vanity Fair*, which emphasise a certain type of femininity, and which contrast markedly with other images of women in the journal. For example, those who made the Hall of Fame pages for outstanding achievements, such as Edith Wharton or Willa Cather, exhibit a direct gaze and business-like stance; they do not present themselves as objects for others' gaze in the same way as the actresses do. The photographers revelled in the actresses, manipulating their flesh and the light to create often quite fantastic, almost abstract, studies of a neck or a cheek (see, for instance, Genthe's portraits of Garbo). In such portrait studies the lens/mirror ambiguity is emphasised, as the narcissistic absorption in the specular image is exploited by the photographer/viewer's enjoyment of erotic promise.

However, while the pose Duchamp/Rrose Sélavy adopts may resemble that of the more feminine portraits, the eyes, it could well be argued, give the game away. They seem to assert control and consciousness, and it is there that the efficacy of the disguise falters. Perhaps therefore this does

clearly indicate the male presence, but rather than uniting in a Jungian wholeness, it is rather an interruption which emphasises difference.

Recent studies have brilliantly revealed the ways in which Duchamp's 'cubist' works – especially *The Bride* – make explicit the aggressive misogyny, perhaps unintentional, of cubist renderings of the female body, and also how far the scientific and religious framework in which *The Bride* is held, in the context of early twentieth-century France, exposes the socially constructed nature of gender.[37]

The photographs of Rrose Sélavy in fact coincide with Duchamp's temporary abandonment of art, the 'other' of the male painter. Rrose Sélavy, appearance carefully gauged to reveal the socially constructed nature of attitudes to sexuality, radically opposes the timeless beauty of the Classical female nude.

Duchamp's interest in making this explicit may have received a stimulus from the different context of New York. It is possible that a different climate of gender relations had its effect on Duchamp's thinking about the subject. Duchamp remarked on his arrival in New York, 'The thing which has struck me most in this country, which has undoubtedly the most beautiful women . . . is the lack of really strong emotions in your men. An American, for instance, if he has to choose between a business appointment and an engagement with the woman he loves, rings her up on the telephone. "Hello, dear", he says, "I can't see you today; I must go to the bank instead." To a Frenchman that seems very stupid.'[38] This casual comment on cultural difference might be seen to mask some ambivalence on Duchamp's part towards the different relationship between the sexes as expressed socially.

Debates about female emancipation and equality between the sexes were more intense in the United States and in England at the beginning of this century than in France. (It is significant that in both countries some women had received the vote by 1920, whereas in France there was no female emancipation until after the Second World War.) Concomitant with this was a sharper debate about the nature of 'womanliness', which frequently took the form of an attempted reconciliation between the notion of enduring feminine qualities and the 'new woman'. In the English magazine *Vanity Fair*, the 'new woman' was advised on the true nature of 'womanliness': 'the truly womanly woman is she who is resolved that her life shall be the full and free expression of the best that is in her.'[39] James Joyce expresses some of the male anxiety at the collapse of the clear equation between biological and social difference, and at the recognised presence in varying degrees of male and female characteristics

in everyone. Leopold Bloom, in his nightmare, is medically affirmed as a 'finished example of the new womanly man.'[40]

Havelock Ellis first published *Man and Woman: a study of human secondary sexual characters* in 1894, and it has rarely been out of print since. Havelock Ellis was moved to undertake his massive research project for social reasons, in order, as he put it, to clear away superstition and prejudice and knock on the head once and for all the absurdity of speaking of the superiority of one sex over another.[41] His careful and sceptical scrutiny also has the effect of de-stabilising stereotypes. There is obviously much of interest here, but two arguments in particular might have struck Duchamp. Firstly, Havelock Ellis's socio-anthropological account of one of the causes of the subjection of women: 'While women have been largely absorbed in that sphere of sexuality which is Nature's, men have roamed the earth, sharpening their aptitudes and energies in perpetual conflict with Nature. It has thus come about that the subjugation of Nature had often practically involved the subjugation, physical and mental, of women by men.' While holding to the inevitability of some equation of nature/female, Havelock Ellis situates it in terms of an historical process which leaves man in possession of anachronistic characteristics and an unjustifiable assumption of superiority.

The second point would demand more space to discuss fully in relation to Duchamp, but can be seen to throw a somewhat unexpected light on his play with mechanisation and his machine/gender metaphors: 'Savagery and barbarism have more usually than not been predominantly militant, that is to say, masculine, in character, while modern civilisation is becoming industrial, that is to say feminine in character, for the industries belonged primitively to women, and they tend to make men like women.'[42] After an exhaustive psychological and anthropological investigation of the sexual differences between man and woman, Havelock Ellis concludes that it was not possible to determine the 'radical and essential characters of men and women uninfluenced by external modifying conditions'.[43]

The new conditions in which sexual and social equality were freely debated were accompanied by a greater degree of female independence. Katherine Dreier, in her account of a journey to Argentina, where Duchamp was also spending some time, described her shock at the treatment of women there, and their lack of freedom by contrast with their position in the United States.[44] But these conditions also created new tensions. 'The woman movement', as the feminist Ellen Key wrote in 1912, 'has now raised a partition between the sexes such as is found in

the aquarium, where it becomes necessary to teach the pike to allow the carp, also, to live.'[45]

Where can Duchamp's female persona, then, be positioned in relation to this state of affairs? How far might he be sharing the socio-political concerns of Havelock Ellis, Dreier or Ellen Key? As a deliberate display of socially constructed, artificial, sexual difference, how far can Rrose Sélavy be seen as critical of socially determined attitudes to femininity and womanliness? The photographs of Rrose Sélavy could be seen to focus on difference in a logical extension of Duchamp's enquiries into identity and the challenges to the symbolic order. As Kristeva says, 'the apparent coherence which the term "woman" assumes in contemporary ideology . . . essentially has the negative effect of effacing the differences between the diverse functions or structures which operate beneath this word.'[46]

The exaggerated femininity of the Rrose Sélavy photographs, curly hair touched in with a pen, and so on, calls to mind Joan Rivière's text from the end of the 1920s, 'Womanliness as Masquerade': 'In daily life types of men and woman are constantly met with who, while mainly heterosexual in their development, plainly display strong features of the other sex. This has been judged to be an expression of the bisexuality inherent in us all . . . I shall attempt to show that women who wish for masculinity may put on a mask of womanliness to avert anxiety and the retribution feared from men.' The subject of this case study was an intellectual woman (a *femme savante*). As Rivière notes, 'Not long ago intellectual pursuits for women were associated almost exclusively with an overtly masculine type of woman . . . This has now changed. Of all the women engaged in professional work today, it would be hard to say whether the greater number are more feminine than masculine in their mode of life and character.' Rivière's patient was given to excessive displays of coquetry after successful professional engagements, which are analysed as an unconscious attempt to ward off reprisals from the father figures whose masculinity she had stolen. She dreamt of people putting on masks to avert disaster. 'Womanliness therefore could be assumed and worn as a mask, both to hide the possession of masculinity and to avert the reprisals expected if she was found to possess it . . . The reader may ask how I define womanliness or where I draw the line between genuine womanliness and the "masquerade". My suggestion is not, however, that there is any such difference; whether radical or superficial, they are the same things.'[47]

Duchamp's Rrose Sélavy might, then, be positioned in relation to such

contemporary socio-political and psychological debates about gender
and identity, which contributed to the destabilisation of assumptions
about masculinity and feminity. Both Duchamp's first idea of switching
religious identities, and then his idea about changing sex, were deliber-
ately disruptive and also denote an imagined shift away from a position
of dominance, but to test out the freedom to change identity is to
introduce in a characteristically ironic form the limits reached immedi-
ately by such an appeal to freedom. So perhaps, after all, Duchamp's
apparent attempt at disruption is simply the assertion yet again of his
control. As the anarchist Max Stirner, who Duchamp admired, wrote:
'The craving for a particular freedom always includes the purpose of a
new dominion.'[48]

J. P. Morgan's Nose:
Photographer and Subject in American Portrait Photography

ERIC HOMBERGER

The portrait photograph is never accidental, never something found by accident. It is arranged, agreed upon. At the heart of the occasion is a contract between the subject and the photographer. It is surprising how little we know of the constructive dynamics and power relations of the portrait. Thinking about these relations in terms of a contract has implications for the way we understand what happens between the two parties. The subject *consciously* consents to the occasion. Portraits of infants and children, of the mentally retarded and of 'natives' – involuntary or culturally unequal portraits – lack that crucial element of self-awareness and understanding.

It is necessary to stress the element of self-awareness in the portrait because it is such an ambiguous aspect of the transaction. We are inordinately skilled at sensing false poses, recognising how they are the product of convention and taste. Only the naïve would suggest that the stiff formality of the nineteenth-century studio portrait was an expression of the sincere being of the subject. We are more likely to regard the pose as an expression of the socially or culturally constructed self – in other words, the resulting portrait, produced in millions for a mass market, is an emanation of the false consciousness of the age. As Lionel Trilling has so powerfully suggested, for various reasons we prefer our conception of the 'authentic' over an older notion of the 'sincere'.[1] But this obscures the essential feature of the portrait, the contract, which seems to grant the subject an equality of rights.

Consent or contract does not necessarily imply a congruence of motives or sympathies. The formality of consent (so manifestly central to the *practice* of the portrait) expresses itself in several kinds of arrangements. In a commercial sense, the contract confirms the consumerist rights of the subject to accept or reject the portrait, to buy it for use or

simply to throw it away as unacceptable and replace it by another. A commercial portrait thus has a clear, indeed a potentially tyrannical, relationship to the wishes of its subject. But there are important examples within the commercial portrait where the power relations are cloudier or undecided. These uncertain occasions provide rich material for an analysis of the dilemmas faced by American portrait photographers.

Beginning work as a professional portrait photographer in New York in 1903, Edward Steichen was commissioned to do a photograph of J. Pierpoint Morgan, banker and creator of the United States Steel Corporation. His description of the session must be the *locus classicus* for the consumerist version of the power relations between photographer and subject:

Morgan arrived with [the painter Fedor] Encke, took off his large hat, laid a foot-long cigar on the edge of a table, sat in the chair . . . and took his habitual . . . pose. After a hasty look at the ground glass I said, 'Still', and made the two- or three-second exposure required. Then, I took over the making of a negative for myself. I suggested a different position of the hands and a movement of the head. He took the head position, but said, in an irritated tone, that it was uncomfortable, so I suggested he move his head to a position that felt natural. He moved his head several times and ended exactly where it had been 'uncomfortable' before, except that this time he took the pose of his own volition. But his expression had sharpened and his body posture became tense, possibly a reflex of his irritation at the suggestion I had made. I saw that a dynamic self-assertion had taken place, whatever its cause, and I quickly made the second exposure, saying, 'Thank you, Mr Morgan', as I took the place holder out of the camera.

He said, 'Is that all?'

'Yes, sir', I answered.

He snorted a reply, 'I like you, young man. I think we'll get along first-rate together.' Then he clapped his large hat on his massive head, took up his big cigar, and stormed out of the room. Total time, three minutes.

Steichen was paid $500 for the sitting. When he made prints from the session, he found that Morgan's 'huge, more or less deformed, sick bulbous nose' utterly dominated the portrait. In his adolescence acne rosacea had taken root in Morgan's nose, which became progressively more enlarged and inflamed. As he grew older the shape of his nose changed, taking on a cauliflower texture. It featured in countless caricatures of the banker; and was linked in many anecdotes with Morgan's fierce temperament. Various treatments were attempted, including an electric remedy suggested by European royalty, but Morgan was unable to find a cure. In later life he became somewhat philosophic about his protuberance. 'Everybody knows my nose,' he remarked to Count Witte, 'it would be impossible for me to appear on the streets of

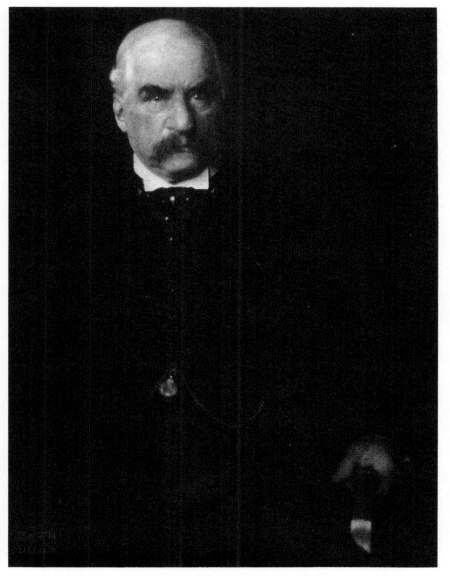

Edward Steichen, *J. P. Morgan*, 1903.

New York without it.' He was even capable of making jokes about it: his nose, he once remarked, 'was part of the American business structure'. It was invariably touched up in official photographic portraits.[2] Steichen nervously contemplated the dilemma posed by Morgan's nose:

What kind of man was Mr Morgan in this respect? If I should retouch the nose, he might be angry about it. However, the only picture that I had seen reproduced frequently was a portrait of him made by one of the Fifth Avenue photographers in which he had been given a beautiful neat Roman nose. So I took the negative that I had made for Encke and retouched that nose as much as I dared. On the good negative that I made for myself I did very little retouching, except to make the nose a little more vague and remove spots that were repulsive.

When I took the proofs to Morgan, he thought the one I had retouched for Encke was fine, and he ordered a dozen prints. Then he looked at the other print that I had made for myself. He said, 'Terrible', and tore it into shreds.[3]

There were several kinds of lesson which a young photographer might learn from such an interview. That the rich were overbearing was naturally a useful thing to know. Steichen was so annoyed by Morgan's destruction of the unretouched proof that he made a large print, gave it to Stieglitz, and was pleased to see it prominently displayed in the latter's gallery at 291 Fifth Avenue. (It was eventually given to the Museum of Modern Art.) The banker glowers out from the image with a fierceness which many felt to afford a profound insight into Morgan's fierce and aggressive character. The portrait of Morgan interestingly shows the subject's left hand gripping the arm of a chair. In the photograph the light reflected from the arm looks wonderfully (and appropriately, in the opinion of Morgan's critics) like a dagger. Steichen rejected this 'fanciful interpretation'. Informed about the (unretouched) photograph on display at Stieglitz's gallery, Morgan sent his librarian to borrow the portrait so that he might see it. Forgetting that he had once thought it 'terrible', Morgan offered Stieglitz $5,000 for the print, but was refused: a small victory for art over Mammon. It took several years of cablegrams and letters before Steichen agreed to make a group of prints for Morgan.

Steichen learned from this experience that it was necessary for the photographer subtly to steal the fleeting mood and expression from a subject determined to impose his or her own preferences upon the occasion. The interpretative portrait aims not merely to document but to seek to have people 'reveal themselves to the camera and express something about themselves which definitely exists, though it may be hidden – perhaps even from themselves?'[4] There is a struggle for control of the product implicit in the occasion of portrait photography. J.P.

Morgan assumed that his wealth and position ensured his complete control of the portrait. Despite the substantial fee, and promise of more, Steichen insisted upon the primacy of the portraitist. 'The sitter is suspicious of the objectivity of the camera', wrote Cartier-Bresson, 'while what the photographer is after is an acute psychological study of the sitter.'[5]

The power relations between Steichen and Morgan suggest that the relations between subject and portrait photographer are not easily regulated by contract; they can be complex and sometimes unpredictable. Consider the portraits of three American photographers: Alfred Stieglitz, Doris Ulmann and Edward Weston. Stieglitz's photographs of Georgia O'Keeffe (page 120) remain touchstones for any consideration of American portrait photography. For a decade and a half from 1917, when they first met, he made love to O'Keeffe through the camera. While they lived together in his skylight studio, he photographed her hour after hour, in every mood and pose. Wartime shortages of photographic paper forced Stieglitz to use glass plates that required three or four minute exposure times. It was physically exhausting to pose for hours; it was also a symbolic expression of the passion he felt for O'Keeffe; and the portraits were an act of possession. 'I was photographed with a kind of heat and excitement', O'Keeffe recalled.[6] One of his biographers has argued that Stieglitz's 'unique and continuous use of her body', was a 'formal acknowledgement' of their feelings for each other, feelings mutually reciprocated.[7] The images are bold, erotic, sometimes charmingly affectionate – and are masterpieces of 'straight' photography. (Stieglitz boasted that the prints were so sharp that you could 'see the pores' in O'Keeffe's face.[8]) The relationship between Stieglitz and O'Keeffe shares nothing of the antagonistic struggle between Steichen and Morgan. The strength of *involvement* gives his portraits their unique and passionate intensity.

Among the New York photographers who remained unsympathetic to the modernist enthusiasms of Stieglitz and his circle, Doris Ulmann, a disciple of the pictorialist Clarence H. White, was the wealthiest and the most socially eminent. Like Julia Margaret Cameron, Ulmann shamelessly used her social position to entice and browbeat worthies in the New York cultural scene into posing in her studio. But she grew increasingly discontented with 'personality' portraits, and before her divorce in 1925 she journeyed into nearby rural areas outside New York City in search of older 'national' physical types. On these expeditions she was accompanied in her automobile by her maid and chauffeur. A fractured

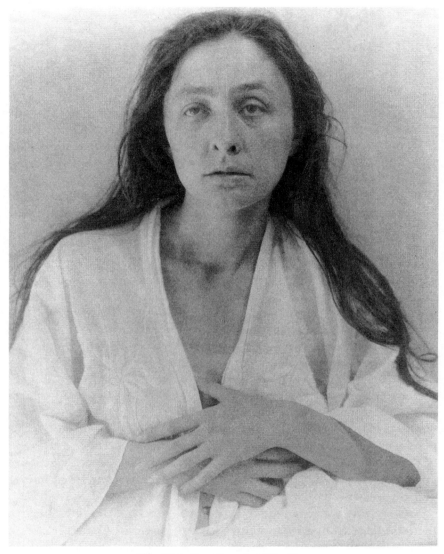

Alfred Stieglitz, *Georgia O'Keeffe:*
A Portrait, 1918.

kneecap in 1926, which left Ulmann dependent on a cane, led her to search for someone who could haul her heavy photographic equipment, and who would serve as a guide to even more remote regions of the United States. John Jacob Niles, a semi-successful singer from Louisville, Kentucky, who was interested in preserving the traditional popular songs of the Appalachian region, was hired by Ulmann as her guide and photographic assistant. (The relationship inevitably amounted to more than that.) Their extended journeys into the Appalachian mountains involved Ulmann travelling in her cloth-topped Lincoln with her chauffeur and the photographic equipment and materials necessary to develop exposed glass plates in darkened hotel rooms. Niles drove his own car. In remoter areas they transferred to horseback. At least on one occasion, Niles carried her piggy-back across a creek in Kentucky. She so enjoyed the experience that it was performed again to be photographed. Ulmann's relations with her rural subjects inevitably had about them something of the *grande dame*. She was a New York aristocrat taking sympathetic interest in some of the poorest of the rural poor. She made no payment to her subjects but tried – without always succeeding – to give each of her sitters a print. At the end of each expedition, hundreds of plates remained to be developed in the long winter months in New York.

Ulmann met the novelist Julia Peterkin in 1929, and was invited to photograph the people about whom Peterkin was then writing, the Gullah blacks who lived in the remoter areas of South Carolina. A native of South Carolina, after the death of her mother Peterkin was raised by a woman of colour who spoke Gullah. In 1928 her novel about the Gullah, *Scarlet Sister Mary*, won the Pulitzer prize for fiction. Ulmann travelled to visit the Gullah in 1929 and 1930. She had previously photographed mountain people, and had done portraits in Dunkard and Mennonite communities near New York, but the Gullah, with their distinctive dialect, represented a more challenging problem. During her first journey to South Carolina in 1929, reflecting on a week in which she had taken pictures in Charleston before heading towards the Gullah, she wrote to a friend in New York of the difficulties she had experienced:

It seems to be exceedingly difficult to get the studies in which I am interested here. The place is rich in material, but these negroes are so strange that it is almost impossible to photograph them. So this is rather a strenuous affair and then I do not feel satisfied! . . .

I think the people in Charleston are rather difficult because they are so very self-conscious . . . There are a number of authors here, John Bennett is one and I shall probably do his portrait today. It will be a rather pleasant diversion after my hunt for Negro types.[9]

Ulmann liked to pose her subjects in such a way that the setting conveyed something of their identity. They appear in the midst of signifying props: blacksmith's equipment, tobacco leaves, stacked ears of corn, spinning wheels, barrels and washboards. 'I am a farmer,' these pictures say, 'I live on the land; with these gnarled hands I have earned my daily bread.' Whatever signs there were that modernity had arrived in the South Carolina hinterland, Ulmann erased. No cars, electricity, radios. She sought out clothes of an earlier age for her subjects to wear, and posed them among props which conveyed an anachronistic message about rural virtue and handicrafts.[10] In the few pictures that directly portray work, the objects of employment are convenient signs to explain the subject: a cotton-picker leans across his tied bag of cotton; another shows a man holding a string of small fish in his right hand and a large fish slung across his shoulder. One of her South Carolina pictures shows a young black woman preparing asparagus for trimming to uniform length. Most convey people in moments of repose and reflection.[11]

The tone of Ulmann's portraits in South Carolina is gentle, rural and placid. Her work there, and elsewhere, is an exercise in ruralist nostalgia, embodying a radical selection from the lives of South Carolina blacks which largely represented her own vision of a world that was vanishing. The industrial workforce, which was growing rapidly in the South in the 1920s, finds no reflection in Ulmann's pictures. Rather, her images suggest a largely self-sufficient, pre-industrial rural world untouched by the alienation and dislocation of the 1920s. These images are culturally significant because they address so many of the anxieties of the decade – the decline in the rural population, the role of the blacks in the emerging urban and industrial culture, and the pervasive fear that a rootless and anomic self had finally usurped the older sense that Americans best knew who they were when they were on the land. The photographs largely share the concerns of the Agrarian intellectuals grouped around John Crowe Ransom and Allen Tate at Vanderbilt University in the 1920s, but Ulmann's evident sympathy for the blacks would not have easily fitted into their manifesto, *I'll Take My Stand* (1930).

There are many examples of photography that construct and represent the 'colonial' or 'native' subject from virtually every period of Western culture in the past century and a half. The concerns that led to photographers seeking out 'native' subjects also led them to domestic equivalents like the Gullah. The work of Peter Henry Emerson among Norfolk 'peasant types' (*Life and Landscape on the Norfolk Broads,* 1887) and Edward S. Curtis's photographs of native Americans (*The*

North American Indian, 1907, 1916–22) are important examples of this way of seeing 'natives'.[12]

A striking exception to this prevailing mood is Ulmann's picture of a black man in overalls on which a button is fastened ('License' is the only legible word), and of a younger black woman wearing a white cotton dress and a cloche straw hat. She is looking down, with her lips tightly pursed, and is holding a man's wide-brimmed black hat. Why is she so discontented? The man, his left hand wrapped around a support pole (they are standing on a covered porch), is looking at the young woman. Are they father and daughter? We run through the possible narratives that might explain the relationship portrayed in this elusive image, without being able to know with certainty anything about these people – except one thing. The man's left arm is missing; it has been amputated. His expression is one of dignity and strength.[13]

Edward Weston's portraits work best in those cases where he had some intense sympathetic or erotic relation with his subjects. In November 1924, D.H. Lawrence agreed to call at Weston's studio in Mexico City. Weston described the visit in his *Daybooks*. Lawrence was a 'tall, slender, rather reserved individual with a brick-red beard. He was amiable enough and we parted in a friendly way, but the contact was too brief for either of us to penetrate more than superficially the other: no way to make a sitting. Perhaps I should not have attempted it; now I actually lack sufficient interest to develop my plates.'[14] When he did manage to make some prints from the sitting they were out of focus. Lawrence seemed happy enough with one, a portrait in profile, but it was a botch to Weston.

When he was not forced to work purely for money, his relationship to his (human) subjects was one of aesthetic eroticism – though 'erotic aestheticism' seems equally appropriate. The various accounts in his *Daybooks* of the transaction of portrait photography are at their most interesting when the duality of his motives could be least concealed. He recorded in his notebooks a session taking Tina Modotti's portrait:

. . . she leaned against a whitewashed wall – lips quivering – nostrils dilating – eyes heavy with the gloom of unspent rainclouds – I drew close – I whispered something and kissed her – a tear rolled down her cheek – and then I captured forever the moment – let me see – f8 – 1/10 sec. KI filter – panchromatic film – how brutally mechanical and calculating it sounds – yet really how spontaneous and genuine – for I have so overcome the mechanics of my camera with my brain that it functions responsive to my desires – my shutter coordinating with my brain is released in a way – as natural as I might move my arm – [15]

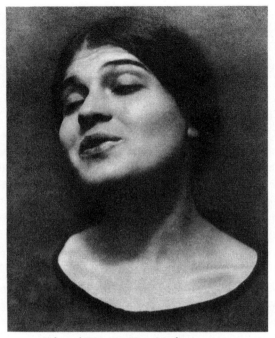

Edward Weston, *Tina Modotti*, 1924.

It was his ability to switch, in mid-impulse, from the lover to the 'brutally mechanical' technical concerns of the photographer that gives Weston's portraits their irresistible flavour.

Bertha Wardell, a dancer and teacher of dance, wrote to Weston offering to pose for him. Their 'Tuesday' sessions together, in which she danced for him in the nude, in due course had an erotic culmination. But when she first posed, Weston looked at her as he might contemplate an interesting, complex object: 'As she sat with legs bent under, I saw the repeated curve of thigh and calf–the shin bone, knee and thigh lines forming shapes not unlike great sea shells – the calf curved across the upper leg – the shell's opening. I made this – cutting at waist and above ankle.'[16] An even more extreme example was the set of portraits he did of the dancer Fay Fuquay, who had seen his photographs of Bertha Wardell, and similarly offered to model for him:

She bent over forward until her body was flat against her legs. I made a back view of her swelling buttocks which tapered to the ankles like an inverted vase – her arms forming handles at the base. Of course it is a thing I can never show to a mixed crowd. I would be considered indecent. How sad when my only thought

was the exquisite form. But most persons will only see an ass! – and guffaw as they do over my toilet.[17]

Weston's biographer correctly suggests that what is revealed in these very great photographic portraits 'is not the personality of the sitter; and not the personality of the photographer, either. Instead, it is an invisible, indefinable interaction of the two. There are portraits by other photographers which are portraits not of the sitter, but of the photographer, either dignified or clownish; and there are competent portraits which are neither – merely, and generally, highly commercial images. But photographs become something more when they are a record of the interaction of the photographer and subject.'[18] Weston's commercial work – he largely earned his living from tourists visiting his studio in Carmel, California, during the summer – was prefaced by a stern assertion of the primacy of the portraitist. Customers were required to sign a release form that read, 'It is understood that prints are to be finished according to my personal judgment.'[19] The lessons of Steichen's struggle with J.P. Morgan had been well-learned.

The sexual and emotional charge which gives life to Weston's portraits is utterly unlike the distance (cultural, racial, geographic) which separated Ulmann from her subjects. Is this element of sexual desire, or at least of sexuality, a necessary dimension of photographic portrait? The portrait as Weston conceived it emerges out of the emotional force and intensity of the transaction between photographer and subject. Perhaps it is less sexuality as such than the 'invisible, indefinable interaction' which defines the ideal relationship between the photographer and subject. The diverse artistic and photographic traditions upon which the portraitist draws are certainly part of the story – but only part. 'The portrait', according to Dorothea Lange, 'is made more meaningful by intimacy – an intimacy shared not only by the photographer with his subject but by the audience.'[20]

Stieglitz and Weston suggest how central a motive 'intimacy' has been in defining the achievement of the American photographic portrait. No explicitly photographic contract can legislate for desire, nor can the forms of desire be assumed to fall tidily into conventional patterns. Robert Mapplethorpe's self-portrait, with the handle of a bull-whip stuck into his anus, suggests the point. Perhaps no portraits are more perplexing than the nude photographs of Lee Miller taken by her father Theodore. A stereoscopic photograph, taken in 1928, portrays Miller sitting with her head sharply turned to her right, and her arms interlocked

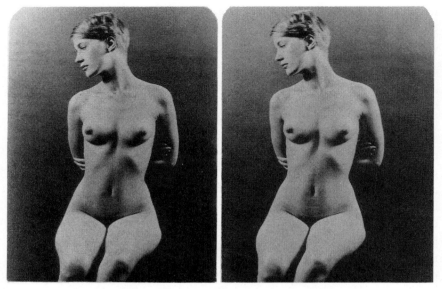

Theodore Miller, *Stereoscopic Photograph of Lee Miller*, 1928.

behind her back. The pose, which pulled Miller's shoulders back and thrust her breasts forward, draws upon the provenance of images from fine art as well as from pornographic material. Theodore Miller's portrait is an 'Orientalist' image of the nude female in the tradition of Jean-Léon Gérôme's painting, *Oriental Slave Market*. The 'bondage' content of his daughter's pose is equally obvious. Such pictures function within the male fantasy of absolute possession of women's naked bodies.[21] Lee Miller's face is expressionless. She is displayed here before the man with whom she had the most intense ties. Yet the absence of expression is itself disturbing, for it embodies a narcissism, a disconnection from the fact, which everyone who looks at the image cannot forget, that she is posing here for her father. Weekend visits with girlfriends to her family home at Kingswood Park, Poughkeepsie, New York, would usually involve nude photographic sessions. Theodore 'begged' her friends to pose together for him; it was his 'secret passion'.[22] Even while living with Man Ray in Paris (who also found her an incomparable nude subject), Lee resumed nude photographic sessions with her father when he came to visit. There is nothing in the photographs themselves that indicates the relationship between the subject and the portraitist, yet when we are aware of the 'contract' between a father and daughter which made them possible, the images become highly charged with new meanings. 'Family' photographs

are almost always constructed from a similar range of relationships. But Theodore Miller's portraits of his daughter are much more disturbing, for they calmly transgress the many other kinds of contract that normally govern relations between parents and their children.

Weston also took nude studies of his children. His *Torso of Neil*, 1925, is strongly cropped at the shoulder and pelvis of the subject. The experience of looking at this photograph is centrally shaped by Weston's pictorial instincts. 'Looking at this lovely picture', remarked Janet Malcolm, 'one feels something of the emotion one feels in looking at a Greek statue.'[23] There are certainly other ways of looking at this image, but, as Malcolm suggests, *Torso of Neil* emerges out of an aestheticism. The artistic tradition within which Weston works establishes a meaning for the photograph that *detaches* it from the structure of personal relations, and thus aestheticises the erotic content of the image. Aestheticism is a distancing strategy, a way of safely handling certain explosive emotional and erotic questions. The obsessional enthusiasm of Theodore Miller suggests no such motive.

Some portraits similarly effect their distancing by the suggestion of a context, a framework within which to understand the subject. The painter stands amidst a chaos of materials; a movie star slouches across a bed in a hotel bedroom; a distinguished writer, sitting barefoot on a sofa, stares across the room at the photographer; a novelist, cigarette in hand, has swung his left leg over the arm of a tall chair; another reclines in a leather chair: these are among the portraits which Diane Arbus made in the early 1960s for *Harper's Bazaar, Esquire*, and other magazines. They are informal portraits, with natural lighting.[24] We recognize the subjects, or most of them, but what comes through them is an unengaged professionalism.

Arbus's husband, Allan, worked in fashion photography, the most extravagantly demanding form of commercial work, but he really wanted to become an actor. Their marriage began to break down after the summer of 1959. But she was virtually unable to earn money with her camera. Arbus had briefly studied photography with Berenice Abbott and Alexey Brodovitch, but it was only during her lessons with Lisette Model in 1957 that she made a decisive advance in her command of the medium.[25]

Arbus's first images, of giggling children and sideshow curiosities, were too quirky for art directors, who were equally alarmed by the photographs of Robert Frank. (*The Americans* was first published in France in 1958.) Emile de Antonio took Arbus to see Tod Browning's *Freaks*

(1932), which was being revived in New York in the late 1950s. It was a movie which attended to something in her subconscious in a way that little else in contemporary American culture could do. Commercial assignments, like her portraits of actors and writers, were simply 'work'. In the evenings she prowled New York, riding the subway, talking to bag ladies and to tramps resting in the bowels of Grand Central Station. These 'weirdos' fascinated her. Arbus repeatedly visited the Ringling Brothers circus when it played at Madison Square Garden, and adored Hubert's Freak Museum, a fixture at 42nd Street and Broadway since the 1930s. An assignment to take fashion pictures for *Harper's Bazaar* was followed by a visit to a nudist camp for *Esquire* – the fashion pictures were published, the nudist camp studies were not. The commercial constraints that the major magazines imposed (*Life*, for example, was only interested in up-beat stories) left Arbus profoundly divided. Her hundreds of photographs of pinheads, giants, fat ladies, Congo the Jungle Creep, and the lady in the sword box, were regarded as profoundly uncommercial work in the late 1950s and early 1960s.

Although she adored the fakery of the sideshow, and the camaraderie of its grotesques, approaching such people was fraught with difficulties. The tramps, who did not expect such attention from a frail, white, middle-class Jewish lady, were more open than the circus performers:

When she first approached the freaks offstage with her cameras, they stared at her blankly; they seemed haughty, taciturn; they didn't feel comfortable with a 'normal' in their midst. She was gentle and patient with them, coming in every day, talking with them until they got used to her and 'she became almost one of the gang', says Presto, who was performing his fire-eating act at Hubert's then. Once she felt the freaks trusted her, she asked them to pose.[26]

Arbus's empathy, and the trust earned between the photographer and subject, dissolved the tensions implicit in the occasion, and thus led to one of the most remarkable *oeuvres* in portrait photography. Another interpretation of this scene would stress the photographer's deftly cynical manipulation of the freaks. Thus Mick Gidley finds that 'there is, all told, something profoundly exploitative about these images'.[27] Arbus may have begun as a humble, polite, empathetic photographer, but the aggression and brutality of her later work suggests that she did not long remain demure. Commenting on Arbus's 'grotesque photographic rape' of Germaine Greer, Estelle Jussim describes Arbus as 'a brutal little savage.'[28] But perhaps we should remember that her subjects were performers, public people, who posed willingly. Arbus had earned their consent. And if the viewers of the photographs saw them in contexts far

removed from the theatrical – indeed, saw them as quite different kinds of 'freaks' to those that Arbus had come to know – there was nothing she could do about it.

Arbus met Joseph Mitchell, whose profiles of eccentrics in *The New Yorker* provided her with a fund of information. In particular, Mitchell explained the hierarchy among freaks, their class distinctions (as between those born, and those 'made' by tattoo). Mitchell urged Arbus not to romanticise freaks, but she found that her own inclinations were in collusion with the forces in American intellectual life that were then hoisting the counter culture into a new and aggressive prominence. The Beat Generation, James Dean, Elvis Presley, Kafka, Jean Genet, Henry Miller, William Burroughs – a stumbling new pantheon had arisen to challenge the bland middle-brow culture of the 1950s. A new subject-matter was there, if one cared to look, on the streets of New York. Hers was a journey of social exploration like that which Orwell had made three decades earlier. In *Down and Out in Paris and London* (1933) Orwell showed himself to be equally interested in the social hierarchies of the rootless poor, and was determined to resist any attempt to romanticise tramps and *plongeurs*. The sociological dimension of his work, and evident distaste for the chic and the fashionable, makes his accounts of doss houses and Salvation Army Hostels immune to the voyeuristic enthusiasms which greeted Arbus's work. What seemed like lonely and heroic pioneering photography by Arbus was, in retrospect, riding the crest of the *Zeitgeist*.

Richard Avedon was at the height of his professional career as a fashion photographer while Arbus struggled to secure her livelihood. Despite their warm personal friendship, and despite being so often linked in subsequent comment, they represent opposite versions of the relations between photographer and subject. Where Arbus, early in her career, is empathetic, and makes an emotional engagement with her subjects (Patricia Bosworth quotes Arbus's daughter, Doon: 'I was often frightened by her capacity to be enthralled, by her power to give herself over to something or to someone, to submit'[29]), Avedon is coolly disengaged. While Arbus prowled on her own across New York at night, Avedon travelled across the country with crew, assistants, and equipment in a way that seems more akin to Doris Ulmann in South Carolina. His career as a fashion photographer, celebrated in his *Photographs 1947–1977*, was certainly glittering. To have photographed in Helena Rubinstein's apartment in Paris in 1949, to have models wearing clothes by Balenciaga, Fath and Dior, to have worked with Dovima and Suzy Parker, is

enough to suggest the ambience. Historians of the *pax Americana* should use Avedon's powerful images of elegance to illustrate their texts. They are among the most important clues we have to the dream-world of the post-war, cold war decades. For most American critics of photography, Avedon's pictures have a particular resonance. His Dovima and Suzy Parker are women with whom a certain troubling relationship persists. Of course they are too beautiful, too poised, and much too *expensive* to leap from the world of elegance to that somewhere else where the critics of photography lived when they were teenagers. It is somehow calming to assert that no such world ever existed, but maybe that is simply confessing that the writer did not live there. When he was not on location (The Ritz, Paris; the Casino, Le Touquet; Antigua), Avedon worked in a large warehouse-like studio in Paris.

Once, unusually, the mask slips. He photographed Suzy Parker in August 1956 wearing a formal evening dress by Dior with plunging neckline, and with a dramatic cape-like length of fabric which ballooned outwards and downwards gracefully from her shoulders. It is perhaps not a cape, for the material on Parker's right is unhemmed. Avedon has stepped back from Parker, and captured the taut frame of dark material before which the model posed. Beyond that, there are curtains, gently lifted by a breeze coming through an open window to Parker's left. Overhead, the glass forming the roof of the studio is visible.[30] For a moment, the artifice of Avedon's world is unmasked. The glamour is created by his capacity to disguise the production of his images. And then we begin to wonder about the dressers, assistants, the lighting, about how often Cyd Charisse had to race across the studio waving part of her dress before Avedon finally caught the image (ten times? twenty? perhaps all afternoon, with irritable breaks for work with the make-up people, hair-dressers and lashings of deodorant).[31]

In a brief note in *In the American West* (1985) Avedon refers to the 'silent theater' of the photographic portrait. Its careful artifice is a 'fiction' in which 'another person' willingly takes part. The transform-ation of 'subjects' into bit-players in the photographer's creation brings the story to one kind of resolution. From 1979 Avedon travelled for five summers across the western states, and each of the portraits he made during these trips is similarly structured. The subject stands, patiently, staring at the photographer. As the minutes roll by, as the assistants fuss, as the photographer adjusts the camera (sometimes talking to the subjects, sometimes to his crew), the subject's patience is stretched. Some subjects waited so long that the perspiration on their faces dried, leaving

their skin blotched and stained. Avedon catches facial expressions that range between the bored and the intimidated. Each subject was posed before a white studio screen, with umbrellas and screens to ensure a flat, indirect light that allowed no nuance of effect. The subjects are, literally, nowhere. When displayed, only the frame of the 8″ × 10″ plate defines the space where the photograph ends and the wall began. His subjects have only their clothes to place them. This widely-discussed book disturbs, and was perhaps meant to disturb.[32]

With the work of Richard Avedon there is no human relation between the photographer and subject. That, largely, is the point. We may identify this moment in American portrait photography more precisely: Avedon began taking photographs of his elderly and unwell father, Jacob Israel Avedon, in October 1969. The selection that appears at the end of his *Portraits* (1976) depicts, in a rough narrative, the death of an old man. People who see these portraits know nothing of the relation between Avedon and his father. In the final two images he is wearing a hospital nightgown. These are literally terrible portraits. Weston, breaking off his lovemaking of Tina Modotti to grab a shot, seems something of a trifler, compared to Avedon, in the matter of being photographically dispassionate. The portraits of his father signal the end of the tradition of empathetic or humanistic portrait photography in America, and its completion. Whatever it was that made Avedon able to take photographs at once so loving and emotional, and yet so detached and calculating, has made him a very great photographer indeed. Whether, in human terms, it is a greatness that one should admire – that is another question altogether.

7
Hoppé's Impure Portraits: Contextualising the American Types

MICK GIDLEY

I

The images that constitute our primary concern here – what Emil Otto Hoppé (1878–1972) termed his 'American types', themselves part of a much larger grouping of 'human documents' – have barely been seen, and have certainly not been seriously discussed, for some seventy years.

Hoppé produced approximately 400 'American types', and they were often taken in series, but not necessarily on the same occasion; typical entries for them in his negative books are 'Coloured Woman', 'Jewish Girl Types', 'Negro Type', and 'New York Type. Female. Holiday mood'. I would wish to avoid the seemingly almost inevitable tendency, when faced by a mass of related imagery, to construct, more or less silently, a quintessential selection – Dorothea Lange's *Migrant Mother* (1936) as *the* Farm Security Administration photograph, for instance – which might well belie the true variety of the collection as a whole and, therefore, its complexity. Not all the negatives still exist, sometimes only incomplete documentation survives, and in several cases sequence and individual titles have become detached from the images they originally denoted, so that it is uncertain which of several negatives was meant to be captioned 'Jewish Merchant', for example. Partly on these evidential grounds, but mostly as a consequence of the intractability of the conceptual issues that need to be addressed, I see this essay as a preliminary effort of photographic and cultural archaeology.

Very many of the 'American types' were images of New York City residents and transients – immigrants, hoboes and derelicts – and to make the task of treating the topic almost manageable, while remaining sensitive to the problems posed by the plenitude of these 'types', I have culled most of the specific examples here from those emanating from New York. The only time any of them were publicly exhibited as a group was in January 1922 as part of a show called 'New Camera Work' that

Hoppé mounted at the fashionable Goupil Gallery on London's Regent Street. This was a relatively large exhibition of 221 images, each with a price tag (quite high for the time) of between two and four guineas.[1] A partly cultural and partly biographical contextualisation of the 'American types', such as this essay, may sensibly begin there.

The 'New Camera Work' pictures were mostly portraits, and this is what Hoppé's public would have expected. As early as 1911 he had contributed the sections on portraiture to *Photography* in Hutchinson's Concise Knowledge Library, a popular series of British 'how to' books; from 1916 onwards his portraits and fashion photography had appeared in the British edition of *Vogue*; and by the 1920s he was commonly recognised as the leading photographic portrait maker of the day. Later in his life he described the first portion of his career, from his arrival in England at the turn of the century, ostensibly to learn banking, up to 1925, as predominantly one of 'pure portraiture' of 'members of the upper strata of society'.[2] Everybody who was anybody, as the cliché has it, visited his famous studio in the Kensington house formerly owned by the Pre-Raphaelite painter, Sir John Everett Millais. Royalty, like Queen Mary, industrial and commercial magnates, the aristocracy, parliamentary personages, literary and artistic figures, such as Thomas Hardy, Henry James and Augustus John, and the leading lights of stage and screen – all sat for him. The resulting images were widely disseminated, his opinions began to be as sought after as his pictures, and he became a celebrity himself. (Given the extent of Hoppé's fame in the earlier part of this century, it is odd that his work has tended to slide almost into oblivion.)

Hoppé so prospered that he was able virtually to double the volume of his portrait business by opening a New York branch of his studio for four months of each year between 1919 and 1922; it was during these transatlantic visits that most of the images with which we are concerned were made. In the United States, mainly through the friendship of Dr Christian Brinton, an influential art critic and polymath of the period, he cultivated friendships with numerous American socialites and artists. Robert Frost, Willa Cather, Theodore Dreiser and Carl Sandburg were just some of the writers who sat for him. Lillian Gish, Tom Mix, Paul Robeson, and Jack Dempsey came to his studio, and so did Albert Einstein, artists Robert Henri and Max Weber, and Justice Oliver Wendell Holmes. In 1922 Hoppé – who never missed an opportunity for self-promotion and who subtitled *Hundred Thousand Exposures* (1945), his autobiography, with the words 'The Success of a Photographer' – was

E. O. Hoppé, *New York Type. Female. Holiday Mood, c.* 1921.

E. O. Hoppé, *Jewish Merchant*, c. 1919.

particularly in the public eye. This was due to his heavily advertised search for physically attractive women for inclusion in his *Book of Fair Women* (1922). William Randolph Hearst, the newspaper tycoon, had summoned him to the US so that American women could be included – and, perhaps not surprisingly, Marion Davies, Hearst's film star 'protegée', was selected.[3]

Interestingly, during a later visit to the US in 1927, Hoppé gave an interview in which he claimed that 'American beauty achieves its own distinct type', one 'full of animation and thoughtfulness' indicating 'mental independence'. In terms of actual complexion, Hoppé's choices *were* mostly 'fair' women, and the inclusion of just a few darker skinned women in *The Book of Fair Women* provoked the racist London *Daily Despatch* to wonder whether, 'to those of us who are more familiar with what the Americans call the Nordic type of beauty', Hoppé might be expecting 'a little too much' when 'he asks admiration for Indian, Hawaiian, and Chinese beauties'. The paper went on to suggest that while 'there may be Venuses among the Hottentots, it must be a very

educated palette that appreciates them . . . or people capable of blinding themselves to the natural distaste for colour.'[4] While such sentiments were alien to Hoppé himself, it is worth noting that the section of his Goupil Gallery exhibition devoted to *The Book of Fair Women* contained, along with Miss Davies, only Western European women, and when he did include women of colour in *The Book of Fair Women* itself they were invariably described as 'princesses', as if their admission was to be understood as partly a matter of social status. Hoppé's work, as I hope to elaborate, abounds with complex interactions among various categories of difference.

II

Perhaps the first distinction to be made – or, rather, questioned – concerns the notion of 'pure portraiture'. The preconditions of portraiture – from the psychological puzzles of facial recognition in nature, through the complexities of cultural interpretation of facial expression, to patterns of patronage and other economic and sociological issues – have long proved intractable subjects.[5] For example, 'A face is a poor guarantee', wrote Montaigne in his essay 'On Physiognomy' (written in the 1580s), one of the earliest treatments of the meaning of the face, but he added, 'nevertheless it deserves some consideration'. Montaigne went on to recount two incidents in which the candidness of his own face had been taken by others to match the frankness of his words, even to the point of saving his life. The Victorian intellectual Lady Eastlake – who, in another essay also discoursed perceptively on the then new medium of photography itself – shared this fascination, claiming in the London *Quarterly Review* of December 1851 that 'no single object presented to our senses . . . engrosses so large a share of our thoughts, emotions, and associations as that small portion of flesh and blood a hand may cover, which constitutes the human face.'[6]

Similarly, the portrait itself in all of its forms – but especially painting, so often seen as a model for, or in tandem with, photography – has eluded anything like the final or, at least, unproblematic definition that Hoppé seems to have had in mind when he referred to the primary output of the first phase of his career. Its evolving conventions, relationships to other genre, changing styles, and various other aspects, have all come under scrutiny. Nevertheless, alongside the doubts, there has also been a persistent uncritical conception of portraiture as the actual or attempted revelation of individual character through the depiction of a likeness of a

person's body, especially the face. Despite the objections of such figures as Schopenhauer, who believed that the portrait, in order to catch 'the soul', must be 'a lyric poem, through which a whole personality, with all its thoughts, feelings and desires, speaks', an ideal that the photograph, as in his view a mere 'reflection', could not hope to meet, it has been commonly assumed that the camera has an exceptional capacity to capture likeness. Herbert Furst, for example, an art critic acquaintance of Hoppé, repeatedly insisted in his *Portrait Painting: Its Nature and Function* (1927) that photographic portraiture had usurped the role of painting in this particular endeavour.[7]

Nathaniel Hawthorne, in a famous passage in *The House of the Seven Gables* (1851), even had his daguerreotypist muse that while 'we give [the daguerreotype] credit only for depicting the merest surface, it actually brings out the secret character with a truth that no painter would ever venture upon, could he detect it'. At the turn of the century, James F. Ryder personalised his camera as if it were a kind of infallible god: 'He could read and prove character in a man's face at sight. To his eye a rogue was a rogue; the honest man, when found, was recognised and properly estimated.' Edward Weston set forth a continuation of this approach in his essay 'Portrait Photography' (1942): 'The photographer's primary purpose has been to *reveal* the individual before his camera, to transfer the living quality of that individual to his finished print'. 'This is', he continued, 'the aim of good portraiture in any medium – not to make face maps . . . but to . . . record the essential truth of the subject; not to show how this person looks, but to show what he is.' And in such an unproblematic (if nebulous) view of portraiture, of course, what was valued was the rendition of the specific person with his or her own unique features – even, as the common saying has it, the person's 'warts and all' or, as Diane Arbus put it in describing what happens when 'you see someone on the street', 'what you notice about them is the flaw'.[8]

In a kind of tension with this valorisation of individuality – the distinctive features, fairnesses and flaws that make for 'pure' portraiture – much of the writing on the genre has acknowledged portraiture's inevitable ties to *typology*. Max Friedlander, for example, believed that the very idea of the likeness of a specific individual was subversive of the predominantly platonist tradition of Western art until, and even beyond, the Renaissance, so that there was a heritage of emphasis on depicting 'Man the Beautiful'. 'From the fifteenth century', he said, 'the awakening of personality tended in the direction of the portrait, whilst the rigid ideas as to the nature of art led, under the influence of those venerable

forefathers, to the type'. Furst, with idealist approval, expressed a similar
position: 'It is not . . . so truly *sub*-traction as *pro*-traction that brings
about that organisation of form we call a work of art; which is essentially
a *pourtraicture*, a drawing forth of something from the mass of material
and store of ideas, and truly it may be said that all art is in a very
profound sense a *portraiture* of the human idea: Man feels himself into
and draws himself out of Nature.'[9]

Again, the patrician art historian Bernard Berenson said: 'the portrait
is the rendering of an individual . . . and of the individuality of the inner
man as well as of his social standing. That is what Rembrandt, for
instance, did supremely well, particularly in his last years.' When,
according to Berenson, there was too much emphasis on social standing,
the artist produced not a true – or, as he might well have said, 'pure' –
portrait, but an 'effigy'. 'The effigy', he claimed, 'aims at the social
aspects of the subject, emphasises the soldierliness of the soldier, the
judiciousness of the judge, the clericality of the clergy.' In contrast, John
Berger saw such seeking after representativeness as the very heart of the
genre; he argued that 'the actual function' of a portrait cannot be seen in
the work of the exceptional artist, such as Rembrandt, but is clear in the
generality of portraiture: 'the function of portrait painting . . . was not to
present the sitter as 'an individual' but, rather, as an individual monarch,
bishop, landowner, merchant and so on . . . The satisfaction of having
one's portrait painted was the satisfaction of being personally recognised
and *confirmed in one's position*: it had nothing to do with the modern
lonely desire to be recognised "for what one really is".'[10]

Perhaps no portraiture was – or could be – as 'pure' as Hoppé seems to
have believed. Indeed, he himself described the subjects of this work as
'members of the *upper* strata of society', as if 'position', in Berger's word,
was an issue – perhaps even formed part of the image. Interestingly Robin
Simon recently devoted much of *The Portrait in Britain and America*
(1987) to providing information on the conventions of painted portrait-
ure, such as stylised poses, special costumes, the habitual employment of
drapery painters, the use of stuffed lay figures as models for the body and
its poses, and the painting of the body separately from the face by
different artists – who, in turn, often presented subjects with regularised
body and facial features. All of this suggests that there were consider-
ations of rank, propriety, fashion, and the like which were at least as
important as an individual 'likeness' as such.[11]

It is hardly surprising that in portrait photography there has been the
same tendency towards the type. Weston argued against 'the kind of

pigeon-hole observation that attempts to classify people by their like-
nesses and tends to see them as types', and indeed questions of type have
been at issue from at least as early as the first American treatise on
photography. In *The Camera and the Pencil* (1864), the portrait maker
Marcus Aurelius Root, who proffered advice primarily to the growing
amateur public, often stressed the beneficial, socially educational aspects
of photographic reproductions on 'the masses'. The most interesting
tension in his text is, precisely, that he *both* spoke of photography as the
supreme medium for achieving a unique likeness of an individual *and*
advocated the adoption of conventions to indicate social roles or types.
With regard to posing, for example, he suggested that while poets,
historians, and others with primarily sedentary and private roles should
be photographed in a seated position, 'statesmen, lawyers, clergymen,
and public figures generally, should be taken in a standing posture'.
Meanwhile, in Europe, André Adolphe Eugène Disdéri, the immensely
successful Parisian patentee of the cheap and popular *carte-de-visite*
portrait process, had already developed a set of practical conventions to
depict 'The Actor', 'The Painter', etc.[12]
 In the work of twentieth-century art photographers such crude
typologies have, of course, been largely eliminated. However, a few
vestigial obeisances occur in posture – army commanders *are* usually
stiffly erect and writers seated – and in other meaningful visual elements
such as setting and costume. If we look at Hoppé's own work in terms of
setting, for instance, we find that he depicted the sculptor Jacob Epstein,
mason's mallet in hand, standing in front of a massive block of half-carved
stone (his monument to Oscar Wilde), and many of the authors he
portrayed are backed by bookshelves. In fact, almost all of the 'thirty-two
camera studies' Hoppé produced for each of Arthur St John Adcock's
Gods of Modern Grub Street (1923) and *The Glory That Was Grub Street*
(1927) present their subjects either as faces surrounded by darkness (or
light), specifically without a definable setting, which tends expressionisti-
cally to accentuate their introspection, or seemingly at work. G.K.
Chesterton, for instance, bulks over his typewriter, papers around him
(page 140), while Ian Hay, the now virtually forgotten humourist, seems
to be pushing himself back from an over-tidy desk, as if to walk about for
inspiration. Each portrait bears the name of the subject, virtually as part of
the composition, and is thus lent the appearance of a book plate. Similarly,
Hoppé frequently used costume typologically, most obviously in the
expensive dresses of many of his female aristocratic subjects. These
subjects included some of his 'fair women', such as Lady Hazel Lavery,

E. O. Hoppé, *G. K. Chesterton*, photogravure, *c.* 1922.
Reproduced from *The Glory that was Grub Street.*

who was even shown with a very young Indian boyservant in train, as if she and he were characters in an orientalist narrative painting. Also, there was much of the typological in, for example, the extravagant outfits which served to identify the subject as an 'artist', whether writer Rebecca West when young, in an elaborate beaded headdress, or George Bernard Shaw, wearing a 'sensible' country jacket, seated, with pen raised above his notebook, the side light falling in such a manner as to highlight the quizzicality of his smile under his venerable whiskers.[13]

Inherent in Root's kind of advocacy of typological conventions was the possibility of amassing photographs as data in the discernment – indeed, construction – of cultural categories of difference, whether by class, race, ethnicity, or even, as we have seen in passing, 'beauty'. If Hoppé's ostensibly 'pure' portraiture exhibited some of these features, perhaps his 'American types' were less of a radical departure than may first have seemed the case. The point at which that departure nevertheless took place was, precisely, where the fundamental idea of class – or more widely, 'position', in Berger's sense – was paramount. And Hoppé himself disclosed this, perhaps unwittingly, when in his later life he described his 'human documents' as 'types of the *lower* strata of society whose faces tell their life history'.[14] In comparison with the 'pure portraits', the subjects of the 'human documents' were rarely granted the courtesy of names in the titles of the images or in the negative books; but

E. O. Hoppé, *Lady Hazel Lavery, c.* 1919.

even beyond this, I think there was something about the whole idea of 'human documents', including 'types' in this sense, which made it applicable *only* to 'the lower strata of society', however that assumed inferiority was conceived.

III

From the early 1920s onwards Hoppé shifted his primary focus in photography from portraiture to topographical and landscape work. He produced, for instance, a succession of massive collections of prints for the Orbis Terrarum book series, each published in four languages, on *Picturesque Great Britain* (1926), then *Romantic America* (1927), then Germany, Czechoslovakia, and Australia. He toured extensively, as his *Round the World with a Camera* (1934) and other travel books testify. This transfer to the topographical was also anticipated and indicated in the Goupil Gallery show by the display of a number of 'lyrical landscapes' and by a series titled 'The Soul of Gotham'. The latter consisted of thirty-nine studies of New York City; these are interesting

both in their own right and in the way they relate to the 'American types'. For the most part they are rather severe, strongly patterned studies that anticipate the sort of cityscapes selected for inclusion in *Romantic America*. In his autobiography Hoppé recalled that most of the pictures he had seen previously of American cities 'depicted the pulsating stream of life flowing through them'. But in his own case, he said, 'I felt more strongly than anything else their static qualities, their loneliness and grandeur.' Stasis, loneliness, grandeur: these words characterise Hoppé's New York cityscapes. *In the West Street District* is typical. The caption for it (in *Romantic America*'s words) is 'Dockland on the North River and a centre for the Transatlantic Lines and ferries', but the photograph itself says almost nothing about the business – certainly not the busy-ness – of docks and mass transportation.[15] What human presence there is – the unemphasised fruit stall and the scattered, seemingly aimless figures, all in the bottom strip of the picture – is reduced to insignificance by the great triangular divisions of the total composition. The photograph, in essence, becomes a study in shades of grey and black triangles on a flat, two-dimensional plane.

Peter Conrad, speaking of artistic views and versions of New York generally, quipped, 'The city of realism is congested. Abstracted New York is empty.'[16] Several of Hoppé's New York studies in the Goupil Gallery exhibition were overtly 'abstract' in this sense, and their titles, such as *Squares and Angles* and *Stone and Steel*, announced the fact. Thus even the Bowery, backdrop to many of the 'American types' and so often highlighted by other photographers as the epitome of teeming tenements, is presented as a series of scenes of silent desolation – seemingly abandoned barrels in an empty courtyard, clothes lines, mute shop fronts – in which human beings are curiously absent. In some of the Bowery images it even seems that humans flee out of the frame, as if in shame. In Hoppé's aesthetic sensibility there was a severe disjuncture, at least at first sight, between people and the abstracted city. By the time he put *Romantic America* together the dismal decay of the Bowery was not thought suitable for inclusion at all. Given that one of the objectives of the publication was the depiction of life on the American continent, this is puzzling. Perhaps Roland Barthes' acute observations on the *Blue Guide* could help us to understand it. Barthes pointed out that such a guide 'hardly knows the existence of scenery except under the guise of the picturesque', and if this is so, it must hold even truer for a wholly 'armchair' guide like *Romantic America* – an illustrated one moreover – aimed even more resolutely at Barthes' derided 'bourgeoisie'. In such

guides, according to Barthes, 'the human life of a country disappears to the exclusive benefit of its monuments'. Indeed, in comparison with Hoppé's representation of England in *Picturesque Great Britain* as predominantly rural, misty, unchanging and composed, perhaps the surprising thing is that his rendition of the United States in *Romantic America* was as determinedly hard-edged, modernistic and abstract as it was, even if its 'monuments' were justly skyscrapers and other 'cathedrals of commerce'.

Barthes also noted that in the version of the picturesque presented in such publications, 'men exist only as "types" ', and he proceeded to mock the notion of Spain as a country composed exclusively of adventurous Basque sailors, light-hearted Levantine gardeners, clever Catalan tradesmen, and so on.[17] As if in concordance with Barthes' view, the few portraits in *Romantic America* – of a black fruit vendor, a cowboy, two Native Americans, an Hispanic guitarist and an elderly black man actually described as 'Uncle Remus' – are both types in his sense and constitute some of the most truly picturesque of the book's images. These figures are not actually 'human documents' or 'American types'. But it is worth noting that part of their picturesqueness is due to the fact that they are usually isolated within the frame, cut off visually from other people and any milieu. In composition and content these images construct their subjects as different, archetypal, even exotic, and thus constitute or affirm the ('bourgeois') viewer as an adherent of cultural norms from which such subjects deviate. It is this that they share with Hoppé's 'American types'.

IV

The 1922 Goupil Gallery show included twenty-eight 'human documents', half taken in New York, half in London. When later in Hoppé's life he described his 'human documents' as 'types of the lower strata of society whose faces tell their life history', he implied that he had devoted a major portion of his career to them. But his negative books show that while he did take quite a number of such individual pictures over the years – some of his more numerous London ones appeared in *Taken from Life* (1922) by J.D. Beresford, and twenty-five of them were used in *London Types Taken from Life* (1926) by William Pett Ridge – he really concentrated on them for only a short time and never afterwards exhibited any American ones. Considering how relatively few 'human documents' there were in the Goupil show, it is significant that John

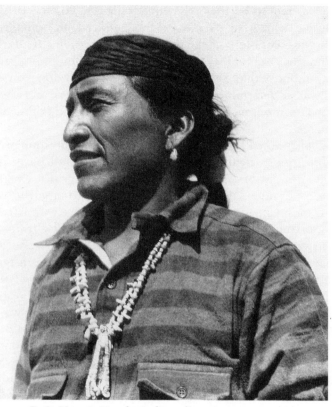

E. O. Hoppé, *Navaho Indian*, photogravure, *c.* 1926.
Reproduced from *Romantic America*.

Galsworthy, then at the height of his fame as a novelist, chose to dwell on them, rather than on the landscapes or the 'pure' portraits, in his Foreword to the exhibition catalogue. What Galsworthy had to say is interesting: 'The photograph is a rare exponent of national or group psychology, and I would draw attention to the little collection of London types over against the collection of New York types, culled from much the same ranks of life.' For Galsworthy, the principle categories of difference, as we might expect from the author of the then recently completed *The Forsyte Saga* (1906–1922), were nation and, of course, class (thus reflecting Hoppé's notions of 'upper' and 'lower' strata of society). 'Mr Hoppé', he continued, 'always concerned with the underlying, succeeds by selection and grouping, in revealing to us the peculiar difference that lies between the simple citizens of an old, and of a new

country.' Galsworthy appreciated that the photographic revelation of difference could be achieved not so much through the individual image as by 'selection and grouping', processes conducted both before and after the photographic act itself. (Hoppé must have shared this appreciation, in that at least once he referred to the 'human documents' as 'studies in group psychology', a usage which obviously emphasises the typological at the expense of the individual.)[18]

The process of selection that preceded the making of Hoppé's 'human documents' was inevitably determined by previous history. Doubtless Hoppé was personally and impulsively motivated by the unparalleled diversity of humanity that he witnessed in New York City as soon as he stepped out of his hotel or studio, but his renditions of it could not be simple, innocent transcriptions, the results of a kind of spontaneous combustion. First, from at least the time of Wordsworth's bemusement by the faces of unknown Londoners – 'the endless stream of men . . . / The Comers and Goers face to face / Face after face' – there existed a sense of awe before the spectacle and mystery of the metropolitan city and, especially, its multifarious inhabitants; the significance of the investigation of the Parisian *demi-monde* by Baudelaire and others, and of the efforts of such figures as Jacob A. Riis to illuminate those depths of New York City normally hidden from middle-class eyes, is readily apparent.[19] Second, there was also already a history of representations of street life; the codification of such subject matter had occurred before and, particularly, after the invention of photography, as the mention of Riis and his revealingly titled *How the Other Half Lives* (1890), which was illustrated by photographs, should indicate. Let me take up instances from each of these related points in turn.

An anonymous contributor to Dickens' *Household Words* in 1855 wrote of 'Passing Faces' in a manner which showed that he or she expected not only to discover individual secrets from them, but also – and here seeming to prefigure Hoppé's very words – 'their social condition and their histories, stamped on them as legibly as arms are painted on a carriage panel'. Henry Mayhew, in the bravura blurb for one of his publications on the London scene, spoke of the city's 'pluralities of worlds', listing those of 'fashion and vulgo-gentility, of science, art, letters, vanity, and vice; its lions and puppies, sharks and gulls, big-wigs and small-fry, philosophers and fast men; its lawyers, doctors, parsons, "magsmen", soldiers, servants, merchants, shopmen, "duffers"; authors, artists, showmen, nobles, swell-mobsmen, and "shallow coves" . . . the very best and the very worst types of civilised society.' Similar sentiments

were expressed about urban experience in the western hemisphere, as
when Emerson remarked, in his essay on 'Fate' (1860), 'At the corner of
the street you read the possibility of each passenger in the facial angle, in
the complexion, in the depth of his eye.' By the opening of the twentieth
century, certainly by the time Hoppé arrived there, New York was *the*
city to excite such a sense.[20]

The whole of the May 1900 issue of the New York *Photo-Miniature*
magazine was given over to a treatise on 'Street Photography' by
Osborne I. Yellott. It was a 'how to' piece for middle-class amateurs, but
also referred to well-known professional work by Alfred Stieglitz and
others, in which Yellott claimed that while no book on street photo-
graphy yet existed, 'a good-sized one' could easily have been written;
clearly, street photography was seen as a truly workable area, and one
quite broad in scope. Yellott proffered advice on how to capture
buildings, the streets at night or under a sheen of wetness, and, most
interestingly for our present purposes, street figures, including a 'blind
accordionist' and boys playing craps or marbles. When we conjure up
justly celebrated New York images produced around this time by
Stieglitz, Edward Steichen, and Riis – or, a little later, by Paul Strand and
Hoppé himself – which would, indeed, fit into these various sub-
categories, I think we can see some justice in one of Susan Sontag's
indictments of photography:

'Photography first comes into its own as an extention of the eye of the
middle class *flâneur*, whose sensibility was so accurately charted by
Baudelaire. The photographer is an armed version of the solitary walker
reconnoitering, stalking, cruising the urban inferno, the voyeuristic
stroller who discovers the city as a landscape of voluptuous extremes.'
'Adept at the joys of watching, connoisseur of empathy,' she continues,
'the *flâneur* finds the world "picturesque".'[21]

An incomplete list of forerunners to Hoppé's 'American types' would
include John Thomson's 'woodburytypes' for Adolphe Smith's *Street
Life in London* (1877); Sigmund Krausz's *Street Types of Chicago*
(1892); the work of Riis and Lewis W. Hine; and, of course, the portfolio
of studies that August Sander thought constituted a collective vision of
Germany in the years after the First World War, a *Face of our Time*,
which he published in 1929. The Preface to the first of these, *Street Life in
London*, claimed that 'the unquestioned accuracy' of photographic
'testimony' would enable the presentation of 'true types of the London
Poor', thus shielding its authors 'from the accusation of either underrat-
ing or exaggerating individual peculiarities of appearance'. This deter-

mined quest for types through photography echoed the methodical, quasi-scientific searches for living types by Hippolyte Taine and others and, though it is mostly beyond the scope of this essay, the more far-reaching fully 'scientific' activities of anthropology. The cranky apex of elision of individual differences in the research into types was reached in the construction of 'composite photographs' (of doctors, for instance, but also of 'criminals') by the British eugenicist so popular in America, Francis Galton.[22]

In the relevant output of the precursors listed above – sometimes alongside elements of reforming zeal, as in Riis's case – there was, as Sontag noted and as Peter Bacon Hales has elaborated, an element of the picturesque. It appeared mostly as a residue of the picturesque genre study of aspects of everyday life. The genre study, as a form, tends to accept the way things are in society; as John Berger said with Franz Hals' genre studies in view, 'Here the painted poor smile as they offer what they have for sale . . . They smile at the better-off – to ingratiate themselves, but also at the prospect of a sale or a job. Such pictures assert two things: that the poor are happy, and that the better-off are a source of hope for the world.' In the photographic types there is much less smiling – except perhaps in such Krausz portraits as that of the black kid stereotypically eating watermelon! – but the effect is the same. Except in Hine's work, or the best of it, with all its power to constitute the viewer as an active participant in its interpretation, not just to see, but to *be* a witness, there was often that note of reassurance.[23]

Interestingly, in *Taken from Life*, J.D. Beresford went out of his way to deny any social import to the London 'types' written about and imaged in it: 'I had nothing more in my mind than the presentation of certain little pieces of human history.' It is impossible to know whether Hoppé himself shared precisely this view of the 'types', but it is clear that in Beresford's formulation – 'certain little pieces of human history' – there is a whiff of both the sentimentalisation of poverty and the voyeuristic. In this kind of photography, I think it is probably impossible to disentangle voyeurism from scientific investigation, aesthetic delight from the satisfaction of discovery, and a sense of otherness from reverence. Something of this fusion and confusion is apparent in a comment from Hoppé's auto-biography on the subjects of his 'human documents': 'A philosophy garnered from a life of toil, a brave resignation to circumstances, and . . . that matchless sense of humour which is a substitute for contentment . . . stamps their faces with a spiritual beauty which may not be bought in any beauty parlour.'[24]

V

It was the process of what Galsworthy termed 'selection and grouping' after the images were made that produced 'types'. 'By assembling his Londoners', Hoppé 'elicited', as Galsworthy put it, 'the fixity of philosophy and class characteristics, the closed-door look which we have in England beyond, I think, all other Western countries. The faces are brimful of character, but it is character functioning within strictly confined opportunity. These are people with an outlook limited from birth. Pass from them to the New York East-side types, and one is conscious of a lifted lid, of a range unfixed.' The obvious conclusion to draw from Galsworthy's description of the difference between the two groups revealed by Hoppé's 'human documents' is that, since for him class was culturally *the* overriding differentiating category, he simply saw the Londoners as more solidly class-bound, even though the New Yorkers were ostensibly 'culled from much the same ranks of life'. And though Galsworthy did not overtly formulate the reason for the distinction between the two groups, he seems to have intuited the nature of that which, so to speak, 'unfixed' the New Yorkers' range of vision and opportunity: ethnic identities and differences. This may be deduced from the fact that, as we will see, when he mentioned a particular image from the New York set, he located its subject by ethnic affiliation.

Galsworthy, following Hoppé, recognised New York City as, in Thomas Bender's phrase, 'a center of "difference" ', a place of heterogeneity, contention and, even, discord.[25] Though he bemoaned the 'closed-door look' produced by the British class system, his very vocabulary betrayed at least an unease, and perhaps a positive disquiet, over the lack of social fixity that New York's ethnic diversity entailed. This can be seen in his description of Hoppé's *The Jewish Vagabond*: 'Another specimen of group psychology is disclosed by a single face – that of the New York Jewish vagabond, with his head up, smoking a cigarette. This photograph is an amazing revelation of the whole restless, shiftily rebellious, tramp species of mankind; the type that savours the moment only, as this man is savouring his smoke.' Essentially, what has happened here is that connotations of the two main words in Hoppé's title, 'Jewish' and 'vagabond', have contaminated one another: the term 'vagabond' mixes pejorative associations (with idleness, theft, etc.) with some glamorous ones (movement, colour, nomadicism), and there is ambiguity over the precise allocation – whether to vagabondage or to Jewishness –

E. O. Hoppé, *The Jewish Vagabond, c. 1920.*

of the key qualifiers, 'restless', 'shiftily', 'rebellious'. The description thus teeters on the edge of – or even into – anti-Semitism.

The image itself, on the other hand, while framing its subject in formal terms as 'other', if not as exotically as the *Romantic America* portraits, cannot be said to convey such a stance, especially when viewed alongside other Hoppé images of the same person. Nevertheless, in direct contradiction of Hoppé's claim for his 'human documents', the image cannot be said to tell the life history of its subject. Such a notion relies on the belief that people looked at when they are not aware of it unwittingly reveal their 'true' selves. This belief went unquestioned for a long time. It animated, for example, Yellott's advice in his 'Street Photography' on how to capture subjects' likenesses by creeping up on them unseen; or Strand's famous practice during 1915–16 of shooting such figures as *Man with Derby* or *Blind Woman* and other New York street folk with a camera that seemed to point in a different direction; or Walker Evans's subway passengers in *Many Are Called* (1941), taken without their knowledge by a camera concealed on Evans's person as he sat opposite. However, while as viewers we may stare uninhibitedly and speculate endlessly at images secured in this manner, the subjects of such a gaze remain forever *un*known.[26]

The term 'human document' did not, of course, begin with Hoppé and, as William Stott has itemised, by the 1930s it enjoyed wide, if sometimes inflated, currency, signifying 'emotional' (as against 'rational' or 'logical') evidence of social facts. In the 1920s, when Hoppé adopted it, it seems to have been much less in vogue and probably still carried some literary freight. Beaumont Newhall, in his standard account of photographic history, has pointed out that as early as 1893 *McClure's Magazine* published a series of photographic portraits under the heading 'Human Documents'. However, he failed to mention that these were not portraits of ordinary folk. They consisted of three to six photographs, taken at different points in their lives, of 'Eminent Men' – figures like the writers Robert Louis Stevenson, Hamlin Garland, and Edward Everett Hale – certainly not members of the 'lower strata of society'. Equally significant from the perspective of this essay, one of the other earliest uses of the term was by the novelist Edmond de Goncourt who, in the Preface to *La Faustin* (1882), the story of the rise and then suicide of a star actress, wrote of his desire to do a novel 'that will simply be a psychological and physiological study of a young girl . . . a novel based on human documents'; and, he said, 'I claim to be the father of this expression, much bandied about at the moment, which I see as the best

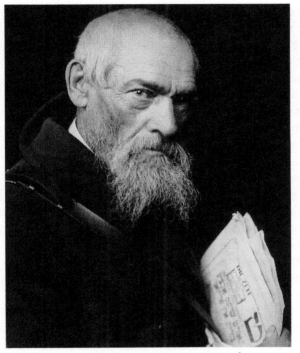

E. O. Hoppé, *New York Type. Newspaper Vendor, c.* 1920.

and most significant definition of the new style of the school which has
succeeded Romanticism: the school of the human document'.[27] There is
obviously no space here to venture into the origins of literary Naturalism,
but it is worth underlining that novels do, literally, 'tell' stories, and the
point of Goncourt's claim was that his story would have its basis in the
psychological and physiological facts of someone's experience over time;
it would be a 'life history'.

Hoppé may well have hoped that each of his 'human documents'
would 'tell' the 'life history' of its subject in a manner akin to a Naturalist
novel or, failing that, to a series of portraits like those in *McClure's*. In
fact, neither hope was possible. Photographic images, in their certain
contingent relation to actual time, may invite viewers to supply an
explanatory narrative, a life history, but the individual image itself
cannot provide it. Schopenhauer was right. The photograph can only
evoke such a history in the most general of terms. For example, Hoppé's
'American type' portrait of a peddler of Yiddish newspapers presents a
man whose face is interesting, with a penetrating gaze, but even to say

this much is already to venture towards, if not into, speculation. Leaving Hoppé for a moment, we may say that Russell Lee's famous 1936 photograph of an old woman's worn and misshapen hands tells a life story of unremitting (graphically manual) labour, but without further information we could do no better than guess the nature of the work.[28] The fuller meaning of such texts resides less in what they have to tell about the lives of individuals and more in what they may reveal precisely *as* ethnic and other 'types'. As a consequence, the acquisition of the fuller meaning is subject to a deeper understanding of the discourse of ethnicity in the period of their making.

In fact, racist ideology was noticeably prevalent in the United States during the years of Hoppé's visits immediately after the First World War. We have seen that the London *Daily Despatch* reporter referred to 'what the Americans call the Nordic type of beauty', and in actuality there were prominent American racial ideologues, such as Madison Grant, Henry Fairfield Osborn and Lothrop Stoddard, who propounded and popularised notions of the superiority of the Nordic 'race' over, in more or less equal steps, 'Alpines' and 'Mediterraneans', then, in larger downward steps, over Jews and peoples with darker skins. Grant and others feared that American society would be laid to ruins by the numerical increase of such peoples and, especially, by 'Nordic' inter-marriage with them. It will be remembered that Tom Buchanan in Scott Fitzgerald's *The Great Gatsby* (1925) took Nick Carraway aback by giving vent to such notions: 'Civilization's going to pieces', broke out Tom violently. 'I've gotten to be a terrible pessimist about things. Have you read *The Rise of the Colored Empires* by this man Goddard? . . . The idea is if we don't look out the white race will be . . . utterly submerged. It's all scientific stuff; it's been proved . . . The idea is that we're Nordics . . . And we've produced all the things that go to make civilization – oh, science and art, and all that. Do you see?' The actual immigration quotas imposed by the United States in 1921 and 1924, which were to prevail for half a century, largely reflected this racist ideology.[29]

There is no reason to suspect that Hoppé – himself the member of a French Huguenot immigrant family in Germany, then an immigrant to Britain – shared such beliefs. But of course photography is neither the straight-forward 'objective' medium it was often assumed to be, nor the willed creation of a single author. Hoppé, however delighted by the variety of humanity in New York City, produced not a simple transcription of what he saw, but images inscribed with contemporary ideas of difference. The very use of a classificatory system of 'types' – 'West

Indian Types', 'East Side Types', and (whatever it signifies) 'Type of haired man', are a few more of the file headings entered in his negative books – has its dangers, and certain commentators at the time understood this. The anthropologist Franz Boas, for example, argued, in a series of articles and reviews from 1899 onwards, that the concept of a type needed sharp definition if it was to be at all useful scientifically, and he repeatedly questioned what he saw as abuses of it, which issued in assumptions of inequalities between human groups. The Progressive political and cultural commentator Walter Lippmann, in his influential contemporary book *Public Opinion* (1922), analysed the difference between the obdurate facts of the world and what he perceptively and aptly termed the 'pictures in our heads', emphasising the pernicious tendency of types to become stereotypes, and pointing out that 'photographs have the kind of authority over imagination today' that 'the printed word had yesterday, and the spoken word before that'.[30]

Dickens, as Mary Cowling has reminded us, discoursed on the popular types of his time – the hackney coachman, the clerk, the cabman, and many others – with as much confidence as his contemporary Kenny Meadows displayed when he produced a book of etchings of such types entitled *The Heads of the People* (c. 1840). Hoppé's similar, and much less systematic, use of a typology – if only simply to recognise (and, of course, categorise) rather than to read the diverse faces of ethnic Americans – does indicate, I think, an unquestioned assumption of cultural norms that were demeaning to many groups in society. The readiness to employ a typology, whether from such discredited pseudo-sciences as phrenology, or from the growing literature of anthropology, in order to read the individual human being, is what Barthes addressed when, in 'The *Blue Guide*' essay, he spoke of 'the disease of thinking in essences, which is at the bottom of every bourgeois mythology of man'. To the unquestioning typologist, every individual belongs to an enduring essence; the typologist's task is not actually to look for variation, but to spot the stable essences behind variation.[31]

It would be unnecessarily harsh to view an enterprise as fragmentary as Hoppé's 'American types' with the same vehemence that Barthes brought to the *Blue Guide*'s Spain, especially as his images possess a presence independent of their captions. We can, as we have seen, create our own characters and stories for the portraits. Maybe we should see a camp self-mockery in the top-hatted black man, the playing out of a role other than that indicated by the image's label; or sense a profound learning in the first of the 'Jewish Merchants', betokened by the way the light illuminates

E. O. Hoppé, *American Type. Negro, c.* 1920.

his features . . . The resulting readings would never be enough to give, in Barthes' words, 'the real spectacle of conditions, classes and professions' in 1920s America, but then *no* representation could do so. Rather, just as Dickens created individual characters (even when they simultaneously share features with a type), so the individual Hoppé images, removed from the constraints of typology, are intriguing. But perhaps the analogy with Dickens' 'characters' could not be sustained: Hoppé's images fascinate, but in the end it is a fascination almost wholly dependent on their status as 'American types'.

8
Images of D. H. Lawrence:
On the Use of Photographs in Biography

DAVID ELLIS

When the subject of a biography is sufficiently modern for photographs
to be available, the question for the publisher is not whether they should
be included but how many he can afford. These days, a biography which
is not illustrated is a fish without a tail. The initial assumption of
biographers is that the photographs will illustrate their text; but the
relationship between words and images is seldom that simple.

In the early 1920s the intensity of Lawrence's imaginative involvement
with the idea of the American Indian was instrumental in persuading him
to accept an invitation from Mabel Dodge Sterne (as she was then called)
to visit Taos in New Mexico. Another female member of the more-or-less
artistic community in New Mexico was Mary Austin, whom Lawrence
knew well enough to satirise in an unfinished dramatic sketch he wrote in
Taos called 'Altitude'. In 1929 – only four years after Lawrence had left
Taos for good – Mary Austin, a fervent supporter of the Indian cause,
collaborated with Ansel Adams on a book in celebration of the Taos
Pueblo.[1] A major task of the biographer of 'Lawrence in America' is to
describe how a romantic notion of American Indians, which Lawrence
had largely imbibed from the novels of Fenimore Cooper, was altered by
contact with the genuine article. What more natural procedure, there-
fore, than to accompany this description with one of the Adams
photographs of the Pueblo (ten minutes walk from where Lawrence first
settled in Taos), or of the Indians who lived there? At least then readers
would know what both looked like.

The first difficulties turn out to be technical. For a photograph to
illustrate certain passages in a text satisfactorily it needs to be adjoining,
so that the eye takes in the words and then moves across to the visual
image which confirms or amplifies the sense. But the truth is, the
publisher quickly explains, that having the photographs precisely where
one wants them means either the expense of printing the whole book on
appropriate paper, or reproducing images of such poor quality that they

are a discredit to the publishing house. The usual solution nowadays is to bunch the photographs together in a number of insets where, like settling comfortably with like, they quickly develop closer ties with each other than with the written text. The thought with which these insets are composed and arranged means that they usually bear as much relation to the putative 'photographic essay' as automatic writing does to literature.

But even if an Adams photograph could be made to appear on cue, it is not certain that it would be much help in illustrating Lawrence's first experience of native Americans. He had been introduced on Lamy Station, near Santa Fe, to Mabel Dodge Sterne's chauffeur, lover, and eventual husband, Tony Luhan, who was himself an Indian from the Taos Pueblo. (Adam's photograph of Luhan in his and Mary Austin's book is an eloquent comment on 'Artistic' photographic portraiture.) But the first Indians that Lawrence saw in a group, and on their home ground, were probably Apaches at the Jicarillo Reservation, where he was taken by Tony three days after his arrival in Taos. He recorded his self-confessedly confused reactions in an article called 'Indians and an Englishman', published in the *Dial* in February 1923. In a culture such as ours, which so privileges sight, one of these reactions is a useful reminder that photography is not much help when the impression is so much more olfactory than visual:

The Apaches have a cult of water-hatred; they never wash flesh or rag. So never in my life have I smelt such an unbearable sulphur-human smell as comes from them when they cluster: a smell that takes the breath from the nostrils.[2]

This passage is sufficiently characteristic of the article as a whole, and of the letters which Lawrence wrote from New Mexico during his first months there, to make it clear why, as the one illustration to accompany a description of his initial efforts to reconcile his previous view of the Red Indian with reality, an Adams photograph might seem a trifle pictur-esque. But how, in any case, could one imagine any of the photographs from the Taos book obediently playing second fiddle? Adams's view of the world, like that of his mentor Stieglitz, or Weston (two photo-graphers whom, unlike Adams, Lawrence did come to know) is so distinctive that there is much more probability of it striking a discordant, challenging or rival note. The aesthetic claim of his work would be much more likely to overpower than merely illustrate the biographical account.

Using photographs in biography is a tricky business, and it is especially tricky when they are of the biographer's subject. A prolific biographer of

the 1920s and 1930s was Emil Ludwig, whose life of Kaiser Wilhelm II attracted the serious attention of both Freud and Sartre. In an auto-biography published in 1931, Ludwig explained that he always began his biographies with a portrait he had known for years, 'before I so much as looked at the other documents; and if the painter lied there were others [other portraits, presumably] that could be used for comparison, best of all a photograph.[3] As remarkable here as the confidence in being able to detect a lying painter (before looking at other kinds of testimony), is the belief in the self-evidence of photography's superior standard of truth. But is there really an art, as Ludwig clearly believed there was, 'to tell the mind's construction from the face'. It is Duncan, at the beginning of *Macbeth*, who categorically asserts that there is not (a proposition dramatically confirmed, in his case, by his subsequent fate); but in the nineteenth century especially, confidence in the face as an index of character became very strong. That Ludwig inherited the certainties of a previous age is clear from the opening paragraph of his biographical sketch of Baron von Stein – one of sixteen such sketches, nearly all preceded by a portrait, in *Genius and Character*:

The framework of a massive body supports a squared skull with delicately vaulted forehead and thin uncommunicative lips. Yet two clear blue eyes and a gigantic nose – evidences respectively of faith and energy – stand out upon this face with an aggressive and commanding prominence. For faith and energy are the fundamental traits of this powerful and simple man.[4]

The modern reader has no difficulty in dismissing this as fatuous. Faith and blue eyes? No wonder all those people in Southern Europe are so unreliable! As character analysis this is no more respectable than certain passages in the far more sinister Lombroso. Yet the belief that facial characteristics are associated with moral qualities is deep-seated. Even that most ingeniously sceptical of commentators on biography, Antoine Roquentin in Sartre's *La Nausée*, slips into 'reading faces' in the Bouville art gallery; and, when reading nineteenth-century novels, most of us negotiate with a disturbingly instinctive ease the 'feature code' of weak chins, sensual (rather than 'thin uncommunicative') lips or strong noses, apprehending only if we have a mind to it the intersection points at which a largely spurious folk wisdom can be seen transmogrifying into yet another of the pseudo-sciences so typical of the age.

Appearances, we need continually to remind ourselves – and especially the fixed single appearance which is all a photographic portrait allows – can be deceptive. There is a cheerfully diverting illustration of the deceptiveness of expression in the autobiography of Ray Milland, where

he recalls the praise he received for a scene in which he had to emerge from under water in the company of Dorothy Lamour and regard her lovingly as they kissed. The sequence, he explained, was shot while he had a pressing need to urinate, but was prevented from going to the toilet by the anxiety of his German director who wanted to make the best of the intermittent sunlight. When he was at last told to dive in, the shock of the cold water caused him to evacuate automatically, so that the blissfully adoring look he was able to direct at his co-star, and which the director found so convincing ('That vos vunderful, vunderful. It had a simple extase'), was largely a consequence of physical relief.[5]

That the shape of a face, its architecture, the combined effect of its various features, can mislead just as easily as 'expression' ought to be susceptible of the kind of empirical testing sadistic experimental psychologists favour: the distribution to the sample group, for example, of a photograph of a particularly brutal murderer, the initiation of a debate on evil looks, and then the revelation that the photograph is in fact of one of the murderer's victims. To demonstrate that expectation plays a dominating role in our interpretation of faces ought not to be too difficult. 'Qui cherche trouve' as the French say, 'Seek and ye shall find'; or in its more demotic English version, 'You always find what you're looking for'. In 'A short history of photography' Walter Benjamin discusses a photograph which Dauthenday, 'father of the poet', took of himself and his fiancée: 'the woman whom one day, shortly after the birth of her sixth child, he was to find lying with slashed wrists in the bedroom of his Moscow home'. He notes that, although Dauthenday has his arm round his future wife, 'her gaze reaches beyond him, absorbed into an ominous distance'. However skilled the photographer is, Benjamin adds, and however carefully he poses his model, 'the spectator feels an irresistible compulsion to look for the tiny spark of chance, of the here and now, with which reality has, as it were, seared the character in the picture; to find that imperceptible point at which, in the immediacy of that long-past moment, the future so persuasively inserts itself that looking back we may rediscover it.'[6] In the case of the Dauthenday portrait it is reasonable to suggest that Benjamin only detects 'the tiny spark of chance', and 'the imperceptible point' because he knows beforehand that the woman he is looking at committed suicide.

More often than not, we discover in a photographed face what the context of our expectations determines that we will discover. Avedon seems to toy with this phenomenon in his portrait of an elderly man with gentle melancholy eyes and a suffering expression. Is this a Jewish writer,

artist or (the other portraits in the volume might lead one to think) distinguished physicist in retirement? Familiarity with Avedon's work destroys the effect, but there must have been a moment for nearly all enthusiasts when, drawn first to the photograph and then to the small caption, 'Groucho Marx, Actor, Beverley Hills', they found themselves involved in the drama of the exposure of preconceptions. Not, however, for very long. People are rarely inclined to allow a momentary shock of non-recognition to stand in the way of their expectations. Gradually the picture 'clears', and with the help of some common psychological ground rules – 'the melancholy of clowns', for example – it becomes evident that, yes, after all, this is *their* Groucho.

In the example above the resilience of preconceptions eventually succeeds in confirming rather than challenging the ruling idea. In another type of preconception, a quite different variety, the observer (more exclusive or hard-to-please) searches for the single image which acts as a mnemonic for accumulated complex impressions inspired by another's acting (in the case of Marx), writing, music or – more commonly – a physical presence now temporarily or permanently lost. In this latter case, the 'preconception' someone brings to a collection of photographs has the sanction of intimate personal knowledge. At the heart of Barthes' *La Chambre Claire* is a search for the one photograph that will represent all his mother has meant to him. It is right that the reader is never shown the one he discovers because the enterprise is so predominantly solipsistic: the meaning the ideal photograph has for Barthes so overwhelmingly private. What it expresses above all, he explains, is the '*bonté*' which is the chief impression he has had of his mother after all their years of living together.[7]

The image of his mother which Barthes treasures reveals the photograph in its role as charm or relic. In one of the museums in New Mexico the visitor can see a jacket which Lawrence is supposed to have worn whilst he was living there. For most purposes it does not much matter whether this was in fact his, any more than it matters much whether a splinter in an Italian church is indeed a portion of the true Cross. Whatever might seem intrinsically dumb in the object is rendered eloquent by the faith of the believer. Almost in the same category as the jacket – because anyone who looks at it has to provide so much meaning of his own – is a photograph which happens to have survived of Lawrence in his pram. A baby stares innocently at the camera, not yet aware and therefore unsuspicious of the photographer's power. The open-mouthed expression (a consequence perhaps of the 'snuffy nose'

The author of 'Lady Chatterley's Lover' in his pram.

Lawrence described himself as having suffered from continuously in his childhood?) is very similar to that of the much older child in a photograph of Lawrence at his elementary school, or in a famous family portrait taken when Lawrence was eleven. Yet since all babies tend to look alike, it is hard to say what public significance this photograph might have: what it could convey to a general reader about Lawrence as an object of biographical enquiry. For reasons not easy to define, photographs of the subject as a baby are nevertheless very common in biographies. Perhaps this has something to do with the grumbling resentment of the obscure against the celebrated; or more probably it is a consequence of the way a popular Freudianism (the 'primal scene' which governed the life of the 'Wolf Man' is after all supposed to have taken place when he was one and a half) collaborates with a popular belief, most commonly expressed by mothers, that a person's fundamental character traits are identifiable in early childhood.

In this context, it is interesting to note that for Barthes, the most just impression of his mother is a photograph taken long before he was born,

when she was only five. Not that this means Barthes is curious to learn what his mother might have been like before he knew her. On the contrary, either the aspects of her character which escaped his experience leave him indifferent; or he cannot bring himself to believe they could have existed. His attitude is therefore antithetical to that of the ideal biographer (as opposed to the memorialist, for example), who needs to brush preconceptions aside and keep an open mind as long as possible. For him (or her) to imagine that a single image will ever convey the essential nature of the subject is probably a mistake; but what is certainly futile is the hope that such an image could convey that nature to the biography's readers. Barthes claims that Nadar's portrait of Guizot is *'ressemblant'* because it confirms the myth of his austerity, and also that he can recognise in the portrait of Dumas his own sense of that writer's self-satisfaction (*'suffisance'*) and fecundity.[8] This is resemblance at a very low level of significance. Clothes and a little artistry apart, it is hard to believe that the viewer would lose much if, chosen with appropriate care, one or two of the remarkable mug-shots of Belgian criminals which have come down to us from the 1840s were substituted for some of Nadar's famous portraits – of Baudelaire, for example. ('Ah, but then,' the resourceful Lombrosian might protest, 'the gap between the criminal

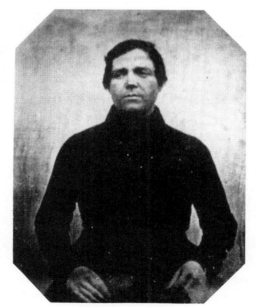

Belgian criminal.

and literary classes is so small.') A friend of mine was apoplectic with rage and embarrassment when the publishers of his edition of *Culture and Anarchy* printed a photograph of J.S. Mill on the dust cover. It was hard to comfort him with the suggestion that, philosophically speaking, and when it is a question of a single image, not much harm was done since one Victorian with side-boards looks very like another. In his film of *Zazie dans le Metro* Louis Malle manages a splendidly comic observation on the arbitrary nature of the relation between a single sign and its visual referent when the uncle, who is taking his niece home in a taxi from the station, waves airily to what he rather pompously explains is the Panthéon whilst the audience is being shown a structure usually designated as the Gare de Lyon.[9]

I mentioned that, clothes and a little artistry apart, the intrinsically biographical difference between a Nadar portrait and one of the Belgian mug-shots is hard to detect; yet why be so perverse as to put clothes apart? They, at least, do usually *mean* something. (It is partly the deliberate reduction to a minimum, in Avedon's portraits, of what one could call sociological props, that makes his work such a courageous gamble.) Early in *Sons and Lovers* the reader is told that Mrs Morel's sisters helped her out with clothes for the children. Looking at the photograph of Lawrence in his pram – the photograph that was apparently without meaning – John Worthen (the author of Volume One of the Cambridge biography) has noted that the clothes seem expensive for a miner's baby; he suggests convincingly that they must have come from Mrs Lawrence's sisters, at least two of whom had married into the middle classes.[10] What the photograph of Lawrence in his pram shows, therefore, is that even from his very earliest days he was already one of those 'in-betweens' he remembered himself as being in the late poem, 'Red-Herring':

> We children were the in-betweens
> little non-descripts were we,
> indoors we called each other you
> outside, it was *tha* and *thee*.[11]

Although the meaning of clothes is usually less specific than this, they are invaluable to the biographer in his role as historian. Reading a great deal by or about a subject so comparatively of our time as Lawrence gives a misleading impression of contemporaneity: the feeling that if he were suddenly to walk into the room there would be no difficulty in

establishing immediate contact. But the knowledge we derive from photographs that, if he did suddenly appear, it would be *in those clothes* is a useful reminder of historical distance.

Clothes can be meaningful in this general sense, but the attempts of subjects, which photographs often reveal, to define themselves in relation to a prevailing sartorial fashion, can sometimes have a more particular significance. People care more or less how they dress, but it is never a matter of complete indifference. In the photographs we have of Lawrence before the Great War, he almost always wears the ubiquitous three-piece suit, but there is a smudgy picture of him at Garsington in 1915 in which he is dressed differently.[12] On his right are Philip Heseltine, later to be known in the music world as Peter Warlock, and Dikran Kouyoumdjian who wisely changed his name to Michael Arlen and was to become rich and famous as the author of *The Green Hat* (1924). In the Garsington photograph Arlen is dressed conventionally, as is Heseltine, whereas Lawrence, already bearded by this stage, is wearing a velveteen or corduroy jacket which buttons up to just below the neck. It is as if, with companions ten years younger than himself who have still to discover who they are, Lawrence, already well-known after the critical success of *Sons and Lovers*, has chosen to appear here as 'the Artist'. The apparition is rare in comparison with the number of images we have of Lawrence in formal or not obviously 'Bohemian' casual clothing, and its rarity confirms a sense derived from the written evidence that the 'Artist' role was one Lawrence adopted only intermittently, was never very comfortable with, and abandoned completely after the war. But that he should occasionally have seen it as an option is important. A photograph may help towards an understanding that he did: it can have that degree of information and suggestiveness; but only if the sights are lowered, the essentialist wild-goose chase given up, and the illusion is abandoned of finding in some single image an illustration of Lawrence's true being.

In Lawrence's 'Introduction to These Paintings' (the paintings he exhibited at the Warren Gallery in 1929, but which were then seized by the police), he complained that English portrait painters of the eighteenth century painted clothes without the bodies inside them.[13] In most photographic portraits of Lawrence it is hard to see more than a vague outline of body through the clothes Lawrence chose to wear. When the interest of clothes is exhausted, therefore, and they have done what they can with 'background' (which is often, of course, also informative and suggestive) biographers are brought back time and time again to a *face*. I have been trying to suggest that the single image of a face is useless as an

index of 'character', but when biographers have given up the ambition of
capturing that dubious entity at one fell swoop, even one photograph can
be of minor use. Most of the portraits we have of Lawrence, for example,
make immediately comprehensible his humorous deprecation of the
shape of his nose. A large, prominent nose, we know from Ludwig, is a
sign of energy (or potency, one might say, remembering Sterne); but if it is
also finely formed then it is aristocratic. In a line which runs from the
Duke of Wellington to W.C. Fields, Lawrence's nose was much closer to
the latter's. This would have no significance if the way a subject feels
about his physical appearance were not also part of the biographical
enquiry (in the case of someone like Pope, a possibly vital one); and if
Lawrence himself had not so often argued against the idea that appear-
ances do not matter. His interest in how he might look to others is evident
in the many descriptions of Lawrence-like figures in his novels. When
others do describe him they often note that it was the shape of his nose
that prevented him from being conventionally good-looking. Lawrence's
own awareness of this is interestingly associated with his whole idea of
himself as both man and writer. In the early days his first literary advisers
– Ford Madox Ford and Edward Garnett – often criticised his work for
its shapelessness and lack of formal elegance. On more than one
occasion, Lawrence's defence of himself includes a reference to noses. On
Christmas Eve 1912, for example, after another 'wigging' from Garnett
about *Sons and Lovers* being too long and sprawling, he writes to his
friend Collings, 'These damned old stagers want to train up a child in the
way it should grow, whereas if it's destined to have a snub nose, it's sheer
waste of time to harass the poor brat into Roman-nosedness. They want
me to have form: that means, they want me to have *their* pernicious
ossiferous skin-and-grief form.'[14] Lawrence is here reconciling himself to
the fact that he was no more destined by Nature to be a matinee idol than
he was to write carefully crafted, elegantly shaped fiction in the post-
Flaubertian manner. The point does not absolutely need visual confir-
mation, but a photograph certainly makes it easier to establish that the
reference to noses in the Collings letter is by no means accidental.

 A single photograph can establish the point about Lawrence's nose,
but it is more reassuring to have it confirmed by several. In general in
biography, the more photographs there are the better. For their very
different reasons, Ludwig and Barthes are content with one; but when it
is a question of the 'life' of a subject one never knew, there is safety in
numbers. Not only is it useful to have a great many photographs, but also
as much information as possible about the circumstances in which they

Robert H. Davis, *Portrait of D. H. Lawrence*, 1928.

were taken. This means information about the sitter's mood and situation at the time (when he saw the picture of a smiling face, pondered Wittgenstein, he might supply it 'with the fancy that the smiler was smiling down at a child at play, or again on the suffering of an enemy'[15]); but also whatever can be discovered about how and by whom the photograph was taken. The portrait illustrated here, which shows so clearly the shape of Lawrence's nose in later life, has the advantage of a detailed, if somewhat self-congratulatory, commentary from Robert H. Davis, the man who took it. Davis had come across Lawrence in Orioli's Florence bookshop in May 1928. He says that from photographs he had already seen he expected him to be 'a strapping fellow with a fierce beard', and was surprised therefore to find him so slight, 'not more than 140 pounds – frail as Robert Louis Stevenson'. Lawrence, we learn, felt that he did not 'make a good picture', although Frieda was delighted with the result on this occasion; the writer had to 'freeze' for six seconds for this portrait, and was advised by Davis to fix his eyes on a spot across the river so that they would 'record interest' and he would not look bored.[16]

The eyes we see here, therefore, are looking from the Lungarno Corsini, across the Arno to a building on the other side.

Although he published his photograph of Lawrence in a collection of portraits called *Man Makes His Own Mask* in 1932, Davis was only a semi-professional photographer. In Orioli's bookshop, he made just two exposures (only one of which is in profile). Full professionals, working in their studios, would be likely to want more. Nickolas Muray, for example, a fashionable Greenwich Village photographer of the period, who photographed Lawrence for *Vanity Fair* in 1923, refers to 'about a dozen';[17] and it is likely that when Weston did his portraits of Lawrence in Mexico City in 1924 there were more than the two we usually see.[18] In the guidelines he laid down for photographic portraiture in 1862, Eugene Disdéri wrote that, 'Ce qu'il faut trouver, c'est la pose caracteristique, celle qui exprime non pas tel ou tel moment, mais tous les moments, l'individu tont entier.'[19] It is likely that some modernised version of this idealist injunction, working together with aesthetic criteria, still determined in Lawrence's time the choice of this or that pose for public distribution, when what would be really valuable, biographically speaking, is them all: not the record of his one or two more or less characteristic moments, but of a whole session. (As with the written evidence, the greatest obstacle to serious biographical enquiry is insufficient information.)

The studio portraits are posed, and the natural logical complement would seem at first to be the 'snapshots' of friends. Typical of these is the photograph Catherine Carswell used as the frontispiece to her memoir of Lawrence, which she published in 1932, two years after his death. She gave the photograph this prominence because it seemed to her to represent Lawrence as she knew him best. She explained in her book how it came to be taken, in Florence in 1921:

I remember a young woman whom I cannot place and of whom I have only a single recollection. A camera is a thing I scarcely ever use, but I had brought a Brownie with me for our walk across the Dolomites, and when I saw Lawrence standing laughing near the parapet I had the sudden desire to take a snapshot of him. I don't think he was more than faintly irritated. Anyhow he went on laughing and did not say anything to stop me. But the young woman thought she divined in Lawrence some serious distaste and tried to prevent the photograph from being taken. At any other time I believe I might have submitted. But feeling certain that Lawrence did not really mind, and longing to have a picture of him in his present light and gay mood, I persisted. I am very glad to have the picture now. It is, I think, a misfortune that by far the most of the photographs and

portraits of Lawrence show him as thoughtful – either fiercely or sufferingly so. His usual expression was a kind of sparkling awareness, almost an 'I am ready for anything' look which was invigorating to behold.[20]

The quality of Carswell's photograph is so poor that it is hard to be confident of beholding anything, or to avoid suspecting that it has a charm – the power to evoke a lost presence – which is highly personal. A general smudginess makes the nose seem quite pointed as well as, since the face is in profile, slightly upturned – a characteristic not obviously apparent in any other view of Lawrence. Yet this lends an air of youthful puckishness to a Lawrence who, in contrast to how he is usually seen (and Carswell is broadly right about the other portraits), seems unusually relaxed and cheerful. This is clearly a photograph of a private Lawrence, 'caught' joking with friends, and as such it nourishes our latent Romantic belief in the truthfulness of the informal over the formal, of the unpremeditated over the self-consciously prepared.

It is not only friendly amateurs who have sought, or felt themselves fortuitously presented with, this kind of truthfulness: Weegee's famous snapshot of Dylan Thomas, for example, is as unposed and off-guard as anyone could wish. But then, of course, neither is it only professionals for

Catherine Carswell, *Portrait of D. H. Lawrence*, 1921.

'Weegee', *Portrait of Dylan Thomas.*

whom Lawrence posed. There is a question as to whether Lawrence was not in fact *posing* for Carswell ('I don't think he was more than faintly irritated. Anyhow he went on laughing and did not say anything to stop me'). A man realises he is going to be photographed, and decides not to alter his demeanour – but that demeanour will change subtly nevertheless. Perhaps it is not very important that it does. Brassai, who appears to have managed to persuade his subjects to pose in the most unlikely positions and situations, could have been right to doubt whether it meant more to catch a subject unawares.[21] A face a man has prepared for public consumption, and that reveals how he wishes to be seen, may be as significant as a snapshot of him.

This is not to say, however, that if the professional Weegee had snapped Lawrence in the way he did Thomas, it is certain that the biographer would prefer the result to Carswell's murky relic. Her description shows that she would have liked to use her photograph to bring home to her reader a conception of the real, or at least most characteristic, Lawrence, but it is too technically inadequate to do that successfully. Weegee's expertise is, by contrast, self-evident, but his

Thomas portrait has two potential disadvantages for biographers. The first is that it may make them think as much of the photographer as their subject. Its second disadvantage is that it threatens to overpower the observer with an interpretation, of becoming at once an image of the familiar 'drunken Welsh poet in decline' which, for the biographer, might then develop into an obstructive, no-need-to-enquire-further cliché.

The biographer needs many photographs – as many as possible – to protect himself against the lure of one or two, but however many he has they will always be no more than records of isolated moments. Still stills. This is more of an embarrassment than it might be with another subject in that the notion of life to which Lawrence was deeply committed, and which he often seeks to convey in his writings, is that of Heraclitean flux. According to this, the captured instant may not only mislead because of what came immediately after or before (as in the Milland anecdote), but has the radical falsity of all arrested movement. 'Anatomy presupposes a corpse', Lawrence was fond of saying, meaning that for life to be analysed it has to be brought to a point where it is no longer available for examination. Hence the value of the remnants of a sequence of portraits of Lawrence which still exist (four, out of the dozen Muray remembered taking); or the regret one might feel that no-one did for him what Nadar did with Eugene Chevreul. If one were trying to draw up a list of developments that have made a radical difference to biography, one of them might well be the filmed interview.

Yet Lawrence on video tape would not solve all the biographer's problems. He was right to imply so often that a genuine encounter with another person, or indeed object, is a complicated synaesthetic experience, and to denounce what Wordsworth had already called in *The Prelude* 'the despotism of the eye'. (Many of his objections apply equally to moving pictures.) His advantage over Wordsworth was that he could characterise mere seeing, what in one context he describes as the 'purely optical', as 'Kodak vision'. In 'Art and Morality' his argument is not what one might at first expect: that the invention of the camera revolutionised people's contact with the world, but that photography was something they had trained themselves to deserve:

Through many ages, mankind has been striving to register the image on the retina *as it is*: no more glyphs and hieroglyphs. We'll have the real objective reality.

And we have succeeded. As soon as we succeed, the Kodak is invented, to prove our success. Could lies come out of a black box, into which nothing but light had entered? Impossible! It takes life to tell a lie.[22]

The 'lie' which Lawrence has in mind at this moment is one of Cézanne's paintings of apples. In *Etruscan Places* he tackles the problem with a more characteristic freedom from irony:

. . . so that one asks oneself, what, after all, is the horsiness of a horse? What is it that man sees, when he looks at a horse? – what is it that will never be put into words? For a man who sees, sees not as a camera does when it takes a snapshot, not even as a cinema-camera, taking its succession of instantaneous snaps; but in a curious rolling flood of vision, in which the image itself seethes and rolls; and only the mind picks out certain factors which shall represent the image seen. That is why a camera is so unsatisfactory: its eye is flat, it is related only to a negative thing inside the box whereas inside our living box there is a decided positive.[23]

The point is obvious enough, and the play on words (negative/positive) perhaps too simple, but Lawrence's remarks make a distinction which for the biographer is essential. It is not surprising that it is a distinction which should have been occasioned by pictures of horses – unrealistic but 'so perfectly satisfying *as* horses' – in one of the Tarquinian tombs. For him the painter always had a better chance of conveying the truth of the world than the photographer. Muybridge's demonstration of how a horse *really* moves – there is no evidence that Lawrence ever saw it – would have left him cold. Like several very different figures, Clive Bell for example, Lawrence was partly attracted to the 'primitive' in art because he believed the camera had functioned as an effective *reductio* of efforts towards pictorial realism.

Lawrence's attitude on these matters remained remarkably constant. In *Sons and Lovers* Paul Morel explains to Miriam that she likes one of his sketches because it is 'as if I'd painted the shimmering protoplasm in the leaves and everywhere, and not the stiffness of the shape. That seems dead to me. Only this shimmeriness is the real living. The shape is a dried crust. The shimmer is inside really.'[24] At the end of his career, in 'Introduction to these Paintings', Lawrence wrote of Cézanne:

In the best landscapes we are fascinated by the mysterious *shiftiness* of the scene under our eyes; it shifts about as we watch it. And we realize, with a sort of transport, how intuitively *true* this is of landscape. It is *not* still. It has its own weird anima, and to our wide-eyed perception it changes like a living animal under our gaze. This is a quality that Cézanne sometimes got marvellously.[25]

About the only concession to the disillusionments of age and experience here is the substitution of 'shiftiness' for 'shimmeriness'. Both passages are of course the work of an essentially religious man; but even those whom talk of 'anima' makes uneasy, and who are disinclined to believe the universe is 'living', are obliged to recognise the life in other human

beings. It is this, of course, which the photographic portrait – still not shifty – fails to represent. Both Sontag and Barthes agree that a photographic portrait is a *memento mori*. One of the senses Barthes seems to attach to this phrase is that the absence of a loved one is made suddenly more cruel and poignant by the illusion the photograph conveys of an immediate presence. Yet photographs are not only reminders of death but are, in their arrested movement, or even in a succession which conveys movement, death itself. In *The Uncommercial Traveller* Dickens describes a visit to the Paris Morgue. He soon tires of looking at a corpse and switches his attention to the crowd surrounding it. Their faces conveyed different feelings but all, he says (the italics are his) 'concurred in possessing the one underlying expression of *looking at something that could not return a look*'.[26] In his 'A short history of photography' Benjamin reports Dauthenday as saying that when people first saw his daguerreotypes they were so amazed by the clarity of detail that they were frightened that 'the little, tiny faces of the people in the pictures could see out at them';[27] but as Lawrence looks across the Arno in the Davis portrait, we are now convinced that there is nothing we could ever do to divert his gaze.

We can never adequately know Lawrence from a portrait. This is not only because of the lack of depth and natural colour, the different scale, the fixed angle and the arbitrary imposition of a frame; but because of a 'livingness' which must always have been an essential part – and if the written records are to be believed, an immediately striking and memorable part – of his contact with others.

If our other means of access to the past were satisfactory, there would be every reason for turning our back on photographs. It is because they are not that photographic portraits remain invaluable. Sontag has done more than most to destroy the notion that a photograph puts one in direct touch with reality but, as she points out, there is a sense in which, scientifically as well as metaphorically, a photograph is a *trace* of the real.[28] Biographers need every trace they can find. There will be occasions when they use a photograph as a prompt for observations which might otherwise have been forgotten, or as a legitimate device for bringing together otherwise scattered material; but when its use is direct rather than incidental, their task is to bring to bear on each image as much relevant information as possible, whilst still leaving the image room to speak for itself. The advantage of a photograph is that, even more than a quotation from the subject's writings (which the biographer can select, edit and surround with commentary), the photograph is likely to speak

out *anyway*. Images are more potent than words, more apt at conveying something quite different from what the biographer intended, and they are, therefore, more useful in reminding all parties what a tentative form of enquiry biography must always be.

9
Likeness as Identity:
Reflections on the Daguerrean Mystique

ALAN TRACHTENBERG

As the earliest example of what the 'photograph' meant, the daguerreo-type continues to haunt the world of the camera. In its day, this peculiarly affecting kind of picture prompted anxious questions regarding what exactly a 'photograph' is, how it works, what it is good for, and how it should look. Though now relegated to the prehistory of photography proper, the daguerreotype at one point raised fundamental issues about photographic representation, and about representation as such. With the demise of the metallic 'mirror image' these issues lost much of their energy, buried, we might even say repressed, by the massive commercial integration of the paper print into conventional systems of portrayal. To re-encounter the daguerrean portrait as a cultural presence on its own ground is to revive unresolved questions, and restore them to the continuing discourse of criticism regarding the character, the work, and the 'good' of the photograph.

The original power of the daguerreotype lay in its physicality. Not only uniquely irreplicable, an image produced without a negative, yet embody-ing the negative-positive nexus on its face, it is also uniquely physical, a solid, palpable object, an image on a copper sheet polished like a hand-mirror and typically set under a gold-plated mat, contained within a small wooden or leather case adorned with tiny brass clasps. It has weight, and yet behaves like a ghost. No wonder it has inspired a diction of its own, rich in romantic tropes of light and dark. Daguerrean portraits lend themselves to a discourse in which atavistic fascination with images as magical replicas, as fetishes and effigies, mingles with sheer pleasure in undisguised technique, in the rigours of craft.[1] The language of the daguerreotype emerged and flowered in the 1840s and 1850s, especially in America, as a mixed discourse of science, technique, art, and magic. And it still flourishes wherever old daguerreotypes are cherished as family relics or avidly collected as precious objects.

Traditional discourses on daguerreotypes typically relate an unex-
pected discovery. Here is a late example, Sadikichi Hartmann in 1912:

A daguerreotype – There it lies in its case among old papers, letters and curios. A
frail encasement of wood covered with black embossed paper. We cannot resist
the temptation to open and glance at it. The clasp is loose: the old case almost
falls apart. A weird tapestry-effect on the inside of the lid greets our eye, and
opposite is a gray blurred image set in a gilded frame with an oval or circular
opening.
 What a strange effect, this silvery glimmer and mirror-like sheen! Held toward
the light, all substance seems to vanish from the picture: the highlights grow
darker than the shadows, and the image of some gentlemen in a stock or some
lady in bonnet and puffed sleeves appears like a ghostlike vision. Yet as soon as it
is moved away from the light and contemplated from a certain angle, the image
reappears, the mere shadow of a countenance comes to life again.[2]

The narrator has stumbled upon something old and neglected, a curio
among other discarded mementoes and refuse of a generation past,
shabby-seeming, ghost-like and ephemeral, yet strangely potent in its
ability to 'come[s] to life again'. In Hartmann's collapsed narrative of
encounter and discovery it comes to life again, moreover, in two separate
senses: the narrator's unclasping the case revives the antique image out of
the dust of the past, restores it to the present, and then the image appears
as it were out of its own shadows, a full emanation of itself.

Hartmann's essay inaugurated a new life for the American daguerreo-
type, an object already long obsolete in 1912 (it had expired before the
juggernaut of the wet-plate collodion and albumen paper process by the
end of the 1850s), as a cultural relic. It appealed in the new age of Kodak
and half-tone, the age of mechanical reproduction, as a relic of an
outmoded photography that produced one-of-a-kind images. Colleague
of Alfred Stieglitz's, spokesman for secessionist photography and then
the 'straight' aesthetic, Hartmann discovered in the daguerreotype a pre-
history for the modern movement he championed. In a brief paean in
1926, Edward Weston named the proto-modernist daguerreotypist as his
precursor:

He was an artisan who dedicated himself to his work with simplicity and without
ambiguities, without finding himself inhibited by the ambitions of his art.
Because the technique of retouching was unknown, there was no way to make
concessions to human vanity – the daguerreotypes were not lies. Although rigid,
those photographs of our ancestors have a rigid dignity. Since the exposures
lasted for minutes, they did not allow for calculated poses. In this manner we
have inherited today the first epoch of photography, the most genuine, the most
honest expression. An image chemically pure, strong and honest, and at the same
time refined: the daguerreotype.[3]

The ghost for Weston is not so much the rigid sitter, but the artisan photographer who enacts the haunting idea of pure, original art.

Hartmann brings us closer to the discourse of mystique by which the daguerreotype found a cultural role, a recognised place and function within the expanding spheres of popular culture in antebellum America. His account of meeting the ghost falls into two parts: the diction of the first paragraph looks ahead to the nostalgic collecting of daguerreotypes in the twentieth century; the language of the second paragraph, its figures of strangeness, of mirrors and ghostly emanations, its inversions of light and dark, and the coming 'to life', all evoke the mid-nineteenth century discourse by which the daguerreotype was recognised, known, and admitted to cultural legitimacy, particularly in the United States. It is that discourse, especially its endowment of 'life' to the daguerreotype, its assimilation of this earliest popular form of the photographic portrait to the trope of the living portrait, which I want to speculate about.

I

I want to focus on that sense of the image coming 'to life', an event which implicates the kinetic behaviour of the viewer – his or her angle of view and body position in relation to available light. The rise of the paper print in the middle 1850s, and the subsequent disappearance of the daguerreotype, changed the physical character of the viewing experience, and muted many of the acute disruptions, as well as pleasures, associated with the displaced mode. To be sure, some of the aura of mystery and speculation was transferred to the stereographic experience.[4] But the 'coming to life' of an image with illusory substance and shadow remained a peculiar daguerrean event and challenge. What happens when this happens, when the daguerrean image flickers into view? Is it a *likeness* which appears, as happens, by definition, in portraits? Or an *identity*, as happens in mirrors or is imagined to happen by means of magical invocation. I mean, of course, not 'what happens', but what was thought to happen, how the daguerrean happening was understood, how the tension between likeness and identity was negotiated.

From the beginning the daguerreotype excited people into states of awe, wonder, reverence clashing with disbelief, and provided a *frisson* of something preternatural, magical, perhaps demonic. A flickering image on mirrored metal, encased like a jewel in a decorated box, the daguerreotype seemed a simulacrum of the real: too real to be understood as just another kind of copy of the world, too immediately compelling to seem only a likeness. Its effect derived, too, from the

image's capacity to negate itself when viewed in another light at another angle, to cancel itself into shadow, and rematerialise, as it were, from within itself. When the eyes go black and the eye cavity appears a blank socket, how startling it is to find in your hands the visage of a skull – as if, as one recent writer puts it nicely, the image 'contains its own death's-head'.[5] Flipping from negative to positive and back (which accounts for the flickering effect), the daguerreotype seems not only alive but dead and alive at once. An image which bears an already-visible trace of its own extinction within its living form, and does so in a portable and intimate physical form: what better *mementi mori* for a time when people died at home, often from epidemic disease, and more often in infancy or childhood? And indeed, in the genre of the 'post-mortem' daguerreotype, the medium provided an image still capable of chilling viewers to the bone.[6] It served, too, as one's own prospective memorial or *et in Arcadia ego*. In a periodical essay reprinted from the French in New York in 1853 a lady 'sighs as she gazes upon' her own daguerrean image: 'Ah, what a sad expression! There is something about the daguerreotype that bespeaks a hand not of this world. Surely, to punish us for penetrating her mysteries, Nature touches us with the shadowy hand of death in revealing them!'[7]

A distinctive mode of address appeared almost at once. It drew from prevailing art practice and theory. Early comparisons likened Daguerre's images to etchings and aquatints, and the American portrait painter and inventor of the telegraph, Samuel F.B. Morse, coined the phrase destined for fame: 'Rembrandt perfected'.[8] This familiarising and idealising vocabulary joined, somewhat uneasily, a more potent set of affective terms from Protestant theology, literary romanticism, and popular gothicism, a synthetic allusive diction of breathing images, spiritual presence, living mirrors, haunted shadows, talismanic likenesses, spell-bound viewers, and *mementi mori*.[9] The daguerreotype stirred archaic reactions to likenesses as such. Nathaniel Hawthorne remarks about portrait painting: 'I remember, before having my first portrait taken, there was a great bewitchery in the idea, as if it were a magic process.'[10] Indelible metaphors for photography as a whole derive from this gothicised discourse – 'mirror with a memory', for example. And with the collecting and revival of historical interest in early photography foretold by Sadikichi Hartmann, old habits of idealisation have returned, colouring the language of curators and historians as well as connoisseurs. I read in the curator's preface to a small catalogue of a recent exhibition of American specimens: 'There is something wonderful, even magical,

about daguerreotypes. They captivate us, inviting our closest scrutiny . . . They are sometimes haunting, sometimes startling, but always personal.'¹¹ Wonderful, magical, captivating, haunting, startling: the core terms of the discourse, the mystique of the daguerrean experience, remain intact.

But does not the discourse persist simply because it is appropriate and true, an accurate account of the way these beguiling miniature images actually affect us? Yes, to be sure – at least in part. No one who has not felt himself or herself spellbound by a daguerreotype portrait, drawn magnetically to the image and beyond, as if it were less an image or likeness than a thing itself, the very identity of the sitter miniaturised and suspended in an ambiguously monochromatic float or medium, can speak knowingly about this mode of photography. Only those who know by experience the sensation of succumbing to the charm of these objects can begin to understand what these objectified likenesses might have meant to their makers and possessors in the past, or the functions they performed within households and between persons, or their hold on the emotions and their influence on consciousness.

This spellbound sensation may even translate into empathy, the opening-of-ourselves to the possibility of reliving experiences inscribed in old objects and art-works as historical knowledge, a knowledge incomplete in itself but indispensable to any larger project of historical analysis and interpretation. By the empathy of the spell we might recover meanings in these old objects as relics of personal histories otherwise lost and forgotten, swallowed up within larger cultural narratives. Every found daguerreotype presents the possibility of restoring to historical consciousness the figure of a person unknown, and very likely unknowable, beyond the visual data of the image. Of course the same is true of any old photographic portrait, but the peculiar physical properties of the daguerreotype, the way its image presents itself on the mirrored metallic surface as legible only at a certain angle of view in a certain light, requires that the viewer play the decisive part in forming the image in his or her own eyes. How often the recorded experience of looking at a daguerreotype begins with a testimony of amazement that there seems to be nothing there, except the mirrored reflection of one's own face! The effort simply to see the image implicates the viewer in the making, the construction of the image. The daguerrean image allows for an engagement between viewer and subject unique in photography; to see the image is to become an active agent in the picture's 'coming to life' as a historical event.

Hartmann concluded his essay on an historicist note:

The daguerreotype speaks a language of its own that touches the common chords of life. The daguerreotype possesses the pictorial magic and historic power to fascinate the many as well as expert minds, for it conjures up to contemporary view and truthfully portrays forms and faces long passed away, things that are dead and lost to living eyes because it was, as [Henry] James would put it, 'the real right thing' in its own peculiar time.[12]

Precisely because of its charm the daguerreotype provides a model occasion for a historicist methodology of empathy, a challenge to learn the 'language of its own' which once 'touched the common chords of life' of an earlier time. That language was and is verbal as much as visual, a discursive speech which familiarised the novelty of the visual image. We need to become native speakers in order to converse with the image on its own terms.

But the daguerreotype also exemplifies the danger of critical understanding thwarted at the site of empathy, arrested, we might say, in and by the discourse of mystique. Like all discourses the daguerrean mystique reproduces itself by unreflective repetition, and becomes a power in its own right, a way of seeing and defining that shapes experience and offers itself as understanding. But we can take the discourse itself as an historical object, an archaeological feature of material objects we cannot in the least understand outside the discursive envelope, and cannot understand entirely within it. We need, in short, a doubled perspective of belief and scepticism, to bring the daguerreotype to life for ourselves, not simply as magic, but as historical experience.

II

What do we mean by calling the daguerreotype image a 'portrait'? There is a literal dictionary sense in which the attributed genre is perfectly sensible – a picture 'of' someone, the 'of-ness' consisting of a likeness, a correspondence of features between what the image conveys and what the living figure looks like. We can hardly object to the commonplace sense of the term; even posed snapshots are called portraits when they show a person showing herself or himself. At the same time we should hear in the word a compressed history of transference of styles, poses, modes of composition, from the formal painted 'portrait' to the mechanically-produced daguerreotype – a history of the formulaic intervention by the photographer into the camera's autotelic act of capturing on a plate whatever falls within the range of its lens. The history of the

Southworth and Hawes, *Standing Portrait of Erastus Hopkins.*
Whole-plate daguerreotype, April 1852.

daguerreotype is a history of such intervention, a history enacted in apprenticeships, informal exchanges of trial-and-error experiences, patented and unpatented technical changes, or 'improvements' aimed at producing an image more in accord with formal portraits, and treatises, handbooks, and journals. The portrait styles most commonly assimilated were the head-and-bust likeness in gentle light of the miniature painting, the republican 'plain style' of forthright, unadorned limning of face and body, and the more elaborate 'grand style' of 'heroic' portraitures and 'conversation pieces.'[13] Countless examples and documents exist for reconstructing the history of the harnessing of the naked power of the daguerreotype into the making of 'portraits', and the story has been told fulsomely, mainly as positivist history.[14] To tell that story as cultural history, as many scholars now understand, requires subordinating chronicles of technical detail to the study of patterns of thought, response, and social function.

One way to learn the language of the daguerreotype is to listen to voices speaking it: ' "I don't much like pictures of that sort – they are so hard and stern; beside dodging away from the eye, and trying to escape altogether. They are conscious of looking very unamiable, I suppose, and therefore hate to be seen . . . I don't wish to see it any more." '[15] Phoebe's unease with pictures of the sort produced by daguerreotypes invokes an early moment in the career of photography in America, a moment of shudder, suspicion, and refusal. This particular moment occurs in Nathanial Hawthorne's *The House of the Seven Gables* (1851), an American romance in which the author attempts, as he has his narrator explain in his Preface, 'to connect a by-gone time with the very Present that is flitting away from us . . . by bringing his fancy-pictures almost into positive contact with the realities of the moment.'[16] A present that flits away, fancy-pictures brought 'almost' into 'positive contact' with 'reality', and portraits that dodge the eye and try to escape (to escape detection?): Hawthorne plays teasingly on that apparent trick of the mirrored metallic face of the daguerreotype image, seeming at once here and gone, a positive and a negative, a substance and shadow. What one sees, a shadow or an image, or indeed one's own visage flashed back from the mirrored surface, depends on how one holds the palm-sized image – at what angle of view, and in what light.

Because of its peculiar image-construction, built up, as one recent expert explains, through accumulated surface granules rather than suspended in an emulsion, what is required for the image to seem legible, or as they said at the time, to 'come to life', is a specific triangulation of

viewer, image, and light.[17] In the face of such contingency and instability of seeing, no wonder that some people, like Phoebe, felt disconcerted by the experience. Others, like Hawthorne in the character of 'the Author' in his Preface, spoke warmly of such 'fancy-pictures' – while many, presumably, felt both unease and pleasure at once. Indeed Hawthorne's 'Author' may also belong among the undecided in regard to the daguerreotype's truth-value, or perhaps to the aptness of the daguerrean metaphor for his own romance: in any case, the qualifying adverb insinuates prefatory doubt and undecidability. As one critic remarks, the narrative itself might be read as a flickering, apparitional, here-again, gone-again daguerreotype portrait.[18]

Hawthorne's prefatory remarks and Phoebe's near-hysterical outcry, both couched in photographic metaphor already conventional at the time, signal how deeply engaged this narrative is with daguerrean seeing, and its ambiguities of effect and ambivalences of purpose. How are we to understand, for example, the full motives and purposes of the novel's ardent daguerreotypist, Holgrave? Before hearing Phoebe's misgivings when he showed her an example of his work, Holgrave had confessed: 'I misuse Heaven's blessed sunshine by tracing out human features, through its agency.'[19] We might be tempted to read 'misuse' as coyly ironic, merely conventional, for is not his practise of daguerreotypy a sign of Holgrave's most appealing traits, his scientific bent, his rationality, his enthusiasm for truth? Phoebe personifies the sun's purest rays. Her female innocence we are surely meant to take as the novel's least controvertible value; in the end it saves Holgrave from himself. Our smile at 'misuse' fades into a deeper, more shadowed concern when we learn of Holgrave's secret purpose of revenge against the Pyncheons, in whose house he resides as a tenant. Is his craft of 'seizing the shadow ere the substance fade', as daguerreotypists advertised their magic, a purposeful atavistic regression to the witchcraft of his ancestors, the original Maules from whom Colonel Pyncheon, founder of the family, had stolen the land for his estate and house two hundred years earlier?

In etching his text with ambiguity and dubiety Hawthorne draws widely on figural terms from the popular discourse of the daguerreotype circulating in the print culture of the 1840s and early 1850s. He draws on that heavily-gothicised discourse not for the sake of local colour, but as a vehicle of his deepest purposes in the romance – in the most general sense, an exploration of modernity and the new systems of meaning of which photography serves as an auspicious type. Alternative views of the daguerreotype portrait, of the autoptic process of direct, apparently

Father Holding his Dead Child, quarter-plate daguerreotype, *c.* 1844.

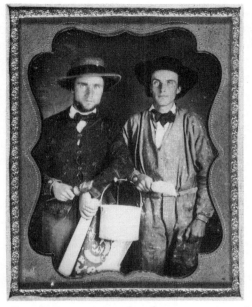

Two Paperhangers, quarter-plate daguerreotype, *c.* 1855.

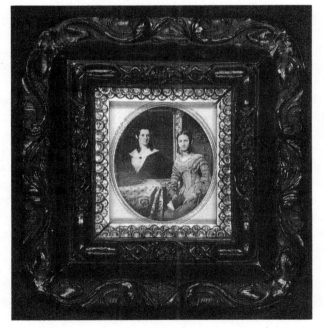

Southworth and Hawes, *Nancy Southworth Hawes next to her portrait in oil, painted by her husband J. J. Hawes*, sixth-plate daguerreotype, *c.* 1848.

unmediated seeing and knowing it supposedly represents, and of the physiognomic principles of portraits as such, serve the novel's ulterior purposes. To be sure, it is a narrative more of picture than action, of tableaux than plot.[20] *The House of the Seven Gables* leaves its largest questions unsettled, its complexities and complications aborted by the quick fix of a hastily arranged fairy-tale ending, in which Holgrave seems to abandon daguerreotypy, along with his resentment and radical politics, for pastoral squiredom. This evasive conclusion reflects on the cultural status of the daguerreotype portrait itself, of photography as a representational practice within a culture undergoing unsettling change toward market-centred urban industrial capitalism.

<div align="center">III</div>

The mix of light and shadow by which Hawthorne paints the character of the daguerreotype recapitulates a pattern of ambivalence, an anxious undercurrent within the overt fascination and celebration that greeted the new medium in 1839. He draws on a fund of covert misgivings, the sort of nagging reservation registered, for example, in Philip Hone's otherwise approving remarks in his diary after viewing the first exhibition of French daguerreotypes in America in December, 1839. Hone states that 'one may almost be excused for disbelieving it without seeing the very process by which it is created. It appears to me a confusion of the very elements of nature.'[21] Among others, Emerson also shared Phoebe's perception of a 'hard and stern' look in the earliest daguerrean portraits. 'The first Daguerres are grim things,' he noted in 1843, 'yet show that a great engine has been invented.'[22] Are we to take 'engine' literally? Indeed, the camera does resemble a machine with moving parts, a polished glass eye, a mysterious chemical procedure. Emerson means, of course, only that photography will prove a great instrument in human culture. But 'engine' resonates or rumbles with other senses. By the 1840s, the word had evolved from the simple sense of a product of ingenuity to the more complex modern sense of a self-powered machine, a self-contained mechanical entity requiring no external power. If the trope links photography with other prominent wonders of the first industrial age, the steam-engine, the railway, the telegraph – a linkage Hawthorne also makes in the extraordinary 'Flight of the Owls' chapter of *The House of the Seven Gables* – it does so by endowing the photograph with nameless internal powers. The open meaning of engine may suggest no more than a mechanical power, but what can it mean to

project upon the daguerreotype an ability to generate its own activity? Similarly Phoebe's language – 'They are conscious of looking very unamiable, I suppose, and therefore hate to be seen' – may seem a conventional rhetorical figure, but it implies a will, a human or extra-human force within the inanimate object. Phoebe's conceit barely restrains an animistic trope common in popular fiction of the 1840s and 1850s: such pictures often possess a life of their own. One might fall in love with them or they with each other, as certain tales imagined.

The *frisson* of an encounter possibly with demons or magicians was often also felt in the experience of sitting before the daguerrean apparatus. T.S. Arthur in an article in *Godey's Lady Book* in 1849 recounts the melancholy tale of a frightened backcountry farmer whose visit to the city brought him into a daguerrean parlour. Once he saw the machinery and the operator's mysterious preparations, he 'dashed down the stairs as if a legion of evil spirits were after him'. The entire experience of having one's image 'taken' exuded a nameless air of possibility, risk, and even erotic temptation. Arthur reports that some clients suffer an 'illusion that the instrument exercises a kind of magnetic attraction, and many good ladies actually feel their eyes 'drawn' toward the lens while the operation is in progress!'[23]

How much such responses derive from and rehearse old superstitions and fears about the power of images, especially human likenesses, and how much is triggered locally by the peculiar surface phenomenon of the mirrored daguerreotype, is hard to say. However, surely much of the response is due to the flickering mirror-effect itself, the sense given off by the image of something actually moving, something alive. Both figures, engine and animation, *hum* with wariness about what living energy may lie within the camera-made image, what latent magic the image might perform, and might have already performed. Again, we need to take the power of rhetorical convention itself into account in weighing the cultural valence of such animistic locutions, but their pervasiveness and persistence suggests at least the residue of belief in living pictures. Here is one N.G. Burgess, himself an 'operator', writing in one of the early professional journals:

No enchantress' wand could be more potent to bring back the loved ones we once cherished than could those faithful resemblances wrought out by this almost magic art of Daguerre. For true indeed has this art been termed magic, as it works with such unerring precision and with such wonderful celerity, that it only requires the spells and incantations of the device to complete the task.

The shaman's spells and incantations transposed to the 'device', produce a 'faithful resemblance' which is both likeness and an identity: this modern avatar of the enchantress, the ancient mother figure, is potent to 'bring back', virtually delivering as a new birth, figures from the past or indeed from death. Burgess continues:

The Daguerreotype possesses the sublime power to transmit the almost living image of our loved ones; to call up their memories vividly to our mind, and to preserve not only the sparkling eye and winning smile, but to catch the living forms and features of those that are so fondly endeared to us, and to hold them indelibly fixed upon the tablet for years after they have passed away.[24]

Burgess and scores of other writers within the newly emerging profession of daguerrean portraitists in the 1850s dipped freely into gothic-tinged diction, but turns of speech like 'faithful resemblance' and 'almost living image' kept their claims safely this side of blasphemy. David Brewster in 1832 provided a system and rationale for imagining modern science and technology as 'natural magic', and daguerrean writers avidly took up the rhetorical trick.[25] They offered magical effects by natural/mechanical means. Daguerrean producers and their publicists fashioned a conceptual frame for their product, a frame which acknowledged simultaneously both the appeal and the threat of the 'living image' trope: the threat of demonism (Phoebe's response: not a very deep threat but discomfiting) and the promise of transcendence, of annihilating space and time (a frequent expostulation in the discourse). Commercial portrait-making moved swiftly ahead in the 1840s, and the daguerrean portrait emerged as a habitual commodity, stratified in appearance and cost to match and reinforce the hierarchy of social class consolidating itself in this first industrial era.[26]

IV

The crux of the historical problem of the daguerreotype lies in that process whereby, in rhetoric and in picture-making, the sensation of something *alive* – a talismanic effigy, a breathing icon – gets transmuted into something *crafted*, an unusually vivid likeness, a resemblance whose relation to its subject is expressed by the qualified '*almost* living image' – in short, a portrait. The aim of the profession was to exalt the maker as 'artist', for how else might the fashionable studios distinguish themselves from the run-of-the-mill 'daguerrean factories' which sprang up in the cities? To claim preternatural power would reduce the maker to a passive (though technically adept) medium, and the entire event to an autotelic procedure. At the same time, the dominant rhetoric retained a hint of the

preternatural, even of divination, partly to distinguish the medium from its predecessors among the hand-crafted methods of portrayal, partly in acknowledgement of the everyday experience of these uncanny images. The problem was of how to preserve the concrete sense of *difference* in this mode of portraiture, and at the same time claim a place for the artefact within the system of formal representation as a 'portrait'. The solution, the generic seal of 'portrait', demystified the image as magic, but remystified it as art.

Daguerreotypes were at first unruly and unregulated experiences. The peculiar link between eye and body at the moment of viewing was one novelty. The character of the flickering image in a mirror was another. And at a deeper level, the way the daguerreotype put into jeopardy conventional expectations about 'portrait' as revelation of 'self' was another. As in all cases of novelty and invention, the new elicited help from the old for explanation and legitimacy. Likeness and portrait on one hand, living image and apparition on the other: both are familiarising terms, the first from the prevailing system of art, the second from surviving archaic mental and emotional habits. The recurrence of archaic reflexes in response to the daguerreotype traces, I think, the startling, often alarming sense of newness, of rupture within commonplace experience, that the first vivid photographs, those of mirrored metal, provoked. In the vividness of their likeness they seemed like half-forgotten dreams of magic mirrors, simulacra, and virtual identities.

This is to speak only of the apparent *presence* of the images, their astonishing exactness of detail, their seeming, as Edgar Allan Poe put it, not a copy but an '*identity* of aspect with the thing represented' [my emphasis].[27] Resemblance, likeness, verisimilitude: such are misapplied, invading the discourse from adjacent systems of formal representation. Indeed, the camera image can be made to resemble a resemblance, to give an effect of likeness, but only under controls (focus, distance, framing, lighting) derived from the formula of likeness. Logically speaking, in the terms invented by Charles Sanders Peirce, what the camera produces is a *trace* rather than an index or symbol, in the order of a footprint or shadow, a literal *impression* of light delineating form and detail from a palpable surface.[28] Photographic images might function within semiotic systems as symbols (referring to general ideas associated with the depicted referent) or icons (referring to an object by arbitrary convention), but their primary logical status remains that of a direct effect of the physical cause the image replicates. The process itself does not imitate; it reproduces. In this, daguerreotypes are no different from

photographs proper; their physical peculiarities only heighten the photo-
graphic experience, rendering it in a mode which served as an extra-
ordinary initiation for modern culture into one of its fundamentally new
conditions: the instant convertibility of experience into image, the
potentiality of endless and continuous doubling of all tangible surfaces,
and the reification of the eye as the leading instrument of everyday
knowledge.

But the daguerreotype startled for other reasons than the uncanny
presence of its images. For just as the polished portraits of the most
masterful makers seem a logical (and ideological) outgrowth of the
formal portrait tradition – centred heads and bodies within fictive
(studio) spaces that are filled with objects signifying possessions, and
with lighting and posing arranged to 'bring out' bourgeois individuality
through 'expression' – the camera was also capable of producing images
that were strange and estranging. It could decapitate as easily as depict a
full head and body, as Samuel F.B. Morse reported about one of
Daguerre's own images of a beheaded man having his shoes shined on a
Paris street corner:

Objects moving are not impressed. The Boulevard, so constantly filled with a
moving throng of pedestrians and carriages, was perfectly solitary, except for an
individual who was having his boots shined. His feet were compelled, of course,
to be stationary for some time, one being on the box of the boot-black and the
other on the ground. Consequently, his boots and legs are well defined, but he is
without body or head because these were in motion.[29]

The camera records motion and duration as blur or absence. Is a 'he'
depicted without body or head still the same 'he?' Is the picture of a
person with a blur in place of a head, or the head cropped away, any less a
picture 'of' that person, no matter how little a *likeness* it projects?

Soon after its appearance photography became a potent source in
modern culture for making the conventional idea of the continuous,
coherent 'self' plausible, but in its most primitive moments, when
Daguerre and others doubted that the medium would ever be suited to
portraiture, it displayed dangerous tendencies to subvert that same
idea.[30] We detect such optical danger in an astonishing likeness the early
Philadelphia daguerreotypist Robert Cornelius produced of himself by
leaping in front of a camera in his garden. To our taste the image seems
wonderfully expressive – not of a 'character', but of the medium itself,
and of its ability to stop an action in its tracks, yet show it continuing as a
blur, or the trace of an event. In the presentness of the moment, in the
sense of the figure throwing itself into the lens – hair flying, eyes seeking

the lens (seeking, that is, their own mirrored reflection) – the image preserves all the original strangeness and difference of daguerreotypy. Such images defined exactly what had to be overcome.[31]

Pedagogies abounded for operators and sitters, prescribing costume and lighting, studio props and bodily and facial expression. Writers of such guides drew particularly on the popular pseudosciences of physignomy and phrenology, and laced their texts with citations from Lavater and Sir Charles Bell.[32] The litany was 'expression of character', and photographers were urged to learn 'the chief power of the old masters in portrait painting', which was 'the ability, while watching the changes and expressions of the sitter's countenance when unconscious of the scrutiny, to keep in mind the best, and after the general form was obtained, to paint them in from memory.' The lesson for the photographer, who must act at once and cannot rely on memory, was that 'outward expression is the revelation of inward feeling, and moods of mind and sentiment are very much under the influence of what affects the senses.' The photographer must provide a setting, an ambiance, conducive to the 'best' bodily expression of characteristic inward feeling. He must attend particularly to 'position' – the expression of inwardness in stillness. 'In position he must remember that every organ and every faculty has a special language. A proud man carries his head erect, a little thrown back, and with a stately air. This is the language of self-esteem.' Pseudoscience lay behind this advice, based as it was upon the codes of phrenology and physiognomy, with a dash of theatricality thrown in. In fact, the codes imply formulas for the *imitation* of inwardness, and resulted in stereotyped poses and in caricature, the underside of the bourgeois fetish of 'character'. For the writer whom I am quoting such formulas signify progress in the art of photography: 'the days of mystery in photography are nearly gone.'[33]

By stilling the sitter and regulating the apparatus, the trade of photography achieved what it sought: a commercially viable and culturally satisfying formal portrait for intimate viewing in galleries, parlours, or private corners. And indeed, the theory of portrait likeness resulted in extraordinary achievements in daguerrean studios and makeshift workshops across the United States. It permitted something revolutionary to develop within the history of Western portraiture, a new kind of collaboration between sitter and artist. The improved apparatus resulted in images of crystalline clarity and presence, while the imperatives of the apparatus, particularly the duration of exposure, eventually shortened to allow for reasonably relaxed self-presentations, even within

the formal portrait frame, and thus gave the sitter considerable control over what the camera saw. Improvisations within the portrait mode changed the entire expectation of portraiture, and had an immediate effect on painting. Cross-fertilisation between painting and photography produced decisive effects in both media; daguerreotype studios employed portrait painters to help pose sitters and arrange lighting, and painters used daguerreotypes (later, paper photographs) as aids in their portraits.[34] No doubt partly as a result of such collaborations, daguerreotype portraits preserve a record of faces and bodies (mainly Euro-American) in an incalculable variety of mood and costume and expressive individuality. (It is a record rivalled in the history of portraits only by late Roman busts.)

If the clarity of the daguerreotype resulted in an unparalleled cultural record, for which the formal codes and conventions of portrait likeness are to be credited, still, the decapitated body and the blurred head never ceased to haunt the high art of this vernacular medium. We detect its power in the increasingly elaborate ornamentation of the daguerreotype case (especially in its depictions of scenes from paintings and statuary in bas-relief), and in the increasingly conspicuous use of colour tints, as if to hold the shadowed image in place. Often the ghost leaps out at us when we remove the plate from its overmat, and we see the signs of the studio, or extensions of the body cropped by the oval or hectagonal mat. At a stroke that act alone, by disclosing what else lies on the plate, replaces the frame with the edge of the plate, undercuts the aptness of the frame and its ideology, as the boundary of a discrete and coherent space inhabited by a unique 'self', whose uniqueness lies as a knowable inscription of manifest inwardness across the body and face. That body, with its pose acting as its expressive vehicle, is assumed to belong to the 'self', and is as much its external and material possession as the objects which define the fictive space. The frame designates closure, self-containment, an act which also signifies at the lower levels the alienation of the sitter's appearance from the sitter's being, the reification of pose and look as definitive possession, an apparatus of a piece with other props. The edge designates something quite different and antagonistic: the contingency of this look and pose upon this event in this place (the studio, not its fictive disguise) and at this time. It designates a relation of image to sitter as that of a radically contingent identity, rather than as an emblematic likeness. The frame encloses and makes utterly still; the edge continues and implies motion, and more accurately expresses the photographic act itself.

For Emerson, in the stillness of the daguerreotype portrait lay deceit:

Were you ever Daguerreotyped, O immortal man? And did look with all vigor at the lens of the camera or rather by the direction of the operator at the brass peg a little below it to give the picture the full benefit of your expanded & flashing eye? and in your zeal not to blur the image, did you keep every finger in its place with such energy that your hands became clenched as for fight or despair, & in your resolution to keep your face still, did you feel every muscle becoming every moment more rigid: the brows contracted into a Tartarean frown, and the eyes fixed as only they are fixed in a fit, in madness, or in death; and when at last you are relieved of your dismal duties, did you find the curtain drawn perfectly, and the coat perfectly, & the hands true, clenched for combat, and the shape of the face & the head? but unhappily the total expression had escaped from the face and you held the portrait of a mask instead of a man. Could you not by grasping it very tight hold the stream of a river or of a small brook & prevent it from flowing?[35]

The mask is still, the expressive face is in motion, and the mask is separable from the man. Hawthorne wrote after seeing himself in a photographed portrait, 'I was really a little startled at recognising myself so apart from myself.' And again, 'There is no such thing as a true portrait. They are all delusions.'[36] Melville simply refused to be photographed by the camera, while Whitman courted it obsessively, each sitting an occasion for another self-making, another emblem of the self's freedom to shift from role to role.[37] In the case of these exceptional sitters (exceptional, at least, in that they left articulate records of their doubts), the daguerreotype even as a portrait likeness seemed to destablise the idea of self and character which underlay American liberal individualism in the nineteenth century.

That idea and ideology informed the course of the daguerreotype's development in the fifteen years or so it held sway in America before the Civil War. To recognise the tension within that development between likeness and identity helps bring the daguerrean record to life as culture and history. Likeness and identity accrue specific and opposing cultural valences within specific historical occasions, the former serving generally as a conventional token of individuality, the latter as a challenge to convention. The popular ideology of individualism served, at least in part, as a bulwark against the alienating effects of the expanding capitalist marketplace and industrial system. Yet it produced its own estranging effects, of which the reification of likeness as the true representation of character provides one instance. Alexis de Tocqueville understood this cultural paradox. Writing in 1835 about middle-class Americans, he observed that each person, 'living apart, is as a stranger to the fate of all the rest; his children and his private friends constitute to

him the whole of mankind. As for the rest of his fellow citizens, he is close to them, but does not see them; he exists only in himself and for himself alone; and if his kindred still remain to him, he may be said at any rate to have lost his country.'[38]

Tocqueville helps us gloss the American daguerreotype, to parse its visual phrases and translate its passages into our own critical tongue. He describes a plot which may provide a key to the aura of sadness and loss these images often convey. Under the aegis of the theory of likeness, the daguerreotype provided a space and time for inward reflection, and the thoughts (physiognomically expressed) seem rarely happy or satisfied, and often simply blank. When he talks of 'that strange melancholy which often haunts the inhabitants of democratic countries in the midst of their abundance, and that disgust at life which sometimes seizes upon them in the midst of calm and easy circumstances', Tocqueville might be speaking of the daguerreotype portrait.[39]

Some admirers discern iconic Americans in these portraits, exuding boundless optimism, pride of character, and an openness to a world spiritual heroism.[40] Any generalisation will stumble over contrary evidence, especially generalisations from the daguerreotype to national traits, if simply because their social profile under-represents whole sections of the nation: the poor, the enslaved, the incarcerated, the unskilled, the excluded and expropriated. It is white middle-class America we see in the main, with marginal figures typically displayed as exotic. And in this limited social panorama, in facial creases and the hump of heavy middle-aged white male bodies, in worry lines etched in the faces of women, and in the solemnity of children, Tocqueville's strange melancholy often seems more present than pride and hope. Do such images portray the costs of individualism, the compulsive booster-ism, gamesmanship, and blindness to others excoriated by leading critics of the time? And also, perhaps, the delusion of selfhood as an unalienable likeness that this ideology of individualism fostered? There are risks in leaping to such conclusions, but it is safe to venture that the daguerreo-type confounds the historical tensions between likeness and identity. However, the tensions remain, and all the more vividly bring these images 'to life'. Likeness *as* identity invariably offers itself as contingent with likeness *and* identity. It is a continuing effect of the daguerrean mystique.

10
The Family Photograph Album: So Great a Cloud of Witnesses[1]

PHILIP STOKES

To look at the portrait of an individual is to invite oneself to all sorts of speculations as to who they were, how they would have spoken, what they would have thought. To look at a family group is to add the assumption of a whole thicket of connections between the sitters; most viewers allow themselves the pleasure of extravagant supposition. The pull is as powerful when the group is contained in a single image, as when multiple images are grouped in collection.

The family grouping, because it requires the artist to deal with a number of persons simultaneously, has tended to belong to the more expensive reaches of the traditional art market. The family is thus treated there far less frequently as a subject than is the individual, and its grandness swells accordingly. By comparison, photography and its lowly manifestation, the family album, hardly have the same prestige; but there is something about the scale and collectivity of the photograph album that holds our attention and attracts our curiosity.

The family album and its attendant boxes of assorted prints bulk as large in the cupboards of their owners as all the associated manufacturing activities do in the annals of the photographic industry. Yet there is a mist of diffidence around it all. Mainstream critics, uncomfortably aware that whatever there might be to say about the album would inevitably take them outside their regular discourse into territories where the standard art-photography games lose their meaning, mumble about the essential privacy of the snapshot and its boringness to outsiders.

Owners are more subtle, as a rule. While superficially as disparaging as the critics, they constantly manoeuvre conversations towards that moment when the visitor may be construed as having asked, or indeed be seduced into actually asking, to see the photographs. Then, with a familiar flourish, the apparatus is unveiled and the munitions delivered. Albums flood out from cupboard hiding-places, their leaves turning;

slides come apart or stick in projectors; split shoeboxes disgorge packets into amorphous mounds.

Family album viewing can be intensely boring. The rolling catalogue of names and places deflects one's curiosity, stringing the images into a visual 'muzak', and leaving the viewer holding on to consciousness and sanity only by means of ribald mental caricature. And yet in every dreary litany there is an instant – I resist any Barthesian tendencies to define it with a name – when a window opens onto a scene of fascination that stops the eye and seizes the mind, filling it with questions or simple joy. The anticipation of such instants, and the knowledge that a sensitive owner will have structured the whole viewing around them, has me always ready to plunge off into new forays through family images.

The potential for intensity in such encounters, and the persistence and scale of the image-making activities that family albums embody, convince me of their importance. My purpose here is to examine merely some facets of these activities, rather than trying to construct any unified theory. Despite their interest, I rule out the earliest albums, such as Talbot's or Llewellyn's, because they were precursive, operating in an elevated, charmed circle of privilege. Likewise, I rule out the albums dominated by the *carte-de-visite* trade – precisely because it was a trade and so did not give room for the personal views of the subject to be fully realised.

Towards the end of the nineteenth century the democratisation of image-making advanced, especially with the introduction of the Kodak roll film cameras in 1888. As a consequence there were many more albums, and their contents became much more varied. In albums from this period through into the twentieth century it is commonplace to find traditional studio portraits alongside trade processing of the 'you press the button, we do the rest' variety, while more and more images were also produced by those keen to do the whole thing, from shooting to printing, for themselves. To judge from the styles of the albums (the Kodak price catalogue for 1904 shows some 47 varieties of album[2]), as well as from the proliferation of activity, this was a period when photography had thoroughly permeated family life, but was still in the foreground of awareness; it had not yet merged into the pattern of the wallpaper.

It is instructive to note that the illustrations in the catalogue mentioned above show album pages populated by a mixture of formal portraits and landscapes, just like a typical contemporary catalogue for a show of paintings. This suggests a public aspiration towards the assimilation of photography into more traditional forms of art. However, the content of

Studio Postcard Portrait.

the family album as it is disclosed to inspection is another matter, proposing a very different agenda; or perhaps, a plurality of agendas.

Formal portraiture changed in principle hardly at all from the period of the *carte-de-viste*, through the vogue for the larger cabinet portraits, to the eventual postcard print (an economical little image that could be, and frequently was, sent through the post as a correspondence card). Using standard backgrounds, minimal props and simple lighting the local studio photographer could turn out large amounts of cheap technically sound postcard prints. Families could go along; babies might be plonked down naked on a cushion to be memorialised without a thought for the eventual embarrassment that would be caused to them. It seems as though older parents often packed off their teenage children to slip into adult personae before the camera, as they left a record of a point of passage and, privately, satisfied a certain twinge of adolescent narcissism, while remaining, above all, *proper*, in a proper situation.

When it came to family portraits done outside the studio, the complicating factors multiply. There were still numbers of travelling photographers who would, if asked, photograph the family in a group on the steps of their house, or in the garden; so that the existence of such an image by no means determines that it was taken by a member of the

family. Be that as it may, the family standing outside the house is a dominant motif. Whether the house was a cottage, one of a terraced row, or stood alone in varying degrees of detached splendour, the front door became a point of congregation when its inhabitants were photographed. No doubt this accords with the general habit of identifying sitters with their material possessions – a matter to which I shall return.

In the portraits one can discern the play of individuality against collectivity, and the acting out of hierarchies, even rivalries, takes place in a dumb theatrical show. The elders, placed centrally at or near the front of the group, are surrounded by relatives, offspring and others. The family, by modern standards large and often extended, is portrayed in a consistent way; but variations within that theme constantly intrigue the viewer. Consider the elder, in the foreground, confident, leaning nonchalantly a little off the visual centre, which is occupied by the dominant male. Note the would-be challenger and the way he makes up for being further back by his upright stance, and the presence behind him of two younger supporters, one of whom rests his hand on the challenger's shoulder.

Then discover that this image is only partly about a family. For we are being shown the holiday get-together of the members of a small engineering firm: given that framework, all the dynamics fall into place. There is also the valuable lesson that internal evidence alone may be very

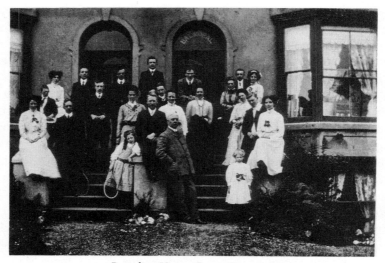

Boarding House Group Portrait:
The dynamics of a family and professionally connected group.

inadequate. For not only do there turn out to be sub-genres, of the private house group and the boarding house group, for instance, but where facts can be checked, one discovers that there may be little if any visual evidence to discriminate between the occasions for taking these group photographs. Even weddings do not necessarily declare themselves.

People still take group photographs today, but somehow they are not quite the same. I ask myself whether this is because of the greater care that used to have to be taken in preparing the bulky roll-film camera, or the bulkier and more awkward plate camera (the 'hand and stand' as the popular versions were called); but referring to the albums and the frequency of group portraits within them, I sense that there was a greater need to mark solidarities, to take every possible step to map the forms of one's personal society.[3]

Such a view is underscored by the work of the Documentary Photography Archive in Manchester in bringing together photographs made by members of the various immigrant communities and religious groupings in that city, where there was considerable recording of processions and specific ethnic events. Thus, alongside the records of indigenous church, Sunday school, brass band and like events,[4] we find a marked emphasis by immigrant Italian families upon the Catholic aspects of public processions in their areas of the city. The Documentary Photography Archive material suggests that while the subgroups sought to project their distinctiveness, they also sought a collectivity which is exemplified partly by the similarity of the individuals making up the groups, and partly by the co-existence of photographic records of a range of such groups within the same albums.

But if the fact of grouping is significant, then so also is the location of groups or individuals. We have already noted the house door as a venue for photography; but it is by no means clear how far we are seeing the association of people with the house as an object, or how far we are being shown some kind of mapping onto an important social space. The mapping notion may be supported by the fairly uncommon, but persistent, images of groups photographed not in a cluster, but distributed throughout the whole visual field, often a garden. All attend to the camera, few are close enough together for physical contact; the adventurous may even be discerned up amongst tree branches. This photographic strategy is virtually never seen today, and its disappearance argues for a conceptual shift, whether as an artifact of changes in photography or in a wider cultural sense.

There may be some kind of halfway house in the photographs taken of

The Garden Archway. *The Garden Archway. (To frame the subject, or as a sign of pride?)*

people standing under, or on either side of, garden archways. These images are both persistent and frequent; in a randomly selected album, out of 41 photographs in a garden environment, 11 were of subjects posed in conjunction with archways. Perhaps they argue for a metaphor of passage between spaces, or perhaps they show that people liked to assert the importance of their property by indicating that it could be divided into more than one space: flower and vegetable, leisure and work, *otium cum dignitatem*. Perhaps they were simply proud to have the skills and resources to construct such things.

There is little or no equivocation in the matter of other objects, especially those connected with transport. People in horse-drawn chara-bancs attend to the camera as avidly as do the more fortunate or later travellers in motorised vehicles. Certainly we see the pleasurable antici-pation of travel; are we also seeing a triumphant aspect of the sense of increased power for the individual to move at will, that had so alarmed the London upper classes as they considered the possible consequences of

Returning from Aberystwyth, Easter 1917.

the masses invading the Great Exhibition in 1851? When individual transport enters the scene, as bicycle, car, or later, aircraft, it is clear that subjects were very keen to be recorded with their possessions.

To judge from the way the vicissitudes of mechanised travel were recorded, whether they involved the repair of the frequent punctures in tyres, or more heroic struggles, these were regarded as confirming the virility and fortitude of the travellers. Sometimes the party clusters around the defunct car as though it were the carcass of some lion shot on safari, while the chauffeur labours away like an askari with his skinning knife.

If motoring adults are the most flamboyant displayers of property, children must be the most persistent – and children's games are the most assiduously recorded of activities. When children's play is recorded as a body of images, say in an album, what comes across is a look that suggests direction by the photographer, but in a different sense from that conveyed in photographs of adults. On the whole adults are simply put in front of the camera and told to look as if they are enjoying themselves. Children though, are often photographed with the clear intention of seeming to have been observed in play; or else, when taken more formally, to be shown as being in charge of their playthings, especially dolls. They act out a proprietorial role that looks more directorially imposed than spontaneous.

With the coming of the roll-film camera, and even with the plate camera, there was little impediment to making images of children playing naturally, so that one wonders at the usual rigid poses.[5] Perhaps it was

technical timidity; or perhaps an unwillingness to record the disorder and untidy behaviour of the children, who were, after all, the family's centre and its future.

Perhaps there was even an attempt by the adults to recapture moments of their own childhoods, a restaging of those memories that persistently recurred like framed pictures, and which they would like their own children to relive, but better: 'see, they have more toys than I did' or even 'what we sacrificed for her to have that'. Often children posed wearing bathing costumes in the edge of the sea, solemnly holding a doll in front of them; they might be photographed in several successive years, growing larger. Such tantalising items apart, the abiding impression is of children at work told to enjoy themselves come what may, never mind the hardship of being cold out of the water, or frozen whilst posing with the toboggan when they could be riding it – a mirroring of the labour which is such an inescapable aspect of so much so-called pleasure in the adult world.

The deeper truth might be that the parent photographers have dragged their child subjects through to the adult side of the looking-glass without perceiving that in so doing they have left behind essential qualities of the play that makes up so much of a child's world; they have produced photographs to convince and tantalise themselves, while leaving the children feeling distanced from the images without quite knowing why.

Much has been made of the fact that, on the whole, amateur photography takes place during periods of leisure rather than at work,

Children working hard at their play.

and that the leisure most recorded is that which comes in slices large enough to accommodate travel away from home. Despite all the speculation to the contrary, it seems to me that this bias of activity is one of the least mysterious photographic phenomena. On the one hand, work is work and usually combines familiarity with the lack of opportunity to record it, if that had crossed one's mind. On the other, holidays are supposed to be about having time to look about and do what one chooses; above all holiday-makers hope that things will be different, tremendously memorable and thus eminently suitable to be photographed. Surely it is in the contest between this aspiration and actual experience that the holiday snapshot gains its particular character.

Another important factor must be that it is only during a holiday that the amateur photographer has the opportunity to become accustomed to his camera. The results are thus more relaxed than is the case with the occasional snap. Perhaps we may see this in the photographs that recur down the years: the bather on the edge of the sea, the person walking towards the camera, the woman gathering up the child. These images are caught time after time, generation after generation, at exactly the same point of movement, presenting the same item of body language, giving an identical glance to the photographer. Rather than mocking a visual cliché, we might consider the possibility that what is represented is an archetype of visual memory, that is, the key data needed to summarise an entire experience. It could be that one of the qualities of photography is the ability of the medium to realise the typical appearance of those sample slices of time, strung together like beads in the mind, that make up our memories.

More photographically scurrilous and often, though not necessarily, less precisely rendered, are the instants when the skirts blow up or when people get themselves into some kind of state of knottedness, hovering on the verges of indecency, as they change on a beach, or horseplay around the picnic cloth. Photography goes from being merely voyeuristic, to arrogating a licence for turpitude, which extends from the subjects who will sometimes act up to the camera, to the photographer who feels licensed by his camera to lurk where he will. In the pages of *Punch* for these years, it seems that this often meant skulking around the women's bathing machines; one might guess that the wit of the cartoons transformed a very real irritation for some, and a obsessive preoccupation for others, into a flippant stalking horse for essentially opposed social attitudes. How much it was simply a matter of invoking the power of the eye or evoking a phallic intrusion, and how much a matter of acting out a

An aspect of motoring.

kind of saturnalian role reversal behind the mask of the photographic apparatus, is a source for conjecture.

All this recording of holiday-makers drove out the topographical imagery which used to be manifested in the form of professionally made albumen prints in varying degrees of grandeur; except so far as echoes might be seen amongst the ubiquitous postcards, or in the painstakingly done and often excruciatingly boring landscapes to which amateurs had recourse when threatened by artistic stirrings. It was only when people were set in a landscape, so that the photographer dealt with them and the land on similar levels of importance, that one can see a pleasant unmanneredness in the photographic style.

What, for instance, is it that draws participants to photograph and be photographed on a bridge? This motif or idiom is more common than that of the extended group, referred to above; indeed it crops up everywhere, despite being difficult to attain, since the photographer usually had to go off at right angles to the bridge, and often ended up working from a considerably lower level than the subjects. Groups were arranged, despite the restricted standing room; it is not hard to imagine the frustrations expressed by others who wanted to cross while all the

posing was in train. Perhaps the two rows of men shown in one memorable photograph, set close and pressed against each parapet of a Welsh bridge, were a response to some such imperative.

It seems the quality we most attentively fix on in pictures from the family album is either an insistent strangeness, or a typicality so clear and intense that we can hardly imagine discovering it in an ordinary day's encounters: strangeness by another route. One might argue that life is inherently more curious than may be entrapped in any one photographed moment; but an opposing contention suggests that the photographs are curious only because they have been snipped out of the context of ordinary lived experience, to remain as little else than cues for our own fictions. My contribution is to argue that human life is so complex that it would be wrong to seek to justify any interpretational instrument so blunt as a binary choice; if we care for the subtlety of things, why not admit the tinctures of both sorts of curiosity to our readings?

The structuring of any collection of photographic images is important – and family material is no exception. There were more ways to proceed than via the album: single pictures were framed in profusion on walls, or arranged in serried ranks on tables. Several photographs might be mounted in the same frame, and mounts could be bought joined up, to display photographs in the form of miniature zig-zag screens. However, generally *ad hoc* flexibility was the norm. In any case, the numbers of photographs in any practicable display are small compared to the numbers in an album.

By the coming of the period thought of as the Kodak era, albums had moved on from the splendid productions for the *carte-de-visite* and the cabinet portrait, with their chromolitho decorations on elaborately constructed pages.[6] Now, pages were either blank, for photographs to be stuck down at the owner's whim, or provided with masks cut out in various single or multiple arrangements. These masks were sometimes formal in their style, but frequently displayed an extraordinary mix of sizes and figures, ranging through all the rectangles, including the diamond, to ovals and circles. Now the result seems quaint, but at the time the main effect of such a profusion was to bar any more individual layout.

The most usual way of proceeding was the most obvious one, whereby prints were inserted as they came back from processing, and the life of a family unfolds as a succession of outings, sittings-out in gardens and holidays. Sometimes there is editing to emphasise the highlights; to viewers at the time this probably seemed merciful. However, the

collections which include every possible permutation amongst group members, and all the moves from front door to garden archway, to child's playpen, bring us to a better understanding of what was considered to be visually interesting at the time of taking. The minutiae of change in persons, their clothing, possessions and situations may easily be followed in these collections, and it can be fascinating as well as historically valuable.

More sophisticated versions of the chronological sequence may be found in those albums which deal exclusively with one event, say a holiday overseas, and take in postcards or other material to establish the scene in which the action recorded by the family had taken place. The most evolved of this type of collection is either the rare fully organised visual diary, again, usually dealing with travels; or the record of the early life of a child (frequently called the 'Baby Book', or, in the case of Alfred Stieglitz's study of his daughter Kitty, *The Journal of a Baby*).

Albums can be put together in a more interesting way than the simple representation of a temporal sequence. Perhaps a group of images might open with a front-door photograph of the family, showing the parents middle-aged and surrounded by their children. It may be followed by a pair of images that show the husband and wife both younger and older than in the opening shot. Then perhaps there might be a pairing of a spotty albumen print of one of the daughters as a child, seated by a woman who looks like her grandmother, against a still perfect gelatine print of the daughter grown up, with her own baby – thus revealing the changes in both human being and technical process.

The process of structuring and restructuring the family album reveals how the status of photographs ebbs and flows between that of precious object and an autumn leaf ephemerality. What one generation builds, another reconstructs and a third may discard, only to earn the perpetual resentment of a fourth generation, who scrabble archaeologically to find what they may amongst the remnants. Some people throw away photographs without a thought, others could not bear to tear up even one; still others cut and tear out of hate and fear. And what is saved, or cut, or torn, from time to time shows someone holding up a photograph, image to the viewer, as they themselves are photographed. The whole image, by a typically photographic paradox, may in a moment of fancy appear to carry a child photograph, gestating in the womb of time. Less fancifully, it memorialises a memorial.

So it is that the album, humble to the point of embarrassment, is one of

the more complicated arenas of photographic representation and organised cultural evidence. These untidy masses of images should never be ignored, and instead cherished for the cloud of witnesses contained within.

References

1 *Roger Cardinal, Nadar and the Photographic Portrait in Nineteenth-Century France*

1 Gaspard-Félix Tournachon (1820–1910) shortened his jocular nickname 'Tourna-dard' to 'Nadard' and then 'Nadar', signing himself thus from around 1842. As a professional caricaturist from 1846 on, he doubtless prized the name's connotations of pertinence and energy (*le dard* means dart or piercing weapon); in 1856 he even served an injunction to stop his brother Adrien from usurping the trademark. Nadar's flamboyant signature, entered beneath his caricatures and his photographic prints, and later reproduced as a large gas-lit sign on the façade of his studio building, became an instantly recognisable logo which stood for qualities of vision and creative verve.

2 See B. Vannier, *L'Inscription du corps: Pour une sémiotique du portrait balzacien* (Paris, 1972).

3 Pierre Abraham discusses Balzac's zoomorphic comparisons in *Créatures chez Balzac* (Paris, 1931). In the informative essay 'Physiognomie animale' (in his *Aberrations*, Paris, 1957), Jurgis Baltrusaitis traces the amusing history of the correspondence between human and animal features and its apotheosis in the humanised animals and zoomorphic humans of Grandville's album *Animalomanie* of 1836.

4 The obvious precedent is David Octavius Hill's painting *The First General Assembly of the Free Church of Scotland* (1843), which groups no less than 470 figures based on photos taken by Robert Adamson. This work, of course, did not involve caricature.

5 See 'Les Primitifs de la photographie', in *Quand j'étais photographe* (1900), reprinted in *Nadar. II: Dessins et écrits*, ed. Jean-François Bory (Paris, 1979), pp. 1163–1217.

6 *Nadar. II: Dessins et écrits*, op. cit., pp. 1214–1215.

7 An even more jovial Dumas posed in about 1860 for a similar portrait, squatting this time on a more comfortable velvet stool with flamboyant tassels. This prop crops up in several studio portraits of the 1860s, and notably one of the brash young Edouard Manet of around 1865. It is also used in a family photograph of Nadar's son, Paul, in 1859, where the tassels form a witty visual rhyme for the child's careless tresses. See illustration in Erika Billeter, *Malerei und Photographie im Dialog* (Berne, 1977), p. 70.

8 See Nigel Gosling, *Nadar* (London, 1976), p. 2. Much the same pose had been popularised by David's 1812 portrait of Napoleon, though Balzac's hand-to-breast gesture suggests artistic rather than imperial authority.

9 *Nadar. II: Dessins et écrits*, op. cit., p. 977.

10 The Gothic motif of the painted portrait with the uncanny gaze is a striking ingredient of Charles Maturin's novel *Melmoth the Wanderer* (1820), which much influenced Balzac. It seems plausible to suppose that by the 1840s the photograph would have acquired literary status as an emblem of the magical or the spectral, though I have been unable to trace any instance of a French Romantic tale in which a photographic portrait is credited with paranormal qualities.

11 The exact date of this sitting remains uncertain. Jean-Louis Bory inclines to the sensational by citing mid-January 1855, a week or so before Nerval was found hanged in a dark alley on 26 January. (See his preface to *Nadar. I: Photographies*, Paris, 1979, p. 33.) This is unlikely, given that Nadar – who, as a friend of the poet, had nursed him during an earlier crisis in January 1852, and was one of the first called to the scene when Nerval's body was found – makes no reference to any such dramatic conjunction. Moreover, the fact that Nerval displayed highly disturbed behaviour for at least a fortnight prior to his suicide makes the hypothesis of a formal studio appointment with Nadar improbable at that time. Jean Senelier's date of 1853 (see his *Gérard de Nerval. Essai de bibliographie*, Paris, 1959, p. 326) seems too early, for there is no hint of the prints having influenced the caricature of Nerval in the *Panthéon* lithograph of March 1854. The cautious solution is to date the sitting to late 1854 (cf. Norma Rinsler, *Gérard de Nerval*, London, 1973, p. 18), and possibly a little after Nerval left Dr Blanche's clinic on 19th October. The two photographs were printed together for the first time a whole century later, in Jean Richer's *Gérard de Nerval* (Paris, 1953), pp. 96–97.

12 Albert Béguin, *Gérard de Nerval* (Paris, 1945), p. 88.

13 'Je suis l'autre' is the disquieting motto which Nerval scrawled under an engraved likeness of himself done in 1853 or 1854 by Eugène Gervais (known for his 1850 pastel sketch of Balzac on his deathbed). In a letter to a friend in May 1854, Nerval writes: 'Tell everyone the portrait is a good likeness – though a posthumous one'. (See Raymond Jean, *Nerval par lui-même*, Paris, 1964, p. 53.) While I do believe that Nerval was responding to his engraved image as a locus of psychotic delusions concerning his identity – and while I am tempted to associate such an identity-crisis with a late-Romantic conception of the fractured sensibility, which is relevant to the way Nerval's image was construed by mid-century artists and critics – I am obliged to draw back cautiously here and point out that, despite Raymond Jean's suggestion (p.53), Gervais's rather meek handiwork is most unlikely to have been based on Nadar's haunting prints. The fact is that, in both photographs, Nerval keeps his hands in his lap, while in the engraving he raises one hand thoughtfully to his chin, and indeed adopts a slightly different body angle. As Ben Sowerby rightly comments of Gervais's image: 'the face, with its clear eyes and firm smooth cheeks, is placid and self-assured; the delicate hand is posed artificially against the chin, not supporting it. This, certainly, is not the real Gérard.' (*The Disinherited: The Life of Gérard de Nerval*, London, 1973, pp. 141–42.)

14 Quoted in *Nadar. I: Photographies*, op. cit., p. 253. We may note that Nadar, in his last years, was to write a quirky memorial to his long-dead friend: *Charles Baudelaire intime* (Paris, 1911), making the claim that the poet was impotent.

15 Another print from the same session shows an even less forceful Baudelaire, standing woodenly with hand tucked into gaberdine, in the pose which Balzac had made fashionable. See *Etienne Carjat, 1828–1906. Photographe* (Paris, 1982), p. 21.

16 Nadar's pioneering use of artificial light for portrait work after dusk led to his taking out a patent in February 1861. His subsequent use of the technique was typically daring – a photo-report on the Catacombs and the Paris sewers. Along with his experiments in taking pictures from a balloon, this earned Nadar the renown of being the first man to take photographs both beneath and above the earth's surface!

17 Some may discern a hint of macabre insolence in Baudelaire's expression. It may be noted that, in March 1860, Baudelaire had dedicated to Nadar a sonnet, 'Le Rêve d'un curieux', about a nightmare in which the poet dies and stands contemplating the void before which death's curtain is slowly raised. I sense a private joke here, with the curtain as a sardonic allusion to the cameraman's 'shroud'.

18 To dismiss Disdéri as simply the mass-producer of images in dubious bourgeois taste

would be to overlook the surprisingly perceptive insights into the photographic aesthetic of his 1862 treatise *L'Art de la photographie*. See Robert A. Sobieszek, 'Photography and the Theory of Realism in the Second Empire: A Re-examination of a Relationship', in *One Hundred Years of Photographic History: Essays in honor of Beaumont Newhall*, ed. Van Deren Coke (Albuquerque, 1975), pp. 145–59.

19 *Nadar. II: Dessins et écrits*, op. cit., p. 1190.

20 See *Henri Victor Regnault. 1810–1878* (Paris, 1979); and André Jammes, 'Victor Regnault, Calotypist' in *One Hundred Years of Photographic History*, op. cit., pp. 77–82.

21 See *Charles Nègre. Photographe. 1820–1880* (Paris, 1980), especially pp. 9–129.

22 Baudelaire liked to insist that black dress epitomises modernity. See Richard Stamelman, *Lost Without Telling. Representations of Death and Absence in Modern French Poetry* (Ithaca, 1990), p. 57.

2 *Stephen Bann, Erased Physiognomy: Théodore Géricault, Paul Strand and Garry Winogrand*

1 See Lorenz E.A. Eitner, *Géricault – His Life and Work* (London, 1982), pp. 241–9. The fine exhibition of Géricault, held at the Grand Palais from 10 October 1991 to 6 January 1992, took place after this essay had been written. It is, however, fair to say that this unequalled manifestation of the different facets of the painter's work did not significantly advance discussion on the precise subject of the paintings of the insane. Four were indeed grouped together (the exception being the Winterthur *Monomane du commandement militaire*). The catalogue entry, suggesting that all these works were painted between Winter 1819 and Winter 1822, argued strongly that Dr Georget would have been too young to have commissioned them, and suggested that a more likely medical authority would have been Esquirol. Whether or not the case rests there (and no further evidence is adduced to support the point of view), it is clear that the factors affecting my own discussion remain largely untouched. Equally, the view that the whole series constitutes a plea for the '*normalisation* of the mad' is at the very least arguable. It is possible to agree with the concluding emphasis on the 'obliquity of the look' in the *Monomane du vol*, and, no doubt, on the claim that, with Géricault, 'painting becomes introspective'. But such assertions require a more extended discussion, such as I would claim to have given here. (See exhibition catalogue, *Géricault*: Réunion des Musées Nationaux, Paris, 1991, p. 244 ff.)

2 Quoted in Denise Aimé-Adam, *Gericault et sontemps* (Paris, 1956), p. 327. The passage is from the *Literary Gazette*, 10 June 1820.

3 Géricault did, of course, also paint severed heads in the Morgue in the period immediately preceding the *Raft of the Medusa*. It is interesting that one of the most conventional of these, which uncharacteristically glosses over the fact of dismemberment, has recently been reattributed to his friend, Charles-Emile Charpentier, as a result of a signature revealed during cleaning (*Study of a Severed Head*, c. 1818/19, Art Institute of Chicago).

4 Aimé-Adam, *Géricault*, op. cit., p. 226.

5 Eitner, *Géricault*, op. cit., p. 242.

6 René Girard would no doubt explain the occurrence on a social, rather than an individual, basis as the characteristic modern manifestation of 'mimetic desire'. (See René Girard, *Things Hidden Since the Foundation of the World*, London, 1987, p. 283 ff.)

7 Jan Goldstein, *Console and Classify – The French Psychiatric Profession in the Nineteenth Century* (Cambridge, 1987), p. 154.

8 Ibid., p. 233.

9 For the historiographic parallels developed here, see Stephen Bann, *The Clothing of Clio – A Study of the Representation of History in Nineteenth-Century Britain and France* (Cambridge, 1984), especially Chapters 1 and 2. It is necessary to point out that Thierry's portrayal of Becket as a Saxon hero does not correspond to the facts.

10 See Roland Barthes, 'The photographic message', in *Image, Music, Text*, trans. Stephen Heath (London, 1977), pp. 15–31.

11 Michael Fried, *Absorption and Theatricality – Painting and Beholder in the Age of Diderot* (Berkeley, 1980).

12 Michael Fried, *Courbet's Realism* (Chicago, 1990), p. 29.

13 Ibid., p. 45.

14 Norman Bryson, *Word and Image – French Painting of the Ancien Regime* (Cambridge, 1981), p. 43.

15 Ibid., p. 55.

16 On the implications of this linguistic codification of painting, as developed by Le Brun's master Poussin, see Louis Marin, 'On reading pictures: Poussin's letter on *Manna*', in Elinor Shaffer, ed., *Comparative Criticism*, 4 (1982), pp. 3–18.

17 Bryson quotes specifically from the work of the French art historian, Pierre Francastel, who proclaimed that the fresco of the *Tribute Money* in the Brancacci Chapel incorporated the lessons of 'universal visual experience . . . The goal of representation will be appearance, and no longer meaning' (Bryson, op. cit., p. 7).

18 See *Courage and Cruelty: Paintings and their Context*, III, exhibition catalogue: Dulwich Picture Gallery, 1990, p. 49.

19 Ibid., pp. 95–6, and Bryson, op. cit., pp. 44–7.

20 See Walter Benjamin, 'A Short History of Photography', in *Screen*, XIII, (1972), p. 7.

21 Charles Darwin, *The Expression of the Emotions in Man and Animals* (abridged edition: London, 1934), p. 1.

22 Ibid., pp. 127–8.

23 See T.J. Clark, *The Painting of Modern Life* (New York, 1985), pp. 205–58.

24 See Stephen Bann, *The Inventions of History* (Manchester, 1990), pp. 171–99.

25 I am grateful to James Lastra for drawing this short film to my attention. The first version of this essay was presented at a conference on 'Painting and Photography in the Light of Cinema', held at the Institute for Cinema and Culture at the University of Iowa, 5–7 April 1991. The helpful response of many members of the audience was of great use to me in the preparation of this final version.

26 For a further investigation of the status of the Vendée in Restoration France, see Stephen Bann, op. cit., pp. 206–13.

27 Strand immersed himself in provincial France in his search for 'motifs that would reveal what he considered as the essence of life in rural communities'. Naomi Rosenblum, 'Paul Strand: Modernist Outlook/Significant Vision', *Image*, XXXIII, 1–2 (1990), p. 8.

28 See P. Galassi, *Before Photography – Painting and the Invention of Photography* (New York, 1981).

29 Rosenblum, 'Paul Strand', op. cit., p. 3.

3 *Pam Roberts, Julia Margaret Cameron: A Triumph Over Criticism*

1 F.C. Tilney, *The Principles of Photographic Pictorialism* (London, 1930).

2 'Annals of my Glass House', manuscript notes, 1874 (RPS Collection).

3 Ibid.

4 Ibid.

5 From the 'Report of the Jurors of the Exhibition', *The Photographic Journal*, IX (1864).

6 'The Photographic Exhibition', *The Photographic News*, VIII (June 3, 1864), pp. 265–6.

7 'Exhibition of The Photographic Society of Scotland', *The Photographic News*, IX (January 6, 1865), p. 4.

8 'Report of the Exhibition Committee', *The Photographic Journal*, X (May 15, 1865), pp. 62–4.

9 'The Photographic Society's Exhibition', *The British Journal of Photography*, XII (May 19, 1865), pp. 267–8.

10 'Annals of my Glass House', manuscript notes, 1874 (RPS Collection).

11 Ibid.

12 A.H. Wall, 'Practical Art Hints: A critical review of artistic progress in the domain of photographic portraiture', *The British Journal of Photography*, XII (Nov. 3, 1865), pp. 557–9.

13 'Soirée of The Photographic Society', *The British Journal of Photography*, XIII (June 15, 1866), pp. 285–6.

14 'The Exhibition Soirée of The Photographic Society', *The Photographic News*, X (June 15, 1866), pp. 278–9.

15 'Annals of my Glass House', manuscript notes, 1874 (RPS Collection).

16 *Mrs Cameron's Photographs*, priced catalogue: German Gallery, Bond St, 1868 (The Photographers' Gallery, London).

17 'Photographic Exhibitions in London', *The Photographic News*, XII (March 20, 1868), p. 134.

18 H.P. Robinson, *Pictorial Effect in Photography* (London, 1869).

19 'Meeting', *The Photographic Journal* (May 15, 1869), pp. 33–5.

20 'Photographs at the Derby Fine Art Exhibition', *The Photographic News*, XIV (October 28, 1970), pp. 511–12.

21 'The Photographic Exhibition (Sixth notice)', *The British Journal of Photography*, XVIII (December 22, 1871), pp. 600–1.

22 'The Photographs at the International Exhibition', *The British Journal of Photography*, XX (May 9, 1873), pp. 216–17.

23 'Photography at Vienna. No. II–England', *The British Journal of Photography*, XX (July 25, 1873), pp. 351–2.

24 *Mrs Cameron's Gallery of Photographs*, 9 Conduit Street, November 1873 – January 1874. Articles from the press. 16 pages (RPS Collection).

25 Letters to Miss Moseley, dated Freshwater, September 28, 1875 and October 10, 1875 (RPS Collection).

26 Marianne North, *Recollections of a Happy Life* (London, 1892).

27 'The Late Mrs Julia Cameron', *The British Journal of Photography*, XXVI (March 7, 1879), pp. 115–16.

28 'Photographs – Ancient and Modern', *The British Journal of Photography*, LIII (August 31, 1906), p. 685.

29 'Exhibition of Photographs by Julia Margaret Cameron', June 23rd–July 31st, 1904. With a note by Mrs Meynell. The Serendipity Gallery, 118 Westbourne Grove, London. 12 pages (RPS Collection).

30 'The "Little Gallery" at Brockenhurst (South Western) station', Letter to the editors from G.T. Harris, Sidmouth, *The British Journal of Photography*, LVI (October 29, 1909), p. 850.

31 'Exhibitions: "Old Masters" at Hammersmith', *The British Journal of Photography*, LXIII (November 3, 1916), p. 600.

32 *Exhibition of Photographs by Julia Margaret Cameron*. July 4th – August 12th, 1927. The Royal Photographic Society of Great Britain, London (RPS Collection).

33 'Annals of my Glass House', manuscript notes, 1874 (RPS Collection).

34 'The Late Mrs Julia Cameron', *British Journal of Photography*, XXVI (March 7, 1879), pp. 115–16.

35 Lady Troubridge (formerly Laura Gurney), *Memories and Reflections* (London, 1925).

4 *Graham Clarke, Public Faces, Private Lives: August Sander and the Social Typology of the Portrait Photograph*

1 August Sander, 'The Nature and Development of Photography', Lecture 5, 1931, as quoted in *August Sander, Photographs of an Epoch, 1904–1959*, with a preface by Beaumont Newhall and commentary by Robert Kramer (Philadelphia, 1980), p. 40.

2 Ibid., p. 40.

3 *August Sander, Citizens of the Twentieth Century*, ed. Gunther Sander, text Ulrich Keller, trans. Linda Keller (Cambridge, Mass. 1986), p. 1.

4 See *August Sander, Citizens of the Twentieth Century*, op. cit., pp. 23–35.

5 Ibid., p. 17.

6 See, in this context, Alfred Döblin's Introduction to Sander's *Antilitz der Zeit* (1929), reprinted in *Germany: The New Photography, 1927–33*, ed. David Mellor (London, 1978), pp. 55–59. Döblin notes that, 'You have in front of you a kind of cultural history, better, sociology of the last thirty years.' The images are an example of 'how to write sociology without writing'.

7 See pages 23, 24 and 63 of *August Sander, Citizens of the Twentieth Century*, op. cit.

8 John Tagg, *The Burden of Representation, Essays on Photographies and Histories* (London, 1988), p. 37. The whole of Chapter One is of significance.

9 See 'The Work Art in the Age of Mechanical Reproduction' in Walter Benjamin, *Illuminations*, ed. and Introduction Hannah Arendt (London, 1970), p. 233.

10 A 'study' of portraits by photographers of photographers yields a rich source of significance as to how the portrait is framed and composed, and bears directly upon the tradition of self-portraiture in oil painting.

11 I use the term in relation to Walter Benjamin as suggested in 'A Short History of Photography'. See *Classic Essays on Photography*, ed. Alan Trachtenberg (New Haven, 1980), pp. 199–216.

12 'Punctum' and 'studium' are pervasive terms in Barthes' *Camera Lucida* (1980).

13 See Umberto Eco, 'Critique of the Image' in *Thinking Photography*, ed. Victor Burgin (London, 1982), pp. 32–38.

14 Ibid., pp. 45–46.

15 John Berger, *About Looking* (New York, 1980), p. 34. The essay 'The Suit and The Photograph' is on pages 27–36.

16 John Tagg, *The Burden of Representation*, op. cit., p. 37.

17 Susan Sontag, *On Photography* (Harmondsworth, 1979), pp. 60–61.

18 Erving Goffman, *Stigma Notes on the Management of Spoiled Identity* (Harmondsworth, 1963), p. 11. The whole text is of significance.

19 *August Sander, Citizens of the Twentieth Century*, op. cit., p. 4.

20 Arbus's *Identical Twins* and her *Masked Woman in a Wheelchair* (discussed on p. 91) are reproduced in *Diane Arbus* (New York, 1972).

21 Physical size here is crucial. Sander's image stresses the horizontal rather than the vertical, cutting their bodies in half and further 'squeezing' them into their 'midget' context. The image is fraught with ambiguity and ambivalence. Arbus photographs height and shortness in a similar way – using it as an aspect of an extreme world of difference. It is part of her declared aim 'to photograph the private, secret experiences of people and of worlds hidden from public view'. In Sander the formal pose increases

precisely this sense of a private identity offering a mask for public affirmation – or otherwise. The 'mask' is, of course, basic to both of their visions.

5 *Dawn Ades, Duchamp's Masquerades*

1 *The Little Review* (Winter, 1922).
2 Katherine Dreier, *Western Art and the New Era* (New York, 1922), pp. 112–13.
3 See also Richard Brilliant, *Portraiture* (London, 1991), for a discussion of this as 'anti-portrait'.
4 Robert Lebel, *Marcel Duchamp* (Paris, 1985), p. 133.
5 Ibid. p. 133.
6 Marcel Duchamp, *Notes and Projects for the Large Glass*, ed. Arturo Schwarz (London, 1969), p. 98. A spoof text entitled 'Man Before the Mirror', written by a German friend of Man Ray's and signed by Rrose Sélavy, was published in *Man Ray, Photographies 1920–1934* (Paris, 1934). It described men standing before the mirror absorbed in their secret vice of vanity.
7 Marcel Duchamp, *The Essential Writings of Marcel Duchamp*, eds. Michel Sanouillet and Elmer Peterson (London, 1975).
8 Jean Clair, *Méduse* (Paris, 1989).
9 There is a print of this version in Mme Duchamp's collection.
10 Jacques Lacan 'The Mirror Stage as Formative of the Function of the I as Revealed in Psychoanalytic Experience', *Ecrits; A Selection*, trans. Alan Sheridan (London, 1977).
11 Ibid., p. 3.
12 During the brief New York Dada period in 1921, Man Ray made a short film for Duchamp, which was ruined while being developed, in which a barber shaved the pubic hairs of the Baroness Elsa von Freytag-Loringhoven. Man Ray sent a salvaged shot in a letter to Tristan Tzara. (See Robert Reiss, ' "My Baroness": Elsa von Freytag-Loringhoven', *New York Dada*, ed. Rudolf Kuenzli (New York, 1986).
13 See Jean Clair, *Méduse*, op.cit., for a discussion of the Medusa legend, and the way it exemplifies the face/genitals substitution. He also brings forward evidence that the Medusa face was originally male.
14 André Breton, 'Giorgio de Chirico', *Littérature*, no.11 (January, 1920), p. 28.
15 Quoted in André Breton, *Anthologie de l'Humour Noir* (Paris, 1940), p. 223.
16 *The Evening World*, April 4, 1916.
17 Marcel Duchamp, *The Essential Writings of Marcel Duchamp*, op. cit., p. 16.
18 Jean Clair has discussed the relationship between photography and perspective in the *Large Glass* in 'Opticeries', *October*, no. 5 (Summer, 1978).
19 *Essential Writings*, op. cit., p. 28.
20 See *Essential Writings*, op. cit., p. 38.
21 See *Notes and Projects*, op. cit., p. 212.
22 Pierre Cabanne, *Entretiens avec Marcel Duchamp* (Paris, 1967), p. 54 (my translation).
23 Ibid., p. 118. Picabia's painting, *L'Oeil Cacodylate*, was exhibited at the Autumn Salon of 1921; Picabia had invited friends and visitors to his studio to sign it. Duchamp probably signed it after returning to France in June 1921, after the brief episode of New York Dada. The first manifestation of Rose Sélavy accompanied the work *Fresh Widow*, signed 'Copyright Rose Sélavy 1920'. The double R, to transform the common christian name into '*arroser*', first appeared on Picabia's painting.
24 Serge Stauffer, *Marcel Duchamp: Die Schriften* (Zurich, 1981).
25 In the 1942 *First Papers of Surrealism* exhibition catalogue in New York, Duchamp reproduced a photograph of an emaciated woman, a sign of the American Depression, to identify himself. He had played a similar game with false identities, although with a

reverse effect, in 1924, when Picabia reproduced on the cover of the final issue of his magazine *391* a drawing of the boxer Georges Charbonnier; everyone thought it was a portrait of Duchamp, because the two resembled one another 'like two drops of water' (Duchamp, *Entretiens*).

26 See, for instance, the *Marcel Duchamp* exhibition catalogue, edited by Gloria Moure (Barcelona, 1984).

27 Arturo Schwarz, *The Complete Works of Marcel Duchamp* (London, 1969), p. 484.

28 Quoted in ibid.

29 J.-F. Lyotard, *Les trans formateurs Duchamp* (Paris, 1977).

30 It was this object and not the photo-collage, as Schwarz states, that was used for the cover. The glass-stoppered bottles used for perfume, incidentally, are almost identical to those used for certain scientific experiments, especially those adapted into a triangular shape for the experiments in stereometry that so interested Duchamp.

31 The heavy, feathered velvet hat Duchamp wears could well have figured among Tappé's creations of the previous winter. *New York Dada* also reproduced Stieglitz's 'double exposure' of a bare leg wearing a high-heeled shoe, and the face of Dorothy True, the feminist and suffragette.

32 Hans Arp, 'I become more and more removed from aesthetics', *On My Way* (New York, 1948), p. 48.

33 Georges Bataille, 'La Figure Humaine', *Documents*, no.4 (September, 1929).

34 The second set of photographs is often dated, like the first, to 1921, but a later date, between 1922 and 1924, seems more likely. They were made in Paris rather than New York, but as will be argued below, were affected by the New York milieu.

35 Francis Naumann, 'Marcel Duchamp: a reconciliation of opposites', *Marcel Duchamp: Artist of the Century*, eds. Rudolf Kuenzli and Francis Naumann (Cambridge, Mass.), p. 22.

36 The editor of *Vanity Fair*, Frank Crowninshield, was a friend of Beatrice Wood's family, and advised her when the New York review *The Blind Man*, jointly edited by herself, Duchamp and Henri-Pierre Roche, looked set to create a scandal.

37 See David Hopkins, 'Hermeticism, Catholicism and Gender as Structure: A Comparative Study of Themes in the Work of Marcel Duchamp and Max Ernst', unpublished PhD thesis, University of Essex, 1989.

38 See interview by Nicola Greeley-Smith, 'Cubist depicts Love in Brass and Glass: More Art in Rubbers than in Pretty Girl!', *The Evening World* (April 4, 1916).

39 Laurence Housman, 'What is Womanly?', *Vanity Fair* (London, 1917). (Not to be confused with Crowninshield's publication, New York 1914–1936.)

40 James Joyce, *Ulysses* (London, 1960), p. 613.

41 The detachment of masculine and feminine qualities from the biological characters of man and women was summed up by Freud in the 1915 footnote to *Three Essays on Sexuality*: that the biological characteristics of masculinity – aggression, greater muscular development and greater intensity of libido – were not necessarily assigned to the male in the animal species, and so on. Duchamp's close friends and patrons in New York, Walter and Louise Arensberg, possessed a full set of Freud's works, and it is reasonable to assume that they also possessed a copy of Havelock Ellis.

42 Havelock Ellis, *Man and Woman: a study of human secondary sexual characters* (London, 1904), p. 448.

43 Ibid., p. 440.

44 Katherine Dreier, *Six Months in the Argentine; From a Woman's Point of View* (New York, 1920).

45 Ellen Key, *The Woman Movement* (New York, 1912), p. 138.

46 Julia Kristeva, 'Women's Time', *The Kristeva Reader* (Oxford, 1986), p. 193.

47 Joan Rivière, 'Womanliness as a Masquerade', *International Journal of Pyschoanalysis*, 10 (1929), pp. 303–13.
48 Max Stirner, *The Ego and His Own* (1912), p. 209.

6 *Eric Homberger, J.P. Morgan's Nose: Photographer and Subject in American Portrait Photography*

 1 Some of the ideas developed here were first tried out in a symposium held under the auspices of the European Society for the History of Photography held at Vevey, Switzerland, in July 1989.
 2 See Ron Chernow, *The House of Morgan* (London and New York, 1990), pp. 48, 86–7.
 3 Edward Steichen, *A Life in Photography* (New York, 1984), ch.3 (unpaginated).
 4 Judy Dater, quoted in Ben Maddow, *Faces: A Narrative History of the Portrait in Photography* (Boston, 1977), p. 469.
 5 Henri Cartier-Bresson, *The Decisive Moment* (New York, 1952).
 6 *Georgia O'Keeffe: A Portrait by Alfred Stieglitz*, with an Introduction by Georgia O'Keeffe (New York [1978]), unpaginated.
 7 Sue Davidson Lowe, *Stieglitz: A Memoir/Biography* (London [1983]), pp. 222–3.
 8 Dorothy Norman, *Alfred Stieglitz: An American Seer* (New York [1973]), p. 135.
 9 Doris Ulmann to Averell Broughton, 4 October 1929, private collection, quoted in David Featherstone, *Doris Ulmann, American Portraits* (Albuquerque [1985]), p. 43.
10 Jean Haskell Spear, 'Introduction', *The Appalachian Photographs of Earl Palmer* (Lexington, KY [1990]), p. xliii.
11 Featherstone, op. cit., plates 15–36.
12 On this subject, see Sarah Knights, 'Change and Decay: Emerson's Social Order', in Neil McWilliam and Veronica Sekules, eds., *Life and Landscape: P. H. Emerson: Art & Photography in East Anglia 1855–1900* (Norwich, 1986), pp. 12–20, and Christopher M. Lyman, *The Vanishing Race and other Illusions: Photographs of Indians by Edward S. Curtis* (Washington, D.C. [1982]).
13 Featherstone, op. cit., plate 24.
14 *The Daybooks of Edward Weston*, ed. Nancy Newhall, 2 vols. (Millerton, NY, n.d.), I, pp. 101–2.
15 Ben Maddow, *Edward Weston: His Life* (New York, n.d.), p. 104. Maddow's text differs significantly from that transcribed by Nancy Newhall in her edition of the *Daybooks*, I, p. 46.
16 Maddow, *Edward Weston*, p. 151.
17 Maddow, *Edward Weston*, p. 157. The 'toilet' was his justly celebrated photograph, *Excusado*, about which his own mixed feelings appear in the *Daybooks*.
18 Maddow, *Edward Weston*, p. 106.
19 Quoted in Maddow, *Faces*, p. 419.
20 Dorothea Lange, with Daniel Dixon, 'Photographing the Familiar', *Aperture*, no. 1 (1952), pp. 4–15.
21 Linda Nochlin, 'Women, Art and Power' in *Visual Theory: Painting and Interpretation*, eds. Norman Bryson, Michael Ann Holly and Keith Money (Cambridge [1991]), pp. 21–3, which includes a b/w plate of Gérôme's painting.
22 Antony Penrose, *The Lives of Lee Miller* (London [1985]), pp. 15, 18.
23 Janet Malcolm, *Diana & Nikon: Essays on the Aesthetic of Photography* (Boston [1980]), pp. 11–12.
24 The subjects: Frederick Keisler, Marcello Mastroianni, James T. Farrell, Norman Mailer, William Golding. See *Diane Arbus: Magazine Work*, with texts by Diane

Arbus and essay by Thomas W. Southall, ed. Doon Arbus and Marvin Israel (New York [1984]), pp. 24, 26–7, 30–1.

25 Ann Thomas, *Lisette Model* (Ottawa, 1990), pp. 146–55.

26 Patricia Bosworth, *Diane Arbus: A Biography* (New York, 1984), p. 167. Bosworth is the principal source for Arbus's life, though Arbus's estate refused her permission to reproduce any photographs.

27 Gidley, *American Photography* (No place of publication, 1983), p. 40.

28 Bosworth, op. cit., pp. 363–4; Estelle Jussim, *The Eternal Moment: Essays on the Photographic Image* (New York [1989]), p. 109.

29 Quoted in Bosworth, *Diane Arbus*, p. 175.

30 *Avedon Photographs 1947–1977* (London, 1978), plate 128.

31 Ibid., plate 55. Taken in Avedon's New York studio in June 1961.

32 Richard Bolton, 'In the American East: Richard Avedon Incorporated', in *The Contest of Meaning: Critical Histories of Photography*, ed. Richard Bolton (Cambridge, MA [1989]), pp. 261–82.

7 Mick Gidley, *Hoppé's Impure Portraits: Contextualising the American Types*

1 Much of the data in this essay was derived from an examination of the negatives and accompanying files in the Mansell Collection, London; I am grateful for the assistance of the Director, George Anderson. Hoppé, *New Camera Work*, exhibition catalogue with a Foreword by John Galsworthy, Goupil Gallery (London, 1922); subsequent Galsworthy quotations in this essay are from his brief and unpaginated Foreword.

2 Hoppé, C.S. Coombes, et al., *Photography* (London, 1911). For biographical material on Hoppé, see his own autobiography, *One Hundred Thousand Exposures* (London, 1945), supplemented by: Mick Gidley, 'Hoppé's Romantic America', *Studies in Visual Communication*, XI (1985), pp. 11–41; E.O. *Hoppé: 100,000 Exposures*, exhibition catalogue by Nancy Hall-Duncan, with an Appreciation by A.D. Coleman: The Photo Center Gallery, New York University School of Arts (New York, 1982); and Bill Jay, 'Emil Otto Hoppé, 1878–1972', *Studies in Visual Communication*, XI (1985), pp. 4–10, which is also the source of the Hoppé quotation (p.6).

3 Hoppé, *The Book of Fair Women*, with an Introduction by Richard King (London, 1922).

4 Interview with Margaret M. Lukes for the Sunday edition of the Philadelphia *Public Ledger* of June 19, 1927; I am grateful to Jay Ruby for providing much information, including this clipping from the Richard Hoppé collection. The *Daily Despatch* comment is quoted in Jay, op. cit., p. 8.

5 See, for example, Ernst Gombrich, 'The Mask and the Face; Perceptions of Physiognomic Likeness in Life and in Art', in his *The Image and the Eye* (Oxford, 1982), pp. 105–36; and John Berger, 'The Changing View of Man in the Portrait', *Selected Essays and Articles: The Look of Things* (Harmondsworth, 1972), pp. 35–41.

6 Montaigne, *Essays*, ed. and trans. J.M. Cohen (Harmondsworth, 1958), p. 338. Eastlake is quoted in Mary Cowling, *The Artist as Anthropologist: The Representation of Type and Character in Victorian Art* (Cambridge, 1989), p. 7. Eastlake's classic 1857 review of photography for the *Quarterly Review* is excerpted in Vicki Goldberg, ed., *Photography in Print* (New York, 1981), pp. 88–99.

7 Schopenhauer, as quoted in Aaron Scharf, *Art and Photography* (Harmondsworth, rev. ed. 1974), p. 346. H. Furst, *Portrait Painting: Its Nature and Function* (London, 1927), pp. 50–5, 67, 127.

8 Hawthorne and Ryder quoted in Goldberg, op. cit., pp. 74 and 76, respectively. Weston, in *Edward Weston on Photography*, ed. Peter C. Bunnell (Salt Lake City, 1983), pp. 135–9. Arbus quoted in Goldberg, op. cit., p. 511.

9 Max J. Friedlander, *Landscape, Portrait, Still-Life: Their Origin and Development*, trans. R.F.C. Hull (Oxford, 1949), p. 231. Furst, op. cit., p. 2.

10 And Berenson even insisted that 'for reasons of many kinds, the effigy prevails over the portrait, and the more a portrait is like an effigy, the more popular it is.' See his *Aesthetics and History* (Garden City, NY, 1953), pp. 218–19, 220. J. Berger, 'The Changing View', op. cit., pp. 37–8.

11 R. Simon, *The Portrait in Britain and America, with a Biographical Dictionary of Portrait Painters 1680–1914* (Oxford, 1987), especially the chapter on 'Practice'; much of the sheer information was derived from James Ayres's specialist work on *The Artist's Craft: A History of Tools, Techniques, and Materials* (Oxford, 1985).

12 Weston, op. cit., pp. 138–9. M.A. Root, *The Camera and the Pencil*, reprint ed. (Pawlett, VT, 1971), p. 165. For a discriminating discussion of photographic portraiture in nineteenth-century America, see Alan Trachtenberg, *Reading American Photographs: Images as History, Mathew Brady to Walker Evans* (New York, 1989), pp. 21–70. For Disdéri, see Gisèele Freund, *Photography and Society* (London, 1980), pp. 55–61, 65–8.

13 See A. St John Adcock, *The Gods of Modern Grub Street* (London, 1923) and *The Glory That Was Grub Street* (London, 1927). The portrait of Lady Lavery served as the frontispiece to *New Camera Work*, and both Epstein and Shaw were reproduced in Hoppé's *One Hundred Thousand Exposures*.

14 Quoted in Jay, op. cit., p. 6, my italics.

15 Hoppé, *One Hundred Thousand Exposures*, p. 87. Hoppé, *Romantic America* (New York, 1927), plate 19.

16 Peter Conrad, *The Art of the City: Views and Versions of New York* (New York and Oxford, 1984), p. 110.

17 Barthes, 'The "Blue Guide" ', in *Mythologies*, ed. and trans. Annette Lavers (London, 1972), pp. 74–7. The chapter on 'The Sublime and the Picturesque' in Francis D. Klingender's *Art and the Industrial Revolution*, ed. and rev. by Arthur Elton (London, 1968), constitutes a definitive exposition of artistic uses of types of the poor to create the preferred view. For fuller discussion of the cityscapes in *Romantic America*, see Gidley, op. cit., *passim*, and for Hoppé's nostalgic representation of England, see Ian Jeffrey, 'E.O. Hoppé: A Victorian in Modern Times', in *Cities and Industry: Camera Pictures by E. O. Hoppé*, exhibition catalogue: Impressions Gallery (York, 1978), pp. 6–8.

18 J.D. Beresford and E.O. Hoppé, *Taken from Life* (London, 1922). W. Ridge, *London Types Taken from Life* (London, 1926). The 'group psychology' information is from a typescript of Hoppé's autobiographical notes, probably for a lecture (Richard Hoppé collection).

19 The Wordsworth lines are from Book VII of 'The Prelude', which also says 'the face of everyone/That passes by me is a mystery!' (W. Moelwyn Merchant, ed., *Wordsworth: Poetry and Prose*, London, 1969). More generally, see, for example, Georg Simmel, 'The Metropolis and Mental Life' (1905) in *The Sociology of Georg Simmel*, ed. Kurt Wolff (Glencoe, IL, 1950), pp. 410–13; Walter Benjamin, *Charles Baudelaire: A Lyric Poet in the Era of High Capitalism*, trans. Harry Zohn (London, 1983); and Robert H. Bremner, *From the Depths: The Discovery of Poverty in the United States* (New York, 1956).

20 I am indebted to Mary Cowling's *The Artist as Anthropologist*, op. cit., which contains an excellent outline of Victorian typological thinking, for the *Household Words* and Mayhew quotations on pp. 122 and 186–7, respectively. For Emerson, see *Selected Essays*, ed. Larzer Ziff (Harmondsworth, 1982), p. 366.

21 O.I. Yellott [self-identified in text], 'Street Photography', *Photo-Miniature*, II, 14 (May 1900), pp. 49–88. S. Sontag, *On Photography* (Harmondsworth, 1977), p. 55.

22 *Street Life*, as quoted in Arthur Rothstein, *Documentary Photography* (Boston and London, 1986), p. 7. For commentary on Taine and on Victorian anthropology, see Cowling, op. cit., p. 196 and *passim*. On Galton, see Cowling, op. cit., pp. 309–11, and Miles Orvell, *The Real Thing: Imitation and Authenticity in American Culture* (Chapel Hill, 1989), pp. 92–4. General discussion of street portraiture, including Sander, may be found in Ben Maddow, *Faces: A Narrative History of the Portrait in Photography* (Boston, 1977), especially pp. 228–47 and 258–307.

23 Berger, *Ways of Seeing* (Harmondsworth, 1972), p. 104. Generally, see Peter Bacon Hales, *Silver Cities: The Photography of American Urbanization, 1839–1915* (Philadelphia, 1984), especially pp. 163–276. On Krausz and Riis, see also Ferenc M. Szasz and Ralph F. Bogardus, 'The Camera and the American Social Conscience: The Documentary Photography of Jacob A. Riis', *New York History*, LX (1974), pp. 409–36. On Hine, see Trachtenberg, *Reading American Photographs*, op. cit., pp. 164–230.

24 Beresford as quoted in Jay, op. cit., p. 8. Hoppé, *Hundred Thousand Exposures*, op. cit., p. 90.

25 See T. Bender, 'New York as a Center of "Difference" ', *Dissent*, XXXIV (1987), pp. 429–35, for a positive account of NYC's diversity which, he argues, amounts to an American countermyth to dominant communitarian and agrarian myths.

26 Yellott, op. cit., pp. 76–9. Strand's and Evans's examples are reproduced, among other places, in Ben Maddow's *Faces*, op. cit. David Mellor, in his exhibition catalogue for the Arts Council, *Modern British Photography, 1919–39* (London, 1980), claims that Strand's street work served as 'prototypes' for Hoppé's New York types (p.8). See also Robert E. Mensel, ' "Kodakers Lying in Wait": Amateur Photography and the Right to Privacy in New York', *American Quarterly*, XLIII (1991), pp. 24–45, which also contains interesting data on the general notion of the street as an arena both public and private.

27 W. Stott, *Documentary Expression and Thirties America*, new ed. (Chicago, 1986), pp. 5–25. B. Newhall, *A History of Photography from 1839 to the Present Day*, 3rd. ed. (New York, 1964), p. 137. Some of the *McClure's* series was published in book form as *Human Documents: Portraits and Biographies of Eminent Men* (New York, 1895). E. de Goncourt, *La Faustin*, definitive ed. (Paris, [n.d. 1923]). I am grateful to my colleague Charles Page for bringing this reference to my attention.

28 Lee's *Woodbury County, Iowa*, sometimes helpfully captioned 'Wife of a Homesteader', is reproduced, among other places, in Roy Emerson Stryker and Nancy Wood, *In This Proud Land: America 1935–1943 As Seen in the FSA Photographs* (Greenwich, CT, 1973). On the photograph's refusal to speak, see S. Sontag, op. cit., for example pp. 108–10 and 145.

29 For detailed coverage of relevant racist ideology in the 1920s, see David Spitz, *Patterns of Anti-Democratic Thought* (New York, 1949), pp. 137–62; Thomas F. Gossett, *Race: The History of an Idea in America* (New York, 1965), pp. 353–63, 390–8, 426–7; and Allan Chase, *The Legacy of Malthus: The Social Costs of the New Scientific Racism* (New York, 1977), especially pp. 163–75, 256–301. A parallel study of the British heritage is Nancy Stepan, *The Idea of Race in Science: Great Britain 1800–1960* (London, 1982). Scott Fitzgerald, *The Great Gatsby* (New York, 1925), p. 16; see also Mick Gidley, 'Notes on F. Scott Fitzgerald and the Passing of the Great Race', *Journal of American Studies*, VII (1973), pp. 171–81.

30 See F. Boas, 'The Measurement of Differences between Variable Quantities' (1922) and other essays in *Race, Language and Culture* (New York, 1940), pp. 3–195. W. Lippmann, *Public Opinion* (New York, 1922), especially pp. 77–156; quotation from p. 92.

31 Cowling, op. cit., p. 190. Barthes, op. cit. See also Stepan, p. 94, and, for treatments of

typology in anthropological photography, David Green, 'Classified Subjects', *Ten.8*, 14 (1984), pp. 30–37, and Elizabeth Edwards, 'Photographic "Types": The Pursuit of Method', *Visual Anthropology*, III (1990), pp. 235–58.

8 *David Ellis, Images of D.H. Lawrence: On the Use of Photographs in Biography*

1 *Taos Pueblo*, photographed by Ansel Adams and described by Mary Austin (San Francisco, 1930). Mary Austin had settled permanently in Santa Fe in 1924.
2 See *Phoenix, The Posthumous Papers of D.H. Lawrence*, ed. D. McDonald (London, 1936), p. 95.
3 *Gifts of Life: A Retrospect*, trans. M.I. Robertson (London, 1931), p. 368. Six pages later Ludwig refers to 'my master, Rembrandt, from whom I have derived more knowledge of the chiaroscuro in the human soul than from all the poets'. The attention of Freud and Sartre was drawn to Ludwig's biography of Wilhelm II largely because of the importance attributed in it to the Kaiser's paralysed left arm. See *New Introductory Lectures on Psychoanalysis*, II, Pelican Freud Library, pp. 97–8, and J-P. Sartre, *Les carnets de la drôle de guerre, Novembre 1939 – May 1940* (Paris, 1983), pp. 357–87.
4 *Genius and Character* (London, 1931), p. 31.
5 See *Wide-eyed in Babylon* (New York, 1974), pp. 177–8.
6 Benjamin's essay, translated by Stanley Mitchell, can be found in *Screen*, XIII (Spring, 1972). This quotation is on p. 7.
7 *La Chambre Claire: Note sur la photographie* (Paris, 1980), pp. 107–8.
8 *La Chambre Claire*, p. 157.
9 This is a happy but distant memory of a film I have not been able to see again; but the point does not depend on an accurate recollection of the names which are interchanged.
10 John Worthen, *D.H. Lawrence: The Early Years 1885–1912* (Cambridge, 1991), p. 5.
11 *The Complete Poems of D.H. Lawrence*, eds. V. de Sola Pinto and F. Warren Roberts (New York, 1964), pp. 490–1.
12 See Keith Sagar, *The Life of D.H. Lawrence: An Illustrated Biography* (London, 1980), p. 73.
13 Compare, 'But look at England! Hogarth, Reynolds, Gainsborough, they all are already bourgeois. The coat is really more important than the man. It is amazing how important clothes suddenly become, how they cover the subject. An old Reynolds colonel in a red uniform is much more a uniform than an individual, and as for Gainsborough, all one can say is: What a lovely dress and hat! What really expensive Italian silk! This painting of garments continued in vogue, till pictures like Sargent's seem to be nothing but yards and yards of satin from the most expensive shops, having some pretty head popped on the top. The imagination is quite dead. The optical vision, a sort of flashy coloured photography of the eye, is rampant.' *Phoenix*, p. 560.
14 *The Letters of D.H. Lawrence*, ed. James T. Boulton (Cambridge, 1971), I.
15 *Philosophical Investigations*, trans. G.E.M. Anscombe (Oxford, 1968), p. 145.
16 Davis's remarks are reprinted from his *Man Makes His Own Mask* in Volume III of E. Nehls, *D.H. Lawrence: A Composite Biography* (Wisconsin, 1959), pp. 209–12.
17 See *The Revealing Eye: Personalities of the 1920s in Photography by Nickolas Muray and words by Paul Gallico* (New York, 1967), p. 170.
18 In Volume I of his *Daybooks* (New York, 1961) Weston, who sent two prints to Lawrence, complains that his 'D.H. Lawrence negatives were not up to standard'.
19 See 'Sur le portrait photographique', the extract from *L'Art de la photographie*, reprinted in the anthology *Du bon usage de la photographie*, eds. Michel Frizot and Francoise Ducros (Paris, 1987), p. 45.
20 *The Savage Pilgrimage: A Narrative of D.H. Lawrence* (London, 1932), p. 148.

21 See Susan Sontag, *On Photography* (Harmondsworth, 1979), pp. 36–7.
22 See D.H. Lawrence, '*Study of Thomas Hardy' and Other Essays*, ed. Bruce Steele (Cambridge, 1985), p. 165.
23 '*Mornings in Mexico' and 'Etruscan Places'* (Harmondsworth, 1960), p. 171.
24 *Sons and Lovers* (Harmondsworth, 1948), p. 189.
25 *Phoenix*, pp. 580–1.
26 *The Uncommercial Traveller* and *Reprinted Pieces*, etc. (London, 1958), p. 192.
27 *Screen*, XIII, 1, p. 8.
28 *On Photography*, p. 154.

9 *Alan Trachtenberg, Likeness as Identity: Reflections on the Daguerrean Mystique*

1 David Freedberg, *The Power of Images* (Chicago, 1989), pp. 231–35, 278–80.
2 Sadikichi Hartmann, 'The Daguerreotype', in Harry W. Lawton and George Knox, eds., *The Valiant Knights of Daguerre* (Berkeley, California, 1978), p. 142. See also Mrs D.T. Davis, 'The Daguerreotype in America', *McClure's Magazine*, VIII (November, 1896), pp. 3–16.
3 Peter C. Bunnell, ed., *Edward Weston on Photography* (Salt Lake City, 1983), p. 44.
4 See Jonathan Crary, *Techniques of the Observer: On Vision and Modernity in the Nineteenth Century* (Cambridge, Mass., 1990).
5 Cathy N. Davidson, 'Photographs of the Dead: Sherman, Daguerre, Hawthorne', *South Atlantic Quarterly*, LXXXIX (Fall, 1990), p. 681.
6 See David E. Stannard, 'Sex, Death, and Daguerreotypes: Toward an Understanding of Image as Elegy', in *America and the Daguerreotype*, ed. John Wood (Iowa City, 1991), pp. 73–108.
7 'A Few Photographs', *The Knickerbocker*, V (August, 1853), pp. 137–42.
8 Quoted in Robert Taft, *Photography and the American Scene* (New York, 1938), p. 12.
9 The most comprehensive study of such rhetoric remains Richard Rudisill, *Mirror Image: The Influence of the Daguerreotype on American Society* (Albuquerque, 1971). Also see Alan Trachtenberg, 'Prologue', *Reading American Photographs: Images as History, Mathew Brady to Walker Evans* (New York, 1989), pp. 3–20; 'Mirror in the Marketplace: American Responses to the Daguerreotype, 1839–1851', in *The Daguerreotype*, ed. John Wood (Iowa City, 1989), pp. 60–73; 'Photography: The Emergence of a Keyword', in *Photography in Nineteenth-Century America*, ed. Martha A. Sandweiss (New York, 1991), pp. 16–47; and Susan S. Williams, 'The Confounding Image: The Figure of the Portrait in Nineteenth-Century American Fiction', PhD. Dissertation, Yale University, 1991, especially Chapter 2, pp. 54–125.
10 Nathaniel Hawthorne, *The American Notebooks* (Columbus, Ohio, 1972), pp. 492–93; quoted in Taylor Stoehr, *Hawthorne's Mad Scientists* (Hamden, Connecticut, 1978), p. 83.
11 Judy L. Larson in *A Lasting Impression*, exhibition catalogue: High Museum (Atlanta, Georgia, 1990), p. 4.
12 Hartmann, op. cit., p. 148.
13 Useful sources include *American Portrait Miniatures*, exhibition catalogue by Dale T. Johnson: The Metropolitan Museum of Art (New York, 1990); *American Portraiture in the Grand Manner*, exhibition catalogue by Michael Quick: Los Angeles County Museum of Art (Los Angeles, 1981); Wayne Craven, *Colonial American Portraiture* (Cambridge, 1986); Brandon Frame Fortune, 'Charles Wilson Peale's Portrait Gallery: Persuasion and the Plain Style', *Word & Image*, VI (October–November, 1990), pp. 308–24.

14 For example, Floyd and Marion Rinhart, *The American Daguerreotype* (Athens, Georgia, 1981), an invaluable source of information.
15 Nathaniel Hawthorne, *The House of the Seven Gables* (Columbus, Ohio, 1965), p. 91.
16 Ibid., pp. 2–3.
17 Susan M. Barger, 'Delicate and Complicated Operations: The Scientific Examination of the Daguerreotype', in Wood, ed., op. cit., pp. 97–109.
18 Davidson, op. cit., p. 697.
19 Hawthorne, op. cit., p. 46.
20 Stoehr, op. cit., p. 90.
21 Quoted in Trachtenberg, *Reading American Photographs*, p. 13.
22 *The Journals and Miscellaneous Notebooks of Ralph Waldo Emerson*, eds. Ralph H. Orth and Alfred R. Ferguson (Cambridge, Mass., 1971), IX, p. 14.
23 T.S. Arthur, 'The Daguerreotypist', *Godey's Lady's Book*, XXXVIII (May, 1849), pp. 352–55.
24 *The Photography and Fine Art Journal*, VIII (January, 1855), p. 19. Quoted in Rudisill, op. cit., p. 214.
25 David Brewster, *Letters on Natural Magic* (New York, 1832).
26 See the discussion of this development in Trachtenberg, *Reading American Photographs*, op. cit., Chapter 1, pp. 21–70.
27 Quoted in ibid., p. 15.
28 Charles Sanders Peirce, 'Logic as Semiotic: The Theory of Signs', in *Philosophical Writings of Peirce*, ed. Justus Buchler (New York, 1955), pp. 98–119.
29 Quoted in Trachtenberg, op. cit., p. 15.
30 See ibid., p. 24.
31 *Robert Cornelius: Portraits from the Dawn of Photography*, exhibition catalogue by William F. Stapp: National Portrait Gallery (Washington, 1983), p. 50.
32 A good example is Marcus Aurelius Root, *The Camera and the Pencil* (Philadelphia, 1864), especially Chapter 7, pp. 84–89. See Allan Sekula, 'The Body and the Archive', *October*, XXXIX (Winter, 1966), pp. 30–64.
33 E.K. Hough, 'Expressing Character in Photographic Pictures', *The American Journal of Photography*, I (December 15, 1858), pp. 212–13.
34 See Van Deren Coke, *The Painter and the Photograph* (Albuquerque, 1964), Chapter 1, pp. 17–58.
35 *The Journals and Miscellaneous Notebooks of Ralph Waldo Emerson*, eds. William H. Gilman and J.E. Parsons, VIII, pp. 115–16.
36 Quoted in Davidson, op. cit., pp. 677, 686.
37 On Whitman's subversion of the conventional portrait-self, see Trachtenberg, op. cit., pp. 60–70.
38 Alexis de Tocqueville, *Democracy in America*, II (New York, 1958), p. 336.
39 Ibid., p. 147.
40 Cf. 'What the American daguerreotypist evolved was a vocabulary for rendering the mundane heroic. And that look of heroism, faith and promise – be it on the face of the country peddler, the miner with his pick, or the well-dressed city man – is the mark of American daguerreian [sic] portraiture. It reflected America's self-image – a grand, admirable, naive vision of our own destiny.' John Wood, 'The American Portrait', in John Wood, ed., op. cit., p. 25.

10 *Philip Stokes, The Family Photograph Album: So Great a Cloud of Witnesses*

1 I am grateful to the many unknown photographers whose work I have studied, and for the help and access to material offered by Peter James and Joe McKenna of Birmingham Local Studies Library; Audrey Linkman of the Documentary Photog-

raphy Archive, Manchester; Dorothy Ritchie of Nottinghamshire County Library Local Studies Section, Nottingham; Roger Taylor and Julian Cox of the National Museum of Photography Film and Television, Bradford.

2 It is hard to make strict sense of the range of species and varieties of albums. I have tended to count by variety; others may arrive at higher or lower numbers.

3 Some random counts amongst donations in the Documentary Photography Archive at Manchester showed ratios of groups to total image numbers of from 1:3 to 1:6. Groups were taken as images including three or more persons, formally arranged.

4 Geoffrey Best produces an excellent overview of the growth of leisure activities in both religious and secular contexts in Chapter 3 of his *Mid-Victorian Britain, 1851–75* (London, 1985).

5 Paul Martin is perhaps the best known exponent of casual photography at this time. See *Paul Martin* (Austin, 1977), by Fluckinger, Schaap and Meacham.

6 Some of these show a remarkably modern-seeming urban consciousness, by offering keys to all the plants shown throughout the album.

Select Bibliography

The bibliography which follows comprises general studies of the subject and only includes a few volumes published by, or written about, individual portrait photographers. Many of the texts listed here contain extensive bibliographies in their own right and, like the notes to the individual essays, should be consulted for more detailed references.

Ades, Dawn, *Photomontage*, London, 1986.

Arbus, Diane, *Diane Arbus*, New York, 1974.

Avedon, Richard, *Portraits*, London, 1976.

Barthes, Roland, *Camera Lucida*, trans. Richard Howard, London, 1982.

Beaton, Cecil and Gail Buckland, *The Magic Image*, London, 1989.

Beloff, Halla, *Camera Culture*, Oxford, 1985.

Boni, Albert, ed., *Photographic Literature: An International Bibliographic Guide*, New York, 1962.

Burgin, Victor, ed., *Thinking Photography*, London, 1982.

Coe, Brian and Gates, Paul, *The Snapshot Photograph: The Rise of Popular Photography*, London, 1977.

Cohen, Joyce Tennison, ed., *In/Sights: Self-Portraits by Women*, London, 1979.

Coke, Van Deren, *The Painter and the Photographer: From Delacroix to Warhol*, Alberquerque, 1964, reprinted 1972.

Colnaghi, P., *Photography: The First Eighty Years*, New York, 1976.

Croy, O. R., *The Photographic Portrait*, London, 1968.

Danziger, J., *Interviews with Master Photographers*, London, 1977.

Ford, Colin, ed. and Taylor, Roger, intro., *The Story of Popular Photography*, North Pomfret, 1989.

Freund, G., *Photography and Society*, London, 1980.

Galassi, Peter, *Before Photography: Painting and the Invention of Photography*, New York, 1981.

Gernsheim, H., *Creative Photography: Aesthetic Trends, 1839–1960*, London, 1962.

Green, Jonathan, ed., *The Snapshot*, New York, 1974.

Hartmann, Sadaichi, *The Valiant Knights of Daguerre*, Berkeley, 1978.

Haworth-Booth, Mark, ed., *The Golden Age of British Photography: 1839–1900*, Millerton, NY, 1984.

Heyert, E., *The Glass-House Years: Victorian Portrait Photography 1839–1870*, London, 1979.

Hill, B., *Julia Margaret Cameron: A Victorian Family Portrait*, London, 1973.

Hirsch, Julia, *Family Photographs: Content, Meaning and Effect*, New York and Oxford, 1981.

Jeffrey, Ian, *Photography: A Concise History*, London, 1980.

Lassam, Robert, *Portrait and the Camera*, London, 1989.

Lemagny, Jean-Claude and Andre Rouille, eds., trans., Janet Lloyd, *A History of Photography: Social and Cultural Trends*, Cambridge, 1987.

Lesey, Michael, *Time Frames: The Meaning of Family Pictures*, New York, 1980.

Lyons, Nathan, ed., *Photographers on Photography: A Critical Anthology*, Englewood Cliffs, NJ, 1956.

Mapplethorpe, Robert, *Mapplethorpe Portraits*, London, 1988.

Martin, P., *Victorian Snapshots*, London, 1973.

Morath, A., *Faces Before My Camera*, London, 1947.

McCauley, E. A., *Likenesses: Portrait Photography in Europe, 1850–1870*, Alberquerque, 1980.

Newhall, Beaumont, *The Daguerreotype in America*, New York, 1976.

—— ed., *Photography: Essays and Images*, New York, 1980.

Ovenden, G., *Pre-Raphaelite Photography*, London, 1972.

Sander, Gunther, *August Sander: Citizens of the Twentieth Century*, Cambridge, Mass., 1986.

Scharf, Aaron, *Art and Photography*, Harmondsworth, 1968.

Sontag, Susan, *On Photography*, London, 1978.

Steichen, Edward, ed., *The Family of Man*, New York, 1955.

Stieglitz, Alfred, *Georgia O'Keeffe, A Portrait*, New York, 1978.

Szarkowski, John, *Looking at Photographs*, New York, 1973.

Taft, Robert, *Photography and the American Scene*, New York, 1964.

Tagg, John, *The Burden of Representation*, London, 1988.

The Painter as Photographer, exhibition catalogue, Arts Council, London, 1982.

Trachtenberg, Alan, *Reading American Photographs*, New York, 1989.

—— ed., *Classic Essays on Photography*, New Haven, London, 1980.

Turner, Peter, ed., *American Images: Photography 1945–1980*, Harmondsworth, 1985.

Vaizey, M., *The Artist as Photographer*, London, 1982.

Weaver, M., *Julia Margaret Cameron*, London, 1984.

Weaver, Mike, *The Photographic Art: Pictorial Traditions in Britain and America*, London and New York, 1985.

—— ed., *The Art of Photography 1839–1989*, London, 1989.

Weegee, *Weegee's People*, New York, 1985.

Index